SHADOWS OF WAR

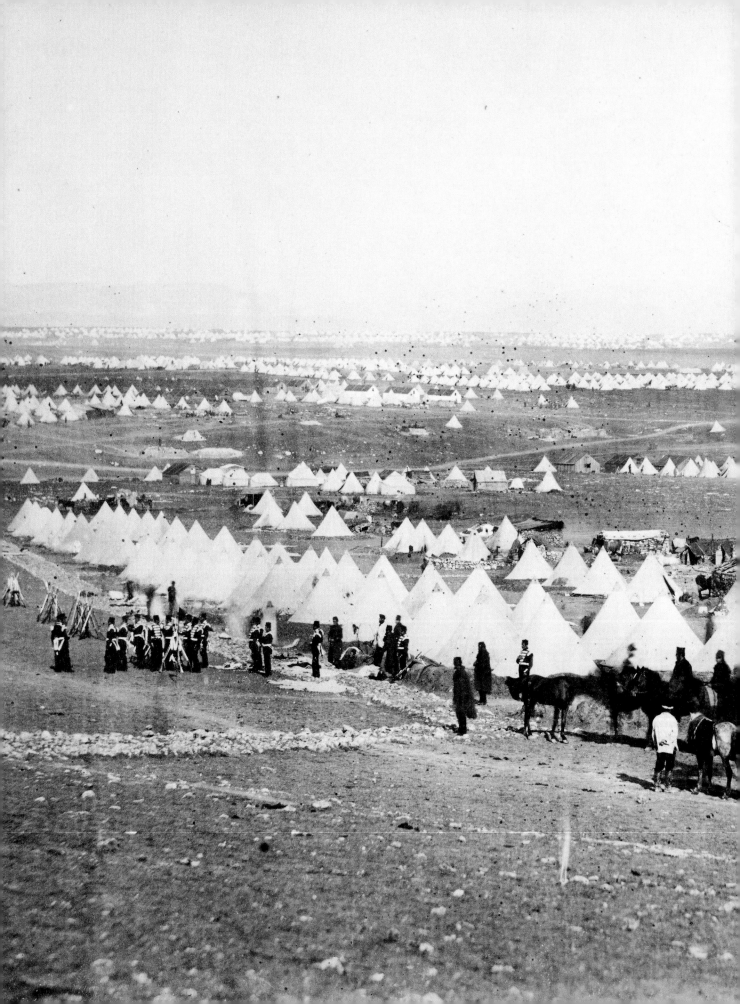

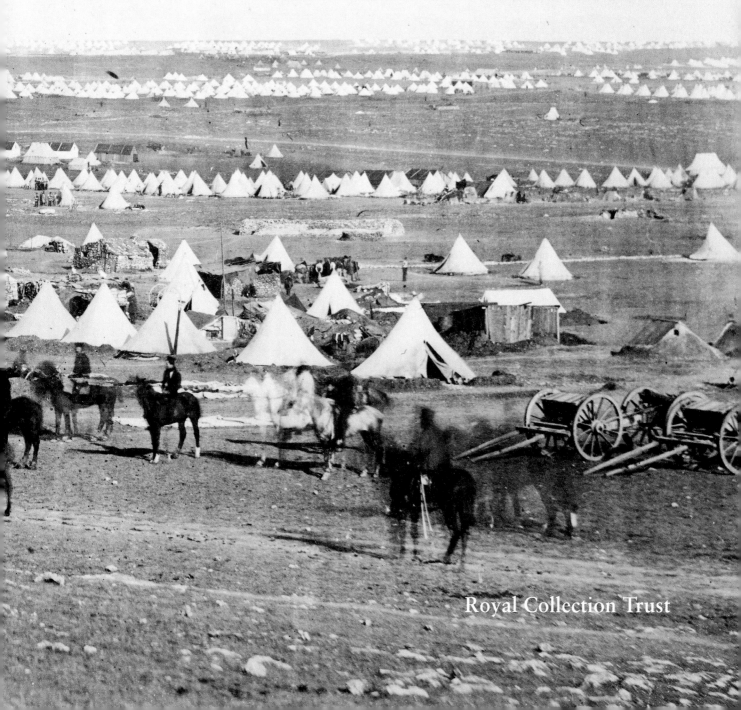

SHADOWS OF WAR

ROGER FENTON'S PHOTOGRAPHS OF THE CRIMEA, 1855

SOPHIE GORDON

WITH CONTRIBUTIONS FROM LOUISE PEARSON

Royal Collection Trust

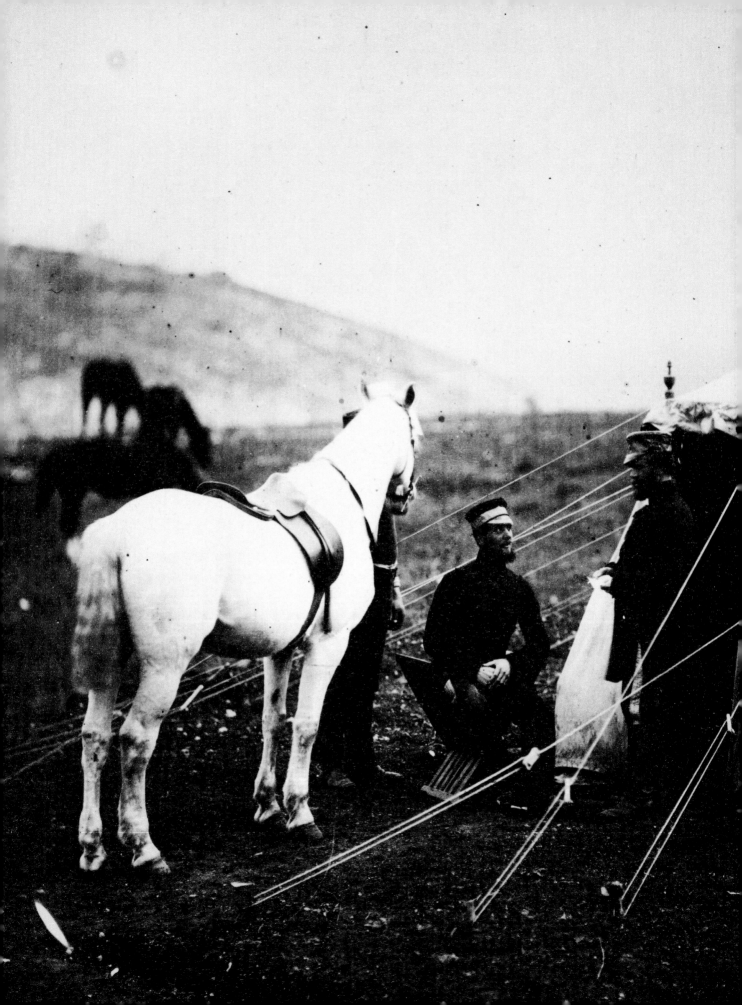

CONTENTS

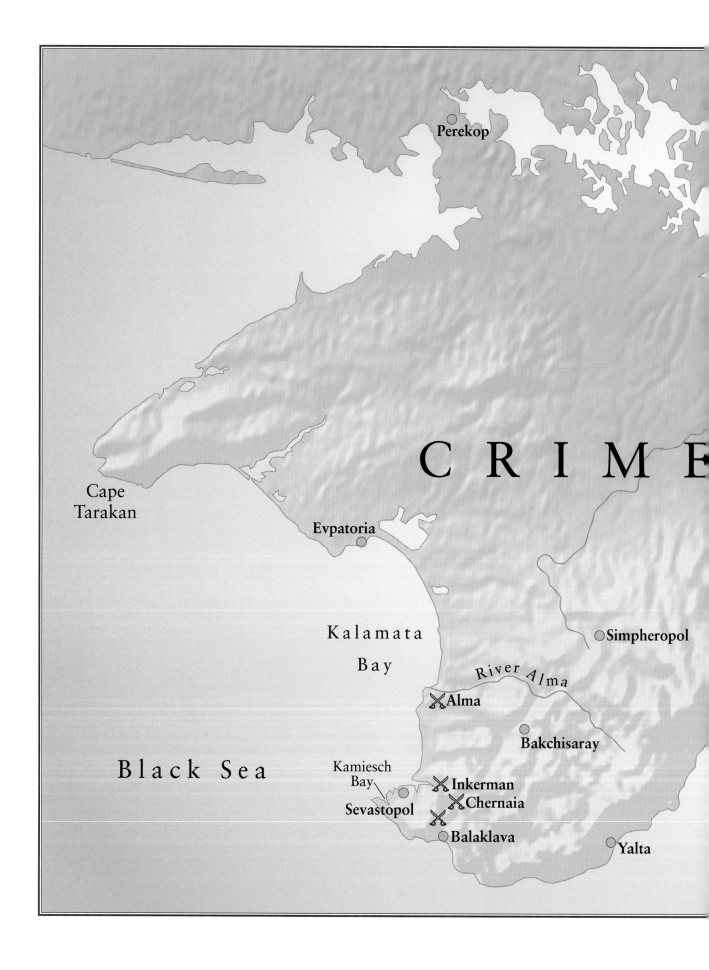

Perekop

Cape
Tarakan

Evpatoria

CRIME

Kalamata
Bay

○Simpheropol

River Alma

⚔Alma

Bakchisaray

Black Sea

Kamiesch
Bay

⚔Inkerman
⚔Chernaia

Sevastopol

⚔Balaklava

Yalta

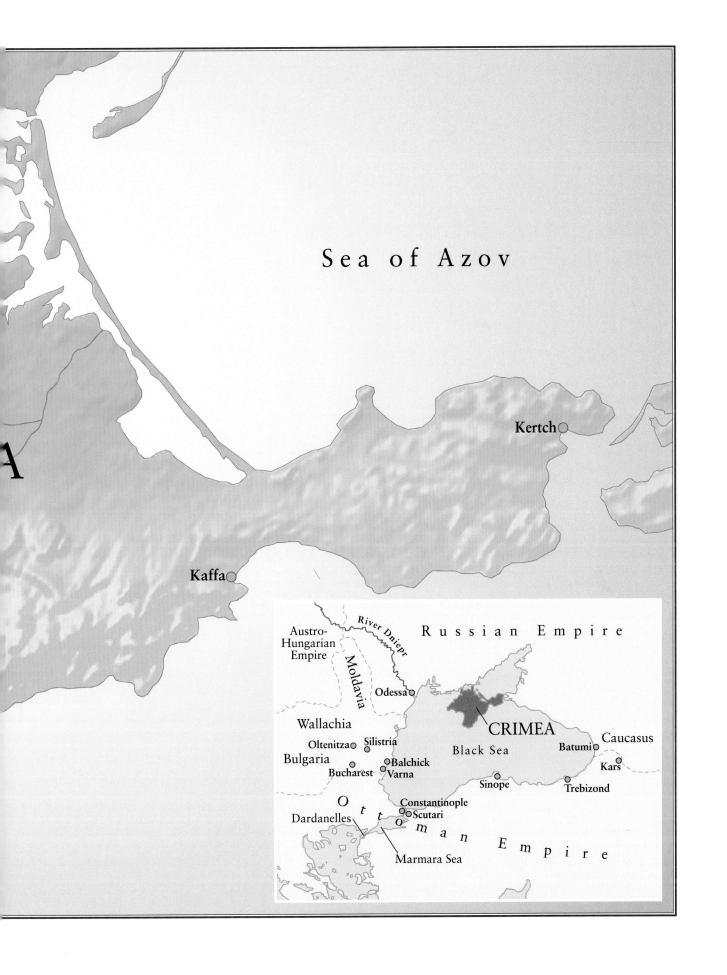

Sea of Azov

Kertch

Kaffa

A

Austro-
Hungarian
Empire

River Dniepr

Moldavia

R u s s i a n E m p i r e

Odessa

Wallachia

Oltenitza Silistria

Bulgaria

Bucharest Balchick
Varna

CRIMEA

Black Sea

Batumi Caucasus

Kars

Sinope

Trebizond

Constantinople

O

Dardanelles

Scutari

t

t

o

m

a

n

E m p i r e

Marmara Sea

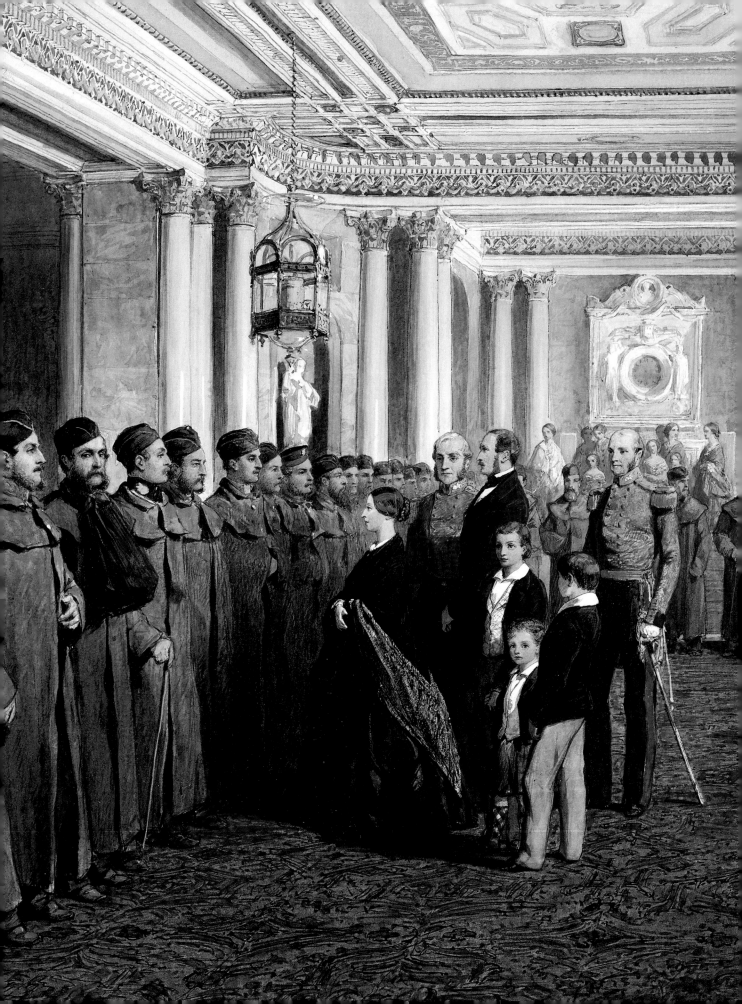

THE RUSSIAN WAR OF 1853–5

Oh, thankless Crimean land!

'The Ruins of Balaklava', from *The Crimean Sonnets* (1825)

Adam Mickiewicz

In Europe today the word 'Crimea' is usually connected with recent political and military events concerning Russia's annexation of the peninsula from Ukraine in 2014. The battle for the land, both ideological and physical, is however part of a long history of warfare that stretches back over hundreds of years. The war of 1853–5 is one of several major conflicts that have been fought there. The geographical location of the Crimea, to the south of Russia and making up part of the Black Sea coastline, situates it as an ideal gateway for Russia to access the Mediterranean and Europe, via Constantinople (Istanbul). From the sixteenth century Russia and the Ottoman Empire struggled for control of the land, sometimes because of this desire for naval access to Europe, but also because the Crimea became the physical focus for more complex ideologies concerning religion and the role that Russia believed she should play on the international stage. There is a set of 18 sonnets by the Polish poet Adam Mickiewicz, known as *The Crimean Sonnets*, which were written at a time when Russia ruled the Crimea (having annexed the land in 1784 under Catherine the Great). At this time the region was enjoying relative peace. The land opened up to poets, travellers and artists, like Mickiewicz, who found a region imbued with Islamic culture, seemingly exotic, colourful and richly receptive to a romanticism that today is difficult for us to appreciate with more recent brutal images of war to hand (**fig. 1**). One of the most evocative works from this time is Alexander Pushkin's poem, 'The Fountain of Bakhchisarai' (1823), which today still resonates with a Russian audience. In the work, a doomed love story, Pushkin writes of the passing of time and the transience of all men and empires, expressing emotions that speak powerfully of the connection

Fig. 1: R.M. Bryson after Carlo Bossoli (1815–84), 'Mouth of the Chernaia River', plate 11 from *The Beautiful Scenery and Chief Places of Interest throughout the Crimea*, London, 1856, colour lithograph, 58.0 × 30.0 cm. RCIN 1046762

Bossoli was a professional artist who travelled throughout Europe, and who was working in the Crimea by 1839. As one of only very few artists who had worked in the region before the war, his work was of great interest to a British audience. His watercolours were exhibited at several London venues in 1855–6. Bossoli tried to sell the entire set of paintings to Queen Victoria, but instead she commissioned a set of drawings of the Alma, Sevastopol, Inkerman and Balaklava to be made from his sketches. The drawings are no longer in the Royal Collection.

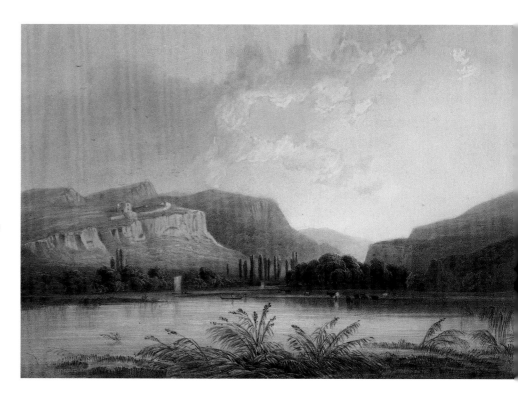

between people and place. Another poem, written while the Crimean War was in progress, became instantly famous in Britain – Alfred Lord Tennyson, responding to newspaper reports describing an action during the Battle of Balaklava, wrote 'The Charge of the Light Brigade' (1854) only a few weeks after the event. The poem is an emotional response to the notorious event, with short, direct lines that evoke the battlefield and describe the perceived nobility of the soldier in bravely engaging the enemy in a doomed action.

These poetic works, although each written for very different reasons, all attempt to engage us at a deep, emotional level by working on our imagination. This usefully suggests an alternative way for us to connect with and interpret the photographs and other images that emerged during and after the Crimean War of 1853–5. Instead of seeking only photographic objectivity and factual information, we should also allow the images to work on our imagination and to evoke, often through subtle implication, an emotional response. The Victorian public in 1855–6 would have responded to the photographs through their already considerable knowledge of the war gained primarily from newspaper reports and published letters from soldiers, but also from other images, mainly prints. In order for a twenty-first-century audience to enjoy a similar response and understanding, it is necessary to begin with the context of the war itself.

Today, most people's knowledge of the Crimean War, often referred to more accurately in nineteenth-century Britain as the 'Russian War', is patchy at best. There are aspects of the conflict that still resonate today, however. The story of Florence Nightingale (1820–1910) is commonly known: tales of the 'Lady with

the Lamp' who transformed the care of the wounded in the hospital at Scutari are still taught, as is the role played by Mary Seacole, a Jamaican woman who travelled to the Crimea to set up a 'hotel' (a general store and canteen) to provide food, drink and assistance to the military. The 'Charge of the Light Brigade' remains a well-known action, largely due to Tennyson's poem, and words and phrases that originate from the war, including the 'Thin Red Line', balaklava and cardigan remain in our modern vocabulary.[1] The war is complicated, however, and difficult to understand. Numerous causes led to the fighting, which took place on several different fronts, including (apart from the Crimea and the Black Sea) the Baltic Sea, the White Sea and even the Pacific.

THE BUILD-UP TO WAR

The Crimean War, which saw Britain, France, the Ottoman Empire and Sardinia allied against Russia, was a hard-fought conflict that remains the most significant war fought in a history of tension between Russia and the Ottoman Empire (**fig. 2**).[2] The war has to be understood within the wider context of Ottoman–Russian hostilities. Following the annexation of Crimea in 1784, Russia had access to the Black Sea. Access to the Mediterranean, however, was still controlled by the Ottoman Empire, which dominated the naval route via Constantinople. The only other route was via the Caucasus, a region

Fig. 2: Unknown maker, Paperweight, *c*.1855–6, glass with coloured prints, 2.7 × 11.0 × 9.5 cm. RCIN 1645

This glass paperweight shows Queen Victoria (centre), the Ottoman Emperor Abdülmecid I (left) and the French Emperor Louis Napoleon III (right). As the Heads of State of the three main allied nations they were frequently depicted together, particularly in items of a more modest nature. There was a thriving souvenir market for cheap prints, pottery figurines, plates, cups and other objects commemorating the war.

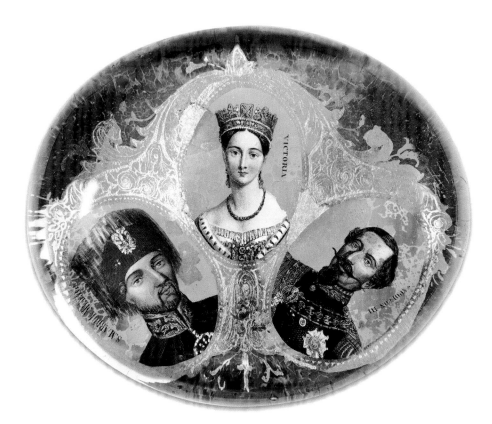

Fig. 3: William Evans (1797–1877), *Windsor Castle: The Grand Reception Room, 3 June 1844*, *c.*1844, pencil, watercolour and bodycolour on card, 27.1 × 37.2 cm. RCIN 919784

The watercolour shows Queen Victoria and Tsar Nicholas I at Windsor Castle. The Tsar arrived in Britain on 1 June 1844 to discuss the role that Britain and Russia would play in the event of the collapse of the Ottoman Empire. Although the visit was considered a success, Nicholas I returned to Russia having misread the position that Britain would take. This misunderstanding played a crucial part in his move towards war in 1854.

inhabited by tribes who became increasingly hostile to Russia during the nineteenth century, as Russian troops attempted to pass through the region. As the Ottoman Empire weakened in the early nineteenth century, it became involved in a series of military conflicts, principally with Russia in 1828–9 following the Greek Uprising which began in 1821, and with Egypt in 1830 and 1838.

At the same time, Russia reasserted an earlier conviction that she was the protector of Orthodox Christianity in the East, positioning herself as the guardian of Christians in the Islamic Ottoman Empire. Whilst this gave Russia an excuse to involve herself in Ottoman sovereign lands, it also alarmed European powers, notably France, who saw this as evidence of

Russia's growing territorial ambitions. Neither Britain nor France wanted to see the collapse of the Ottoman Empire because it would inevitably lead to the growth of an even more powerful Russia. One immediate result of this was France, under Napoleon III, declaring that she, not Russia, was the supreme protector of Christianity within the Ottoman Empire. The Ottoman Sultan, Abdülmecid I, was pushed into signing a treaty that gave France and the Roman Catholic Church control of all Christian sites, which included possession of the keys to the Church of the Nativity, previously in the hands of the Greek Orthodox Church. This church was the most important Christian location in Jerusalem, and control of the building was immensely significant.

Tsar Nicholas I (r.1825–55) also engaged in diplomatic attempts to reassure Britain and France that Russia had no further territorial ambitions and that he would not do anything to hasten the end of the Ottoman Empire. During an official state visit to Britain in 1844, the Tsar discussed with the government, and Queen Victoria and Prince Albert, what might happen to the empire in the event of its collapse (**fig. 3**). Tsar Nicholas believed that he had reached an understanding with the British government who would assist with the partition of the empire in the event of its demise, but he misread the situation and failed to see that Britain would interpret Russian intervention as symptomatic of her growing imperial aims. An increase in Russophobia from the British public, fuelled by pamphlets and the press, also helped determine the British government's response. George de Lacy Evans, who was later to be a commander during the Crimean War, wrote two books on the threat that he believed Russia posed towards India and the peace Britain enjoyed in the 1820s. One oft-cited publication, *On the Designs of Russia* (1828) laid out a step-by-step plan of action against Russia. De Lacy Evans's work led to an official enquiry into Britain's imperial defences and he became an MP, first in Rye and later in Westminster. He wished to return to a military role, however, having served with distinction in India and during the Napoleonic wars. He was eventually given command of the 2nd Division in the Crimea. He was to see Britain adopt many of the policies he had suggested in his 1828 publication.[3]

The lands that separated Russia from the Ottoman Empire were also experiencing a period of increased nationalism and unrest. The Danubian provinces of Wallachia and Moldavia (making up much of present-day Romania) which were occupied by Russia but nominally under Ottoman rule, had seen frequent revolts against Russian occupation. Although these were successfully put down, more restrictive treaties were put in place with the Ottomans as a result. Russian troops were eventually ordered to occupy the provinces in June 1853. The Russians believed that this would trigger a religious war in the region without involving other Western powers, and which would ultimately lead to the downfall of the Ottoman Empire.

WAR BEGINS – OCTOBER 1853

Initially, the British response to the Russian occupation was divided, but it became clear that Russia wanted to occupy the region permanently and the pro-war argument grew louder. The Ottomans declared war on 4 October 1853. They moved troops to the Danube, but also decided to attack Russia in the Caucasus where

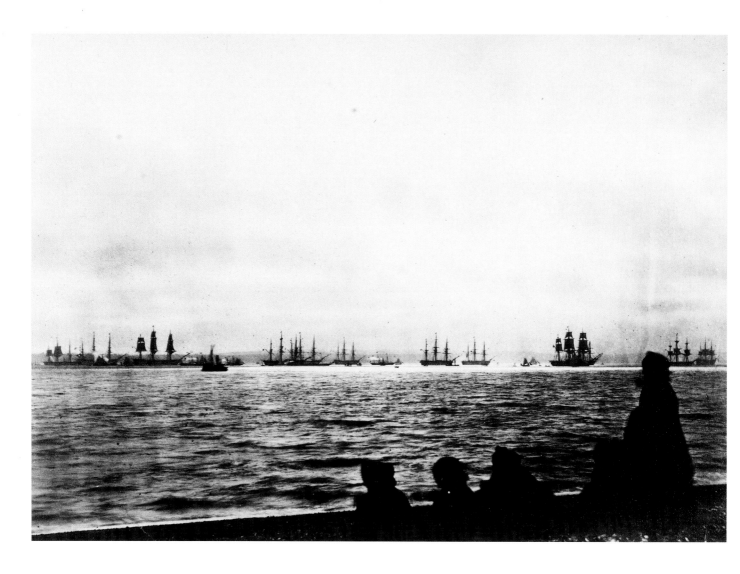

Fig. 4: Roger Fenton (1819–69),
Royal Yacht Fairy *steaming through
the fleet*, 11 March 1854, albumen
print, 20.5 × 14.6 cm. RCIN 2906008

Queen Victoria, with members of her
family, boarded the Royal Yacht to
watch the departure of the Baltic fleet.
The 12-year-old Prince of Wales wrote
in his diary, 'We staid [*sic*] out most
of the day seeing the departure of
18 man of war ships sailing for the
Baltic the commander of them is
Sir Charles Napier.'
RA VIC/MAIN/QVJ1854: 11 March

the anti-Russian Muslim tribes would join them. Engagements ensued around the Black Sea, notably the Battle of Sinope on the northern coast of Anatolia on 30 November 1853, when Russian forces defeated the Ottoman navy. The heavy losses were widely reported in Britain, and public opinion in favour of war was strengthened. Britain and France eventually declared war against Russia on 27 and 28 March 1854 respectively.

The campaign in the Danubian provinces continued, with the Ottomans successfully resisting the Russians who besieged the tactical fortress at Silistria for just over two months. At the same time, a joint British-French fleet was sent out to the Baltic Sea to attack the Russian naval base at Kronstadt, which protected St Petersburg. The British fleet departed for the Baltic from Spithead on 11 March 1854, watched by Queen Victoria and her family from the deck of the Royal Yacht *Fairy*. Roger Fenton produced a series of eight photographs documenting the occasion (**fig. 4**).[4]

Fig. 5: 'The Barracks at Scutari – from a daguerreotype by J. Robertson, Esq. of Constantinople', *Illustrated London News*, 1 July 1854, p. 626.
RCIN 1041767

James Robertson (1813–88) began working as an engraver in the Imperial Mint, Istanbul, in 1841. He opened a photographic studio in the city in 1854 and quickly became known for his architectural and topographical work, some of which was taken with his brother-in-law, the photographer Felice Beato (1832–1909).

The *Illustrated London News* began reproducing Robertson's images of Constantinople and its inhabitants in 1854, as war approached. Although the caption states the engraving is a copy of a daguerreotype, it is unlikely that he was using that process. As a commercial photographer, Robertson would be much more likely to employ the wet collodion process with glass plate negatives, from which he printed salted paper prints or albumen prints.

The commanders of the Baltic fleet, including Sir Charles Napier (1786–1860), considered the Russian defences too strong for the allied fleet and instead undertook a series of raids and effectively blocked Russian trade, forcing them to use more costly land routes instead. The raiding continued in the summer of 1855.

From June 1854, the allied forces began arriving in the Balkan region, eventually making their base at Varna (in modern-day Bulgaria). From here, the Russian route to Constantinople could be blocked. The journey from Britain had taken the troops first to Malta and then to Constantinople, where they were stationed in barracks at Scutari or accommodated in camps in the area (**fig. 5**). By the time the allies embarked for Varna, however, the Russians were already beginning a retreat. At this stage there was the possibility of no further conflict, but in the autumn the decision was made in Britain and France to move the troops to the Crimean peninsula to attack Russia directly. The immediate action of defending Turkey against Russia was forgotten as Britain instead moved towards a larger war against Russia.[5]

THE CRIMEAN CAMPAIGN 1854–5

The main allied fleet arrived at Kalamata Bay on the coast of Crimea on 14 September 1854. Under the command of Lord Raglan and Marshal Saint-Arnaud, the fleet consisted of around 27,000 British, 30,000 French and 7,000 Turkish troops (**fig. 6**).[6] The principal aim of the campaign was to capture Sevastopol (traditionally Sebastopol), the most important naval base in the region. After a disembarkation which took five days, the troops began their advance southwards to the town. The day after they commenced, however, the allies encountered the Russians, led by Prince Menshikov, at the River Alma.

The Battle of the Alma was led by the British 2nd Division, commanded by de Lacy Evans, and the Light Brigade under Sir George Brown. Although there was strong resistance from the Russians, the allies were eventually victorious, aided in particular by an attack from the 42nd Highland Regiment (Black Watch) (**fig. 7**). With over 3,000 wounded or killed, the battlefield took several days to clear before a decision was made not to proceed immediately to Sevastopol and attack the town from the north, but rather to besiege from the south. Sir John Fox Burgoyne of the Royal Engineers proposed the course of action, and with Lord Raglan planned the attack on Sevastopol (**fig. 9**). The allied bombardment began on 17 October 1854. The delay had given the Russians time to fortify the defences under engineer Colonel Todleben, which led to the siege lengthening considerably. The British headed towards Balaklava, and the French to Kamiesch, which they made their respective bases; both ports would enable supplies to reach the armies.

The Russians thought to end the siege by attacking the British at Balaklava, cutting them off from their supply lines. On 25 October 1854 General Liprandi led an assault on the port. It began well for the Russians, who captured redoubts manned by the Ottomans and took some of the British guns. They were prevented from reaching Balaklava, however, by the 93rd Highland Regiment commanded by Sir Colin Campbell (**fig. 10**) (the action became known as the 'Thin Red Line')

Fig. 6: Mayer Frères (active 1850s–60s), *Marshal Armand-Jacques Leroy de Saint-Arnaud (1798–1854)*, *c*.1854, albumen print, 20.7 × 16.0 cm. RCIN 2500001

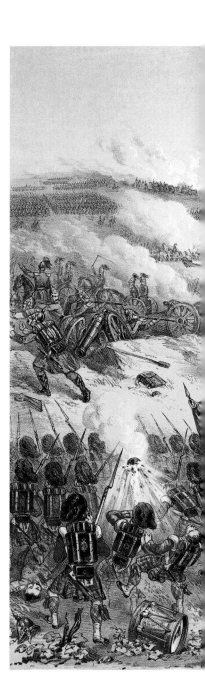

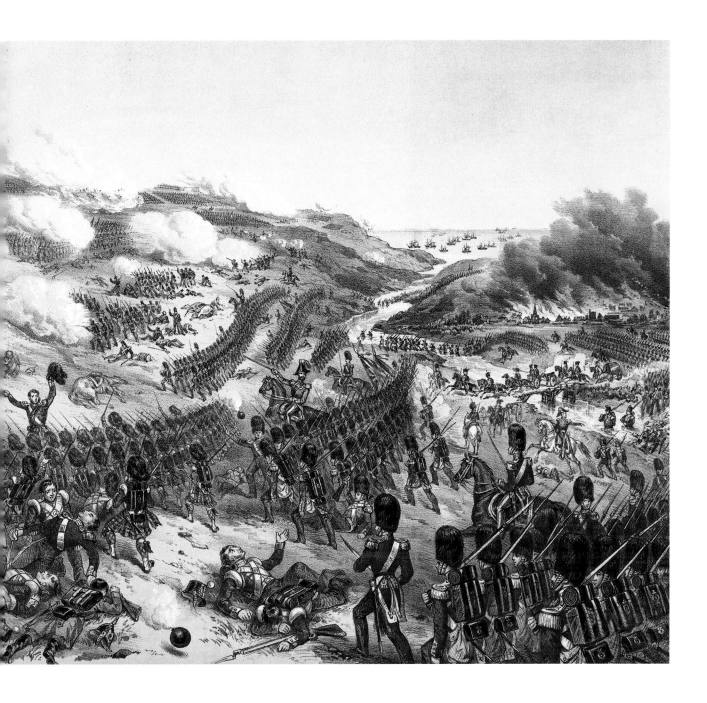

Fig. 7: Augustus Butler
(active 1840–60), *The Battle of the
Alma*, published 28 October 1854,
colour lithograph with hand colouring,
44.5 × 56.8 cm (sheet). RCIN 751010

and an exceptionally successful assault by the Heavy Brigade under
Major-General James Scarlett (**fig. 11**). As more British troops arrived on
the battlefield, Lord Raglan decided that the guns previously taken by the
Russians should be recaptured. He issued an order which was taken by
Captain Nolan to Lord Lucan, the commander of the British cavalry.
The order was misunderstood and, as a consequence, Lord Cardigan led a
charge of the light cavalry towards the wrong guns, under fire from three
sides. The charge was a disaster for the British, but in the eyes of the
Russians it sealed the cavalry's reputation for bravery. The 'Charge of

Fig. 8: Leonida Caldesi (1823–91), *Alma, one of the Queen's own saddle horses*, 26 March 1857, albumen print, 14.9 × 19.9 cm. RCIN 2906236

Queen Victoria named her horse after the Battle of the Alma on 20 September 1854. For decades after the war, 'Alma' was a popular Christian name for girls in Britain.

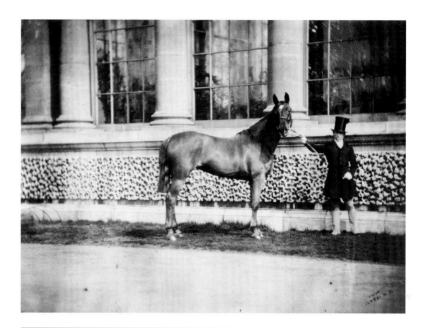

Fig. 9: Roger Fenton (1819–69), *Lieutenant-General John Burgoyne* (1782–1871), 1855, salted paper print, 18.6 × 14.4 cm. RCIN 2506572

Burgoyne served in the Royal Engineers throughout his career and was a key member of Lord Raglan's senior staff during the war. When criticism of Raglan's leadership was at its height during the winter of 1854–5, Burgoyne was recalled to London. He remained in royal favour, however, being invited to Windsor and Osborne to discuss the progress of the war with the Queen and Prince Albert. Since Burgoyne stayed in Britain for the whole period that Fenton worked in the Crimea, this portrait was taken in Fenton's London studio sometime after mid-July 1855.

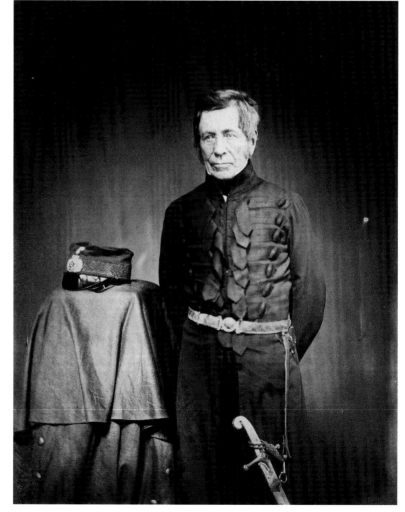

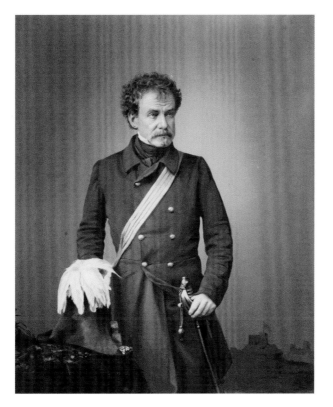

Fig. 10: John Jabez Edwin Mayall (1813–1910), *Field Marshall Sir Colin Campbell, Lord Clyde* (1792–1863), 1855–6, albumen print, 19.4 × 15.8 cm. RCIN 2500029

Mayall's portrait of Campbell was published as an engraving in *The Drawing-Room Portrait Gallery of Eminent Personages* in 1859, where the subtitle in a later edition stated that many of the photographs were 'in Her Majesty's private collection'. Cheaper versions of this portrait also appeared as woodcuts, attesting to Campbell's popularity. In the 1850s and 1860s, Mayall was responsible for a large number of portraits of 'eminent personages', many of which were initially published in the *Illustrated News of the World*, before being issued in volumes with the biographical details of each sitter.

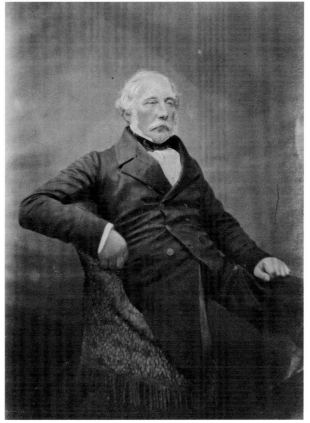

Fig. 11: Unknown photographer, *Major-General Sir James York Scarlett* (1799–1871), *c.*1856, albumen print with watercolour, 19.2 × 14.0 cm. RCIN 2500028

At the time of the Charge of the Heavy Brigade in the Battle of Balaklava, Scarlett was 55 years old. He left the Crimea in April 1855, but after Lord Lucan was relieved of his command of the cavalry Scarlett accepted the post as his successor and returned to the war. In 1882, Tennyson wrote his second poem about the Crimean War, 'The Charge of the Heavy Brigade at Balaclava'. In the poem, Tennyson refers to the men under Scarlett's command as 'Scarlett's three hundred'.

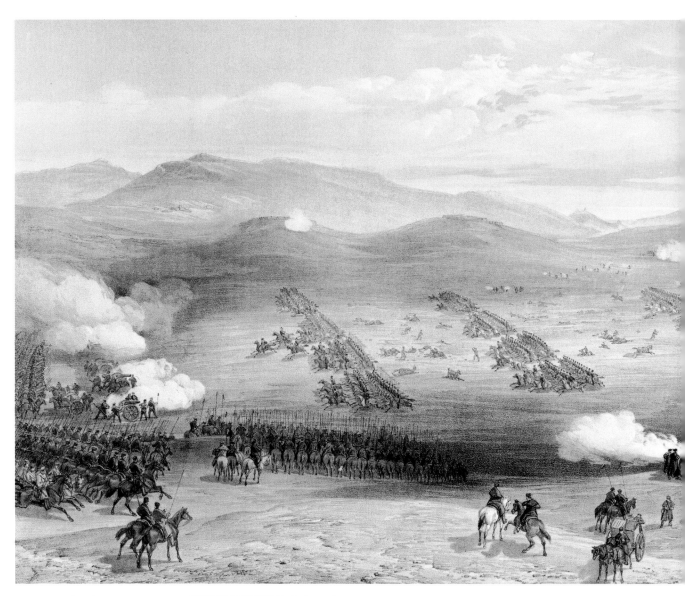

Fig. 12: E Walker (*fl.*1835–46)
after William Simpson (1823–99),
*The Charge of the Light Cavalry
Brigade, 25 October 1854,*
in William Simpson, *The Seat
of War in the East*, London, 1855,
plate xv, colour lithograph,
33.9 × 49.8 cm (sheet). RCIN 750984.k

Fig. 13: After William Luson Thomas
(1830–1900), 'Outlying Picquet of
the 90th Regiment in the snow, in the
Middle Ravine, before Sebastopol',
Illustrated London News, 10 March
1855, p. 233. RCIN 1041769

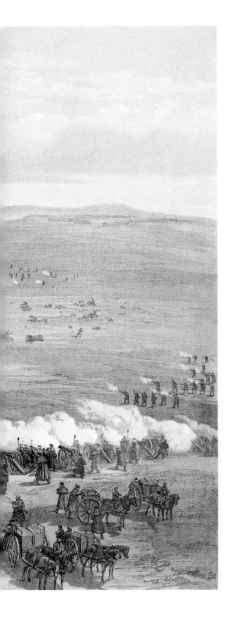

the Light Brigade' saw 673 men and horses charge from five regiments: 4th Light Dragoons, 8th Hussars, 11th Hussars, 13th Light Dragoons and 17th Lancers (**fig. 12**).[7] The action quickly became notorious, with full reports reaching Britain just two weeks afterwards. William Howard Russell, the correspondent sent to cover the war by *The Times*, filed a report which caught the public imagination (as well as inspiring Lord Tennyson):

> 'They swept proudly past, glittering in the morning sun in all the pride and splendor [*sic*] of war. We could hardly believe the evidence of our senses. Surely that handful of men were not going to charge an army in position? Alas! It was but too true – their desperate valour knew no bounds...'[8]

Although the result was not a decisive victory for the Russians, their troops were left in a strong position between the allies and Sevastopol. This allowed them, a few weeks later on 5 November, to make another major attempt to end the siege. The Battle of Inkerman, four hours of fighting in thick fog which prevented men from seeing their commanding officers, resulted in a disproportionately high number of casualties: around 12,000 Russians killed or wounded; 2,610 British, and 1,726 French.[9] While the battle was a victory for the allies, it compromised the chances of ending the siege of Sevastopol, thus committing the allies to remain in the Crimea over the coming winter months.

The arrival of winter highlighted the logistical and administrative problems facing the army. Transport, fuel, supplies of food and clothing were all severely lacking. A fierce hurricane on 14 November, which sank the supply ship *Prince*, exacerbated problems as the army's winter clothes and almost three weeks' worth of hay for the horses were lost. A further 20 British ships and 14 French ships were sunk.[10] Opinion amongst the British officers was divided about the wisdom of continuing the war: de Lacy Evans argued that the troops should return home, but the decision to remain prevailed. Evans returned to Britain, as did many other officers including Prince George Duke of Cambridge, Queen Victoria's cousin who had been given the command of the 1st Division in the field. The Duke had proposed moving British troops back to Balaklava, away from the heights

around Sevastopol where they were encamped. This would have allowed the troops to be better housed and supplied during the cold months, but Lord Raglan overruled him.[11] Those officers who remained in the Crimea fared considerably better though than the men of the ranks. Whilst the officers had servants who could construct huts and funds to purchase clothes and food, most of the men had to survive without proper winter uniforms and in little more than a tent without any flooring (**fig. 13**). Further descriptions of the privations endured appeared in accounts that were published after the end of the war. John Miller Adye, writing in his memoirs published in 1895, stated that in January 1855 the sick list recorded 13,000 men.[12]

One of the consequences of the prominence given to reporting the lack of adequate medical care for the sick and the wounded was the arrival of Florence Nightingale on 4 November 1854. She had been recruited by the Secretary at War, Sidney Herbert, a family acquaintance, to gather a team of nurses to take out to the hospital in Constantinople where the British brought their wounded soldiers by ship from the Crimea. These 38 nurses would create clean and orderly environments for the wounded. This in itself was not a new idea, but introducing such changes required great organisational skills and determination. As Nightingale and her team arrived just as the wounded from the Battle of Inkerman were landing, they were immediately

Fig. 14: Unknown artist, 'Miss Nightingale, in the hospital, at Scutari', *Illustrated London News*, 24 February 1855, p. 176. RCIN 1041769

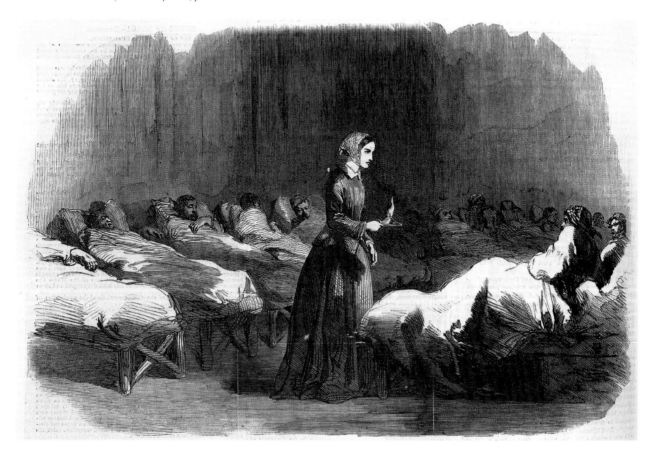

faced with horrendously dirty and crowded conditions. Although they made changes, the death rate from disease nevertheless continued to rise until, in March 1855, the Sanitary Commission – headed by Sir Robert Rawlinson and Dr John Sutherland – arrived in Scutari and discovered that the hospital was built on top of a cesspool. Sewage had been leaking into the drinking water. Once the sewers had been cleaned the death rate began to fall dramatically.

Florence Nightingale remained in charge of the British hospitals in Constantinople throughout the war. She was also given control of the care for the wounded in Crimea but not until spring 1856, when the war was almost finished. Reports of her work and stories about her dedication to the sick began appearing in Britain from 24 February 1855, when the *Illustrated London News* published an image of her holding a lamp as she walked through the hospital ward. By the time she returned home in August 1856 she was famous across Britain and beyond. She was received by Queen Victoria and Prince Albert at Balmoral on 21 September 1856, after which the Queen, who admitted she had expected someone rather cold and stiff, wrote that Miss Nightingale was, 'gentle, pleasing & engaging, most ladylike, & so clever, clear & comprehensive in her views of everything'. She was, the Queen continued, 'most rare & extraordinary!' (**fig. 14**).[13]

Her epithet as the 'Lady with the Lamp' was fixed in 1857, when Henry Longfellow published the poem 'Santa Filomena', which described her thus:

> 'A Lady with a Lamp shall stand
> In the great history of the land,
> A noble type of good,
> Heroic womanhood.'

QUEEN VICTORIA AND THE CRIMEAN WOUNDED

During these winter months, public opinion began to turn against the war. Graphic reports of the battles had filtered back, with critical descriptions of the army's deprivations and struggles to provide adequate medical care. Letters written by soldiers criticising those in charge were published without censorship. Additionally, images began to appear widely, initially as woodcuts in papers such as the *Illustrated London News*, which had a circulation of around 100,000 at the beginning of the war, growing to almost 200,000 by mid-1855.[14]

Soon, fine prints were also displayed in public exhibitions.[15] From early 1855 work by the artist William Simpson (1823–99) started to appear in the public domain. Simpson had been in Balaklava since November 1854. His watercolours, sent back to Britain whilst he remained in the Crimea, were first exhibited in February 1855 at the Graphic Society in London.[16] They were published as lithographs from spring 1855. These images, coupled with the newspaper reports, enabled audiences to have a far greater understanding of the conflict than had been possible during previous wars. Photographs from the war were to come later – Roger Fenton was

working in the Crimea from 8 March until 26 June 1855, and his photographs were on display in London by September. The photographer James Robertson took his Crimean photographs in the summer of 1855, although several of his images of British soldiers on their way out to the Crimea, taken in Scutari, had been reproduced as engravings in the *Illustrated London News* in 1854.[17]

The growing lack of public support for the war strongly influenced Parliament's decision to vote against the Prime Minister Lord Aberdeen in a demand for a select committee to investigate the poor management of the war. Aberdeen resigned after losing the vote, and Lord Palmerston, formerly the Home Secretary, became the new Prime Minister on 6 February 1855.

At the same time, wounded soldiers began to return home, their presence highlighted by the attention given to them by Queen Victoria and the Royal Family. The Queen, keen for her role to be seen as a caring and supportive one, ensured that her concern for the troops was known publicly through carefully planned meetings with wounded soldiers at Buckingham Palace and visits by the Royal Family to the hospitals where the troops were recuperating. She also sent supplies to the troops in December 1854, and one of the Queen's main aides, Sir Charles Phipps, ensured that the troops were made aware of the source of their gifts.[18]

Fig. 15: Vincent Brooks (1814–85) after Louisa Anne Beresford, Marchioness of Waterford (1818–91),
Reading the Queen's Letter, Scutari Hospital, 1855, colour lithograph with hand colouring, 36.4 × 54.9 cm (sheet). RCIN 751018

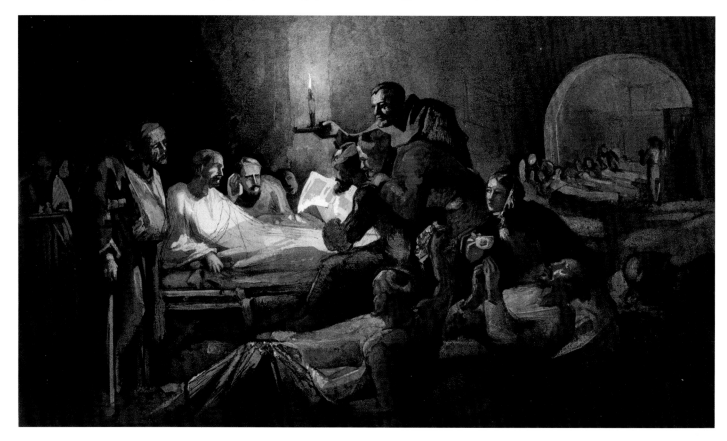

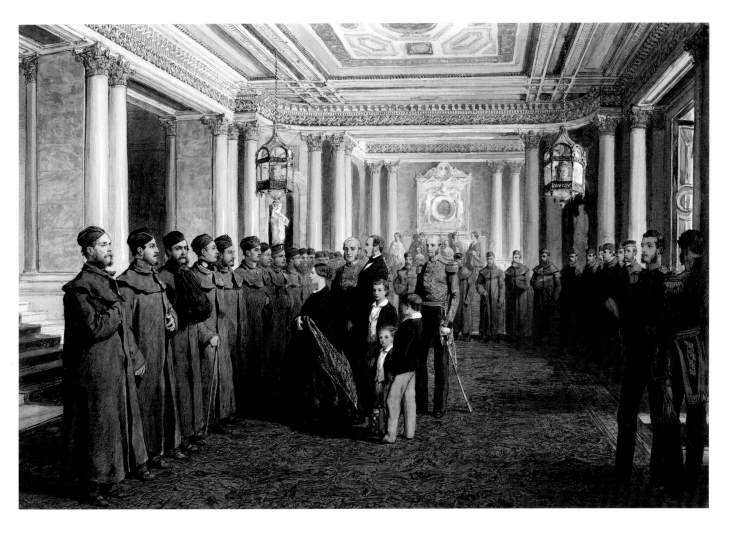

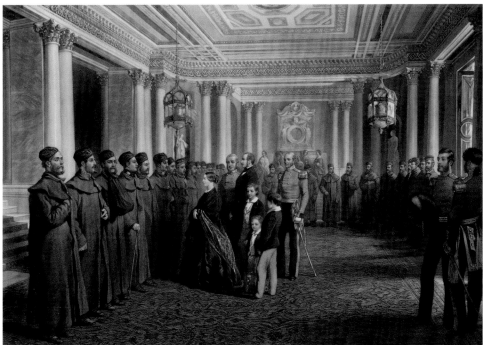

Fig. 16: George Housman Thomas (1824–68), *Queen Victoria and Prince Albert inspecting wounded Grenadier Guardsmen at Buckingham Palace*, 1855, watercolour and body colour over pencil, 32.0 × 48.5 cm. RCIN 916782

Fig. 17: George Zobel (1810–81) after George Housman Thomas (1824–68), *Queen Victoria and Prince Albert with Grenadier Guardsmen*, 1856, mezzotint, 50.2 × 63.0 cm. RCIN 605790

Prints of the royal family were popular with the public. Publishers were eager to turn paintings into prints for financial reasons and the royals were happy for their concern for the troops to be portrayed positively and widely.

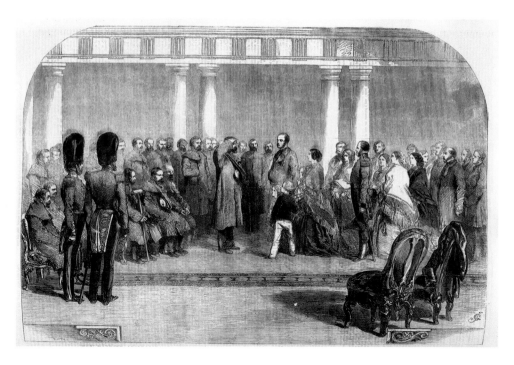

A letter written by Queen Victoria, in which she repeatedly emphasised her sympathy for her troops, was also 'leaked' to the press.[19] Although addressed to Miss Hildyard (the governess of the royal children), the Queen gave express permission for it to be passed to Mrs Herbert, the wife of Sidney Herbert. The letter, which was perhaps intended to be published all along, drew immensely positive publicity for the Queen. The Queen wrote in her journal, 'We have been somewhat startled by the appearance in the papers of a letter of mine. […] Startled as I was at first, it has called forth such very kind observations in the different papers, that I feel it may be the means of my real sentiments getting known by the Army'.[20] It also attracted some criticism for what was seen as a blatant attempt to manipulate opinion.[21] The letter was widely printed and reached the hospitals in Scutari, where the troops learnt of their Queen's concern. Lady Waterford, part of the Queen's close circle, painted a watercolour depicting an imaginary scene showing the soldiers listening to the letter being read aloud. A lithograph, available to the public, was subsequently printed after the watercolour (**fig. 15**).

It was perhaps through the meetings with the troops that the Queen conveyed most clearly and directly her very real admiration for their service. On 20 February 1855, the Queen received a group of Grenadier Guards at Buckingham Palace, followed two days later by an inspection of Coldstream Guards. Images were produced of both occasions – a watercolour by George

Above left: Fig. 18: John Gilbert (1817–97), 'Her Majesty inspecting the wounded Guards in the Grand Hall of Buckingham Palace', *Illustrated London News*, 10 March 1855, p. 237. RCIN 1041769

Above: Fig. 19: John Gilbert (1817–97), *The Queen inspecting wounded Coldstream Guardsmen in the Hall of Buckingham Palace, 22 February 1855*, 1856, watercolour, 106.0 × 182.2 cm. RCIN 451958

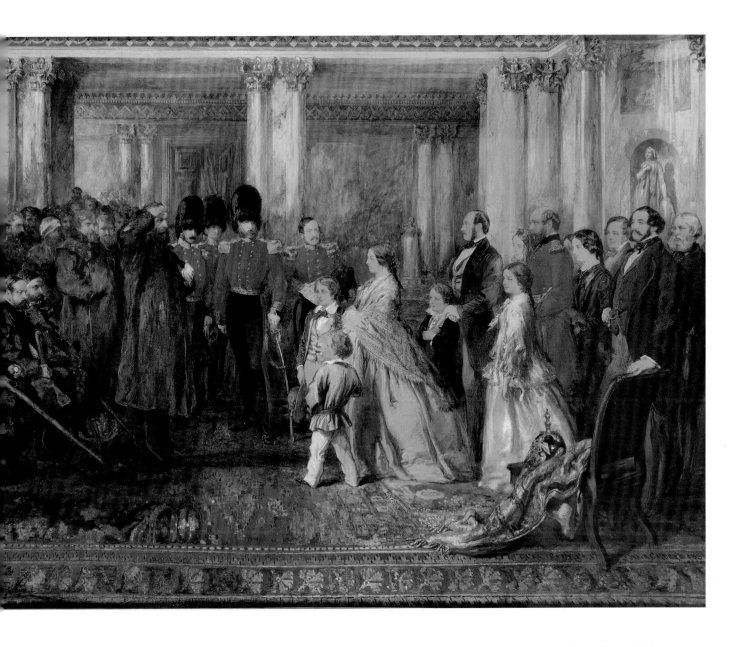

Housman Thomas was reproduced as a print of the former event (**fig. 16**), and a sketch by John Gilbert of the latter occasion, based on a verbal report as the artist himself was not present, was published in the *Illustrated London News* on 10 March 1855 (**fig. 18**). Gilbert later worked up the image into a large watercolour which was eventually acquired for the Royal Collection (**fig. 19**).[22]

On 3 March 1855, the Queen made her first visit to see the wounded soldiers in the Fort Pitt Military Hospital at Chatham, Kent. Accompanied by Prince Albert, the Prince of Wales and other royal children, the royal party first visited Fort Pitt where they were introduced to about 30 men before proceeding to Brompton Barracks to meet more soldiers (**figs 20–21**). The Queen described the occasion in her journal, noting particularly the small, dark rooms in which the soldiers were staying. She also sketched some of the men she met, including Sergeant Breese, who was later photographed by Joseph Cundall and Robert Howlett at the Queen's request (**figs 22–23**).[23]

Fig. 20: John Tenniel (1820–1914), *The Visit of Queen Victoria and Prince Albert to Fort Pitt Military Hospital, 3 March 1855*, 1855, watercolour and bodycolour over pencil, 23.0 × 33.0 cm. RCIN 913684

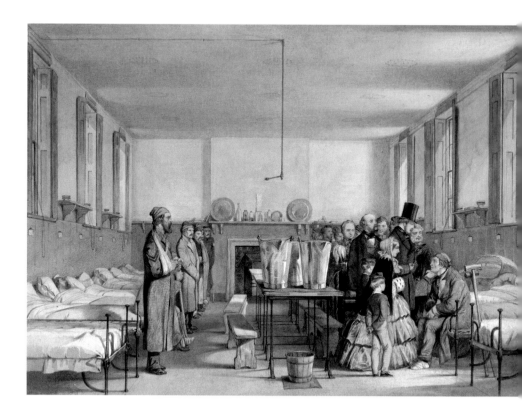

Fig. 21: John Alfred Vinter (1828–1905) after Sir John Tenniel (1820–1914), *Her Majesty and His Royal Highness the Prince visiting the wounded soldiers of the Crimean Army at Brompton Hospital, Chatham*, 1856, lithograph with a single tone plate, 42.8 × 46.5 cm. RCIN 750985.u

The production of a print based on the original watercolour allowed the royal visit to become a public event.

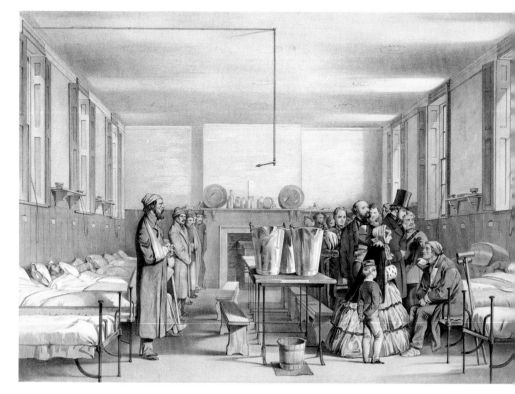

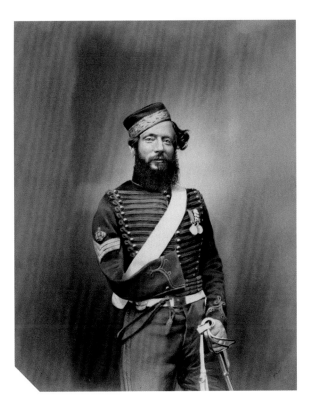

Fig. 22: Joseph Cundall (1818–95) and Robert Howlett (1831–58), *Sergeant John Breese* (1817–89), *c.*1855, salted paper print, 24.8 × 18.9 cm. RCIN 2500154

Following Queen Victoria's visit to Chatham on 19 July 1855, the *Illustrated London News* reported that Joseph Cundall had been tasked with photographing the wounded soldiers at Brompton Barracks, Chatham at the request of the Queen. A number of the photographs were published as engravings alongside the report. The firm Cundall and Howlett were responsible for further series of portraits of the Crimean soldiers, although the later portraits from 1856 did not show such seriously injured men. At the Photographic Society exhibition in 1857, both Cundall and Howlett exhibited portraits from their series titled *Crimean Heroes, taken by Command of Her Majesty the Queen*.

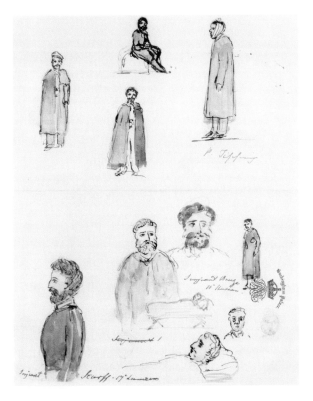

Fig. 23: Queen Victoria (1819–1901), Sketches showing some of the patients wounded in the Crimea, including Sergeant John Breese (pictured bottom, centre with the red hair and beard), whom Queen Victoria met during her visit to the military hospital at Chatham, 3 March 1855.
RA VIC/MAIN/QVJ/1855

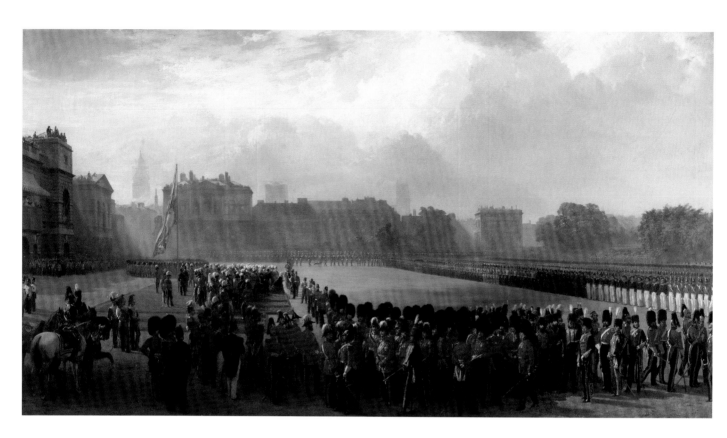

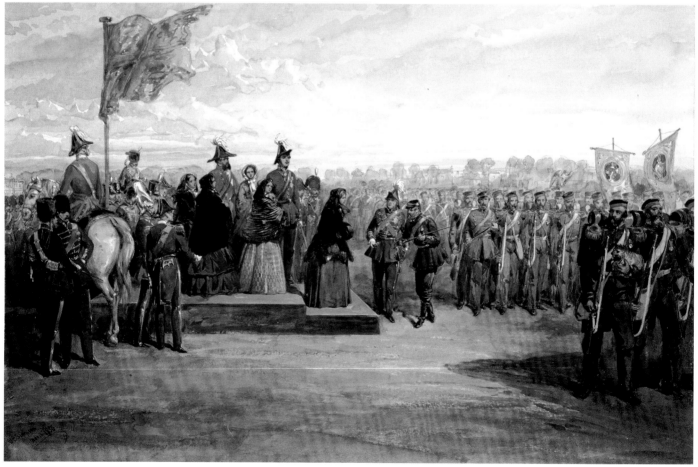

Top left: Fig. 24: George Housman Thomas (1824–68), *The Presentation of Crimean Medals by Queen Victoria, 18 May 1855*, 1855–8, oil on canvas, 99.1 × 177.8 cm. RCIN 405109

Right: Fig. 25: Victoria Cross, purchased by King George VI, 1951. Received by Lieutenant William Buckley for actions on 29 May and 3 June 1855, in the Sea of Azoff. RCIN 440547

When the Victoria Cross was created, the dark blue ribbon was for those who served in the Royal Navy, whilst the Army recipients had a red ribbon. Since 1918 all the ribbons have been red.

Below left: Fig. 26: William Simpson (1823–99), *Queen Victoria reviewing the Royal Artillery at Woolwich on their return from the Crimea, 13 March 1856*, 1856, watercolour and bodycolour over pencil, 29.2 × 45.5 cm. RCIN 916787

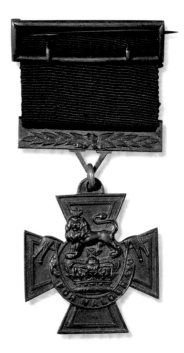

The Queen made a point of visiting as many times as she could, as well as attending public events organised in London to honour the returning soldiers during 1855 and 1856. She presented the newly instituted 'Crimea Medal' to the troops in London on 18 May 1855, and later was to present the first Victoria Crosses to Crimean veterans on 26 June 1857 (**figs 24–25**). The Queen also witnessed the return of the first troops from the Crimea (other than the wounded) at Woolwich on 13 March 1856 (**fig. 26**). Throughout the war, the Queen consistently presented herself in a maternal, caring role, describing her soldiers in her journal as 'Poor brave "Children" of mine' and 'my poor good soldiers'.[24] She successfully established herself, at least in public, as a non-political focus for her subjects during the war. At the same time she distanced herself from the anti-government feeling that began during the winter of 1854–5. This public role also reminded the Establishment that the Queen was the head of the armed forces, a position she was not going to relinquish readily, despite the calls for army reform.[25]

THE END OF THE WAR, SUMMER 1855

The death of Tsar Nicholas I on 2 March 1855 had briefly given the allies at home and in the Crimea hope that the war might end, now that the man regarded as the main instigator of the conflict was no more. His successor Tsar Alexander II was determined, however, to continue his father's war.

In the British press a great deal of attention was given to the progress of the siege of Sevastopol. Gaining control of the town and its harbour had always been the main aim of the invasion. Despite the horrendous winter in the Crimea, the British and French armies remained focused on the bombardment of the Russian defences. The Russians had failed to take advantage of the lull during the winter, but an allied bombardment from 9 to 19 April did not achieve anything. The French commanding officer, François Canrobert, resigned due to differences with Lord Raglan and Emperor Napoleon III over the direction the war should take. He was replaced by Major-General Aimable Pélissier on 16 May, who brought a new wave of energy and fresh focus to the siege (**fig. 27**). An assault on the Malakoff and the Redan, the fortifications on the edge of

Fig. 27: Roger Fenton (1819–69), *General Pélissier*,
June 1855, albumen print, 18.8 × 14.2 cm. RCIN 2500325

Fig. 28: 'Part of the interior of the Mamelon', *Illustrated London News*, 7 July 1855, p. 9. RCIN 1041770

Although dead bodies were never included in the work of any photographer during the war, artists did not shrink from depicting corpses of all nationalities.

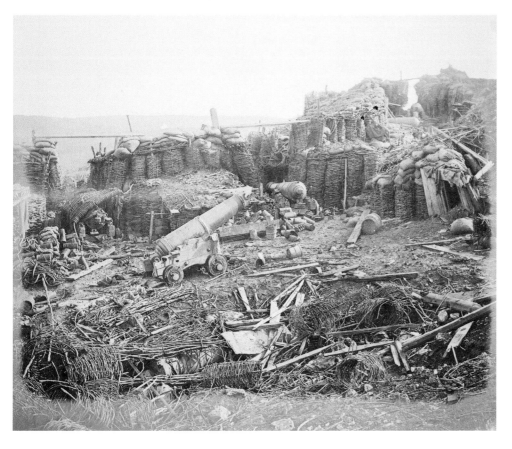

Fig. 29: James Robertson (1813–88), *Interior of the Redan*, 1855–6, salted paper print, 24.2 × 29.0 cm. RCIN 2500698

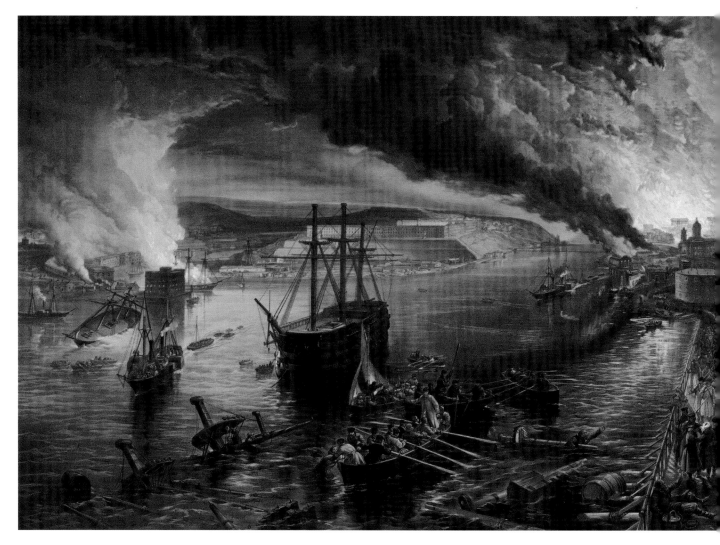

Fig. 30: Day and Son after
William Simpson (1823–99), *The Fall
of Sebastopol*, 28 January 1857,
coloured lithograph, 65.2 × 102.7 cm.
RCIN 770271

Fig. 31: George Shaw Lefevre
(1831–1928), *View of the Russian
barracks behind the Redan*,
shortly after 8 September 1855,
albumen print, 15.4 × 20.4 cm.
RCIN 2500787

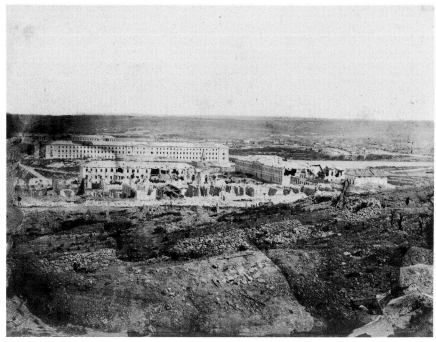

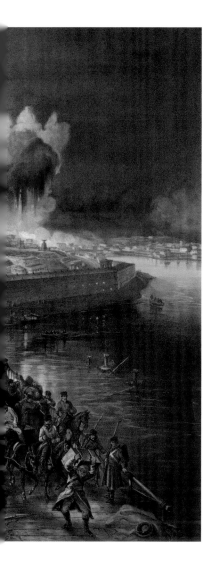

Sevastopol, was planned for June. The French attacked first, preceded by a bombardment. The British went in second to provide support, but they arrived too late and there were heavy losses. The assault was uncoordinated and unsuccessful; the outcome was a severe blow to the allies. Writing years later, Sir John Adye stated, 'The failure of the great assault on Sevastopol on June 18 was undoubtedly the severest blow which the allies had received since their landing in the Crimea'.[26] News of the defeat contributed to the decline of Lord Raglan, who died on 28 June. He was replaced by Lieutenant-General James Simpson.

With the French now the strongest of the allies, new plans were made to try again to end the siege of Sevastopol. It was decided that the French would attempt to take the Malakoff, whilst the British would storm the Redan, both defensive positions held by the Russians (**fig. 29**). The earlier success of the French and Sardinian troops at the Battle of Chernaia on 16 August had effectively cut off all supplies to Sevastopol and left the town without any hope of relief. On 8 September, the French began their assault and quickly took the Malakoff, although the British attack failed. The Russians decided to abandon the town that night, and much of the town was left on fire and in ruins. The 11-month siege was finally at an end (**fig. 30**).

A few days after the fall of Sevastopol, soldiers and civilians began entering the town. There are many written reports, drawings and photographs of the appalling destruction of the city, and of the many injured and dying Russians that were found abandoned there. Perhaps the first photographer to arrive in the city after 8 September was George Shaw Lefevre, who was to publish 12 of his images in 1856 (**fig. 31**). Mary Seacole also visited the town and described what she saw in her memoir *The Wonderful Adventures of Mrs Seacole in Many Lands* (1857), pointing out the visitors who 'thronged the streets of Sebastopol, sketching its ruins and setting up photographic apparatus'.[27]

Although the allied troops faced another winter in the Crimea, the end of the war was now approaching. Britain was much better prepared for winter this time, but the French troops suffered greatly during the cold months. An armistice was eventually signed on 14 March 1856 and on 27 April the Treaty of Paris came into effect, declaring the Black Sea a neutral space (**fig. 32**).

Fig. 32: Mayer Frères et Pierson (active 1855–73), *Delegates at the Congress of Paris*, 25 February 1856, salted paper print, 18.1 × 24.4 cm. RCIN 2935163

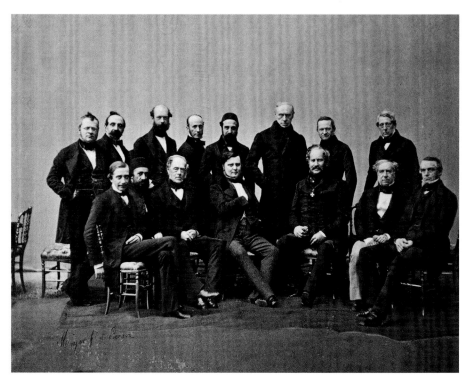

Fig. 33: Thomas Agnew and Sons, *Exhibition of the Photographic Pictures taken in the Crimea*, 1856. RCIN 1083377.b

Separate catalogues were issued for each venue that displayed Fenton's Crimean photographs in 1855 and 1856. The later exhibitions often added extra photographs including those taken in London and elsewhere after Fenton left the Crimea. Many of these are identifiable by an asterisk used in the catalogue entry.

EXHIBITION

OF THE

Photographic Pictures taken in The Crimea,

BY ROGER FENTON, ESQ.

UNDER THE ESPECIAL PATRONAGE OF HER MOST GRACIOUS MAJESTY,

AND

WITH THE SANCTION OF THE COMMANDERS-IN-CHIEF,

AT

THE GALLERY, 53, PALL MALL,

NEXT TO THE BRITISH INSTITUTION.

OPEN FROM TEN TO SIX DAILY.

(In the event of foggy weather, the Gallery will be lighted with gas during the day.)

ADMITTANCE, ONE SHILLING.——CATALOGUE, SIXPENCE.

CHILDREN HALF-PRICE.

PRINTED FOR

MESSRS. THOMAS AGNEW AND SONS,

PUBLISHERS AND PRINTSELLERS TO HER MAJESTY, EXCHANGE STREET, MANCHESTER,

BY THOMAS BRETTELL, RUPERT STREET, HAYMARKET.

1856.

Above right: Fig. 34: Elizabeth Thompson (1846–1933), *Calling the Role after an Engagement, Crimea*, 1874, oil on canvas, 93.3 × 183.5 cm. RCIN 405915

Below right: Fig. 35: Frederick Stacpoole (1813–1907) after Elizabeth Thompson (1846–1933), *The Roll Call, Crimea*, 1878, etching with roulette work, 64.0 × 106.2 cm (sheet). RCIN 751172

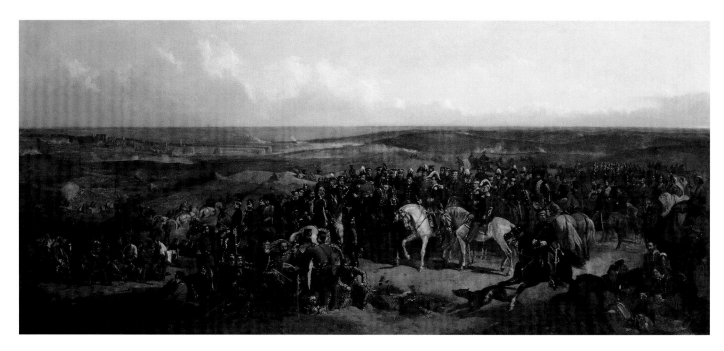

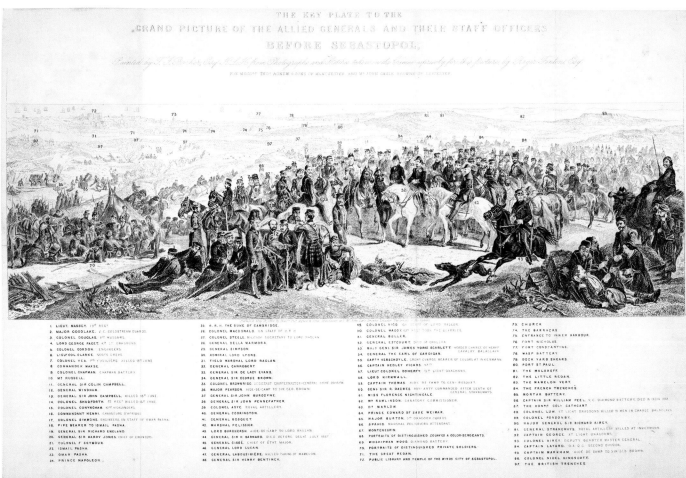

THE KEY PLATE TO THE

GRAND PICTURE OF THE ALLIED GENERALS AND THEIR STAFF OFFICERS

BEFORE SEBASTOPOL,

Painted by T. J. Barker, Esq., F.L.S., from Photographs sent Eastern taken on the terrain expressly for this picture by Roger Fenton, Esq.

FOR MESSRS. THOS AGNEW & SONS OF MANCHESTER AND MR JOHN EARLE BROWNE OF LEICESTER.

1. LIEUT. MASSEY. 19TH REGT.	25. H. R. H. THE DUKE OF CAMBRIDGE.	49. COLONEL VICO. ON STAFF OF LORD RAGLAN.	73. CHURCH.
2. MAJOR GOODLAKE. J. C. COLDSTREAM GUARDS.	26. COLONEL MACDONALD. ON STAFF OF H.R.H.	50. COLONEL WADDE. OFT VICT. TOOK THE QUARRIES.	74. THE BARRACKS.
3. COLONEL DOUGLAS. 11TH HUSSARS.	27. COLONEL STEELE. MILITARY SECRETARY TO LORD RAGLAN.	51. GENERAL BULLER.	75. ENTRANCE TO INNER HARBOUR.
4. LORD GEORGE PAGET. 4TH LT DRAGOONS.	28. GENERAL DELLA MARMORA.	52. GENERAL ESTCOURT. DIED OF CHOLERA.	76. FORT NICHOLAS.
5. COLONEL GORDON. ENGINEERS.	29. GENERAL SIMPSON.	53. MAJR GENL SIR JAMES YORKE SCARLETT. HEADED CHARGE OF HEAVY CAVALRY, BALACLAVA.	77. FORT CONSTANTINE.
6. LIEUT COL CLARKE. SCOTS GREYS.	30. ADMIRAL LORD LYONS.	54. GENERAL THE EARL OF CARDIGAN.	78. WASP BATTERY.
7. COLONEL YEA. 7TH FUSILIERS. KILLED 18T JUNE.	31. FIELD MARSHAL LORD RAGLAN.	55. CAPTN VERSCHOYLE. GRENR GUARDS, BEARER OF COLOURS AT INKERMANN.	79. DOCK YARD SHEARS.
8. COMMANDER MAXSE.	32. GENERAL CANROBERT.	56. CAPTAIN HEDLEY VICARS. 97TH.	80. FORT ST PAUL.
9. COLONEL CHAPMAN. CHAPMAN BATTERY.	33. GENERAL SIR DE LACY EVANS.	57. LIEUT COLONEL DOHERTY. 13TH LIGHT DRAGOONS.	81. THE MALAKOFF.
10. MY RUSSELL.	34. GENERAL SIR GEORGE BROWN.	58. LORD KIRKWALL.	82. THE LITTLE REDAN.
11. GENERAL SIR COLIN CAMPBELL.	35. COLONEL BROWNRIGG. ASSISTANT QUARTERMASTER-GENERAL LIGHT DIVISION.	59. CAPTAIN THOMAS. AIDE DE CAMP TO GENL BOSQUET.	83. THE MAMELON VERT.
12. GENERAL WINDHAM.	36. MAJOR PEARSON. AIDE-DE-CAMP TO SIR GEO. BROWN.	60. GENL SIR R. DACRES. ROYL ARTY COMMANDED AFTER DEATH OF GENERAL STRANGWAYS.	84. THE FRENCH TRENCHES.
13. GENERAL SIR JOHN CAMPBELL. KILLED 18TH JUNE.	37. GENERAL SIR JOHN BURGOYNE.	61. MISS FLORENCE NIGHTINGALE.	85. MORTAR BATTERY.
14. COLONEL SHADFORTH. 57. REGT KILLED 18TH JUNE.	38. GENERAL SIR JOHN PENNEFATHER.	62. MY RAWLINSON. SANATORY COMMISSIONER.	86. CAPTAIN SIR WILLIAM PEEL. V.C. DIAMOND BATTERY. DIED IN INDIA 1853.
15. COLONEL CONYNGHAM. 42ND HIGHLANDERS.	39. COLONEL ASYE. ROYAL ARTILLERY.	63. DR MARLOW.	87. THE HONBE COLT CATHCART.
16. COMMANDANT HENRI. CHASSEURS D'AFRIQUE.	40. GENERAL CODRINGTON.	64. PRINCE EDWARD OF SAXE WEIMAR.	88. COLONEL LOW. 4TH LIGHT DRAGOONS KILLED 11 MEN IN CHARGE BALACLAVA.
17. COLONEL SIMMONS. ENGINEERS ON STAFF OF OMAR PASHA.	41. GENERAL BOSQUET.	65. MAJOR BURTON. 5TH DRAGOON GUARDS.	89. COLONEL PONSONBY.
18. PIPE BEARER TO ISMAIL PASHA.	42. MARSHAL PELISSIER.	66. SPAHIS. MARSHAL PELISSIERS ATTENDANT.	90. MAJOR GENERAL SIR RICHARD AIREY.
19. GENERAL SIR RICHARD ENGLAND.	43. LORD BURGHERSH. AIDE-DE-CAMP TO LORD RAGLAN.	67. MONTENEGRIN.	91. GENERAL STRANGWAYS. ROYAL ARTILLERY. KILLED AT INKERMANN.
20. GENERAL SIR HARRY JONES. CHIEF OF ENGINEERS.	44. GENERAL SIR H BARNARD. DIED BEFORE DELHI. JULY 1857.	68. PORTRAITS OF DISTINGUISHED ZOUAVES & COLOR-SERGEANTS.	92. CAPTAIN GEORGE. 4TH LIGHT DRAGOONS.
21. COLONEL F SEYMOUR.	45. GENERAL CISSÉ. CHIEF OF ÉTAT MAJOR.	69. MIDSHIPMAN WOOD. DIAMOND BATTERY.	93. COLONEL AIREY. DEPUTY QUARTER MASTER GENERAL.
22. ISMAIL PASHA.	46. GENERAL LORD LUCAN.	70. PORTRAITS OF DISTINGUISHED PRIVATE SOLDIERS.	94. CAPTAIN LAYARD. D.A.Q.G. SECOND DIVISION.
23. OMAR PASHA.	47. GENERAL LABOUSINIÈRE. KILLED TAKING OF MAMELON.	71. THE GREAT REDAN.	95. CAPTAIN MARKHAM. AIDE-DE-CAMP TO SIR GEO BROWN.
24. PRINCE NAPOLEON.	48. GENERAL SIR HENRY BENTINCK.	72. PUBLIC LIBRARY AND TEMPLE OF THE WINDS CITY OF SEBASTOPOL.	96. COLONEL NIGEL KINGSCOTT.
			97. THE BRITISH TRENCHES.

Left top: Fig. 36: Thomas Jones Barker (1815–82), *The Allied Generals with the officers of their respective staffs before Sebastopol*, oil on canvas, 1856. Collection of Irina Tsirulnikova, London

Left below: Fig. 37: John Garle Brown after Thomas Jones Barker (1815–82), *Key Plate to the painting Allied Generals before Sebastopol*, 18 May 1859, published by Thomas Agnew and Sons, lithograph on cloth with leather covers, 42.9 × 89.2 cm. RCIN 2956256

The full title of the key includes the phrase, 'Painted by T. J. Barker Esq. K.L.H from Photographs and Sketches taken in the Crimea expressly for this picture by Roger Fenton Esq.'. The key was designed to fold-out like a map so the viewer could stand in front of the image holding the key and compare the two objects. The information provided included the name of each individual, evidently an important element of the work as viewers would have understood the portraits to be truthful likenesses, given they were based on photographs from life (see fig. 53). The only identified woman in the painting is captioned 'Florence Nightingale', however the image appears to be based on Fenton's photograph of Mrs Duberly (see plate 40).

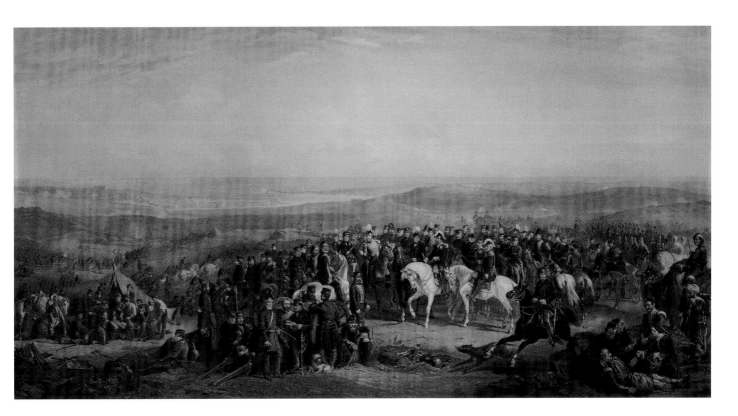

Fig. 38: Charles G. Lewis (1808–80) after Thomas Jones Barker (1815–82), *The Allied Generals with the officers of their respective staffs before Sebastopol*, 1 November 1859, mixed media engraving, 75.5 × 133.8 cm (plate). RCIN 502020

Whilst Barker's painting was exhibited to a paying public eager to learn more about the war, far more substantial sums could be made for the publisher Thomas Agnew and Sons from the sale of the associated print and its key.

The impact of the Crimean War on the Victorian public was immense, both during the conflict and for many decades afterwards. The swift reporting of the war in newspapers at home, followed up by the publication of soldiers' letters sent directly from the Crimea, with photographs and prints showing the places mentioned, meant that the public were fully informed about the progress of the war to an extent that had not previously been possible. In addition, the number of soldiers killed or wounded in the conflict was substantial: Britain sent about 98,000 men of whom around 20,000 died, whilst France sent as many as 310,000 and lost 100,000.[28] Few people would have been untouched by the war.

Memories of the war remained strong in the collective British consciousness well into the twentieth century. They were kept alive by histories and memoirs, as well as images of all types, poetry and literature, and, during the nineteenth century at least, highly publicised reunions for veterans. Fenton's and Robertson's photographs toured Britain in a series of exhibitions which would have been seen by thousands (**fig. 33**). Many people would also have seen the large paintings depicting battles and significant moments from the war in exhibitions; even more would have seen the prints issued after the paintings. The extraordinary impact of Elizabeth Thompson's *Calling the Role after an Engagement, Crimea*, known today as *The Roll Call*, when displayed at the Royal Academy's Summer Exhibition in 1874, is perhaps not typical of a history painting, but its success in becoming one of the nineteenth century's most celebrated works of art demonstrates the power of the subject matter to move audiences 20 years after the war (**figs 34–35**).

The desire to create such impressive works of art within the genre of 'history painting' was in part because this was recognised as the most significant and worthy of the different genres (a hierarchy that had been formalised by art academies in the late eighteenth and early nineteenth centuries). Yet it was also because engravings and lithographs reproducing such paintings were usually extremely popular with the public, and the artist and publisher could potentially make a great deal of money. Roger Fenton was sent to the Crimea by the publishers Thomas Agnew and Sons in order to produce photographs for the painter Thomas Jones Barker, who would then use the images as source material to create a history painting documenting the war. Barker produced his oil painting in 1856, titled *The Allied Generals with the officers of their respective staffs before Sebastopol*, and it was exhibited in London the same year (**fig. 36**). Although presented as a history painting, the scene is entirely imaginery as it would have been impossible for all the individuals depicted to have gathered together at the same time. The painting was subsequently reproduced as a print in 1859 and published with a key identifying all the individuals (**figs 37–38**). How this commission may have affected Fenton's work is discussed in the next chapter.

Right: Detail of fig. 36, p. 38

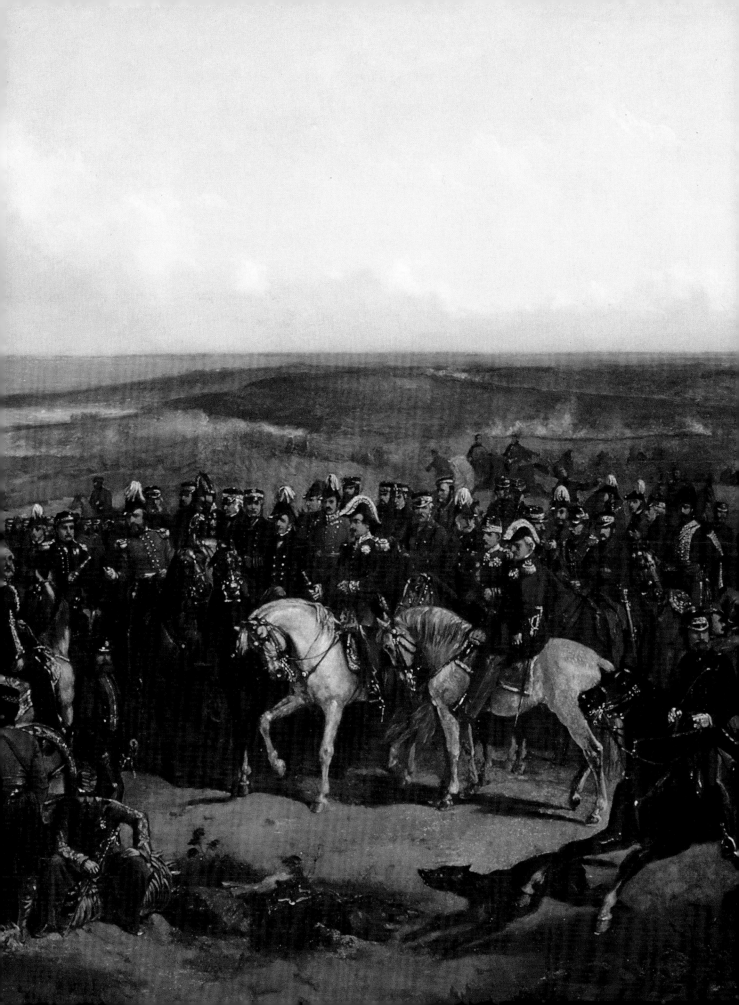

ROGER FENTON: FIRST WAR PHOTOGRAPHER

Roger Fenton departed for the Crimea on 20 February 1855 and was not to return to England until 11 July that year. Taking into account the time required for travelling, he spent just over three months in the region photographing the war. Fenton was not the first photographer to reach the warzone; he arrived in the region several months after the war had begun and after many of the most significant encounters had been fought. Nor was he the last photographer to work during the war – Fenton left before the fighting concluded with the fall of Sevastopol, and so he missed photographing the ruins of that city. Instead, it fell to James Robertson to produce the most substantial set of images of a fallen Sevastopol. Fenton was, however, the first photographer to produce a substantial body of work documenting any conflict in any region, at a time when there was no expectation of what 'war photography' should be. Fenton had been commissioned by the Manchester-based publishers Thomas Agnew and Sons (run by William Agnew at the time) to photograph as many of the officers and other people of interest present during the war in order that the artist, Thomas Barker, could use the photographs as a primary source to create an oil painting.[1] Whilst this task kept Fenton busy, it did not prevent him from photographing the topography and battlefields, which he actively sought out. The resulting photographs, both the portraits and topographical views, were widely displayed in Britain from September 1855. They were viewed by a public that already had a substantial familiarity with the conflict from other sources, such as newspapers, illustrated journals, prints, maps, poems, dioramas and even music. Fenton, whose understanding of the conflict would have been similar to that of his intended audience, was not attempting to present an objective narrative of the war. Rather, his photographs present us with a subjective view of a narrow window of time within a much more substantial event. Although there is no single interpretation that fits every image produced by Fenton, many of the photographs are most easily understood when considered as images designed to evoke an emotional response within a contemporary

Fig. 39: Roger Fenton (1819–69), *Self-portrait as a Zouave*, 1855, salted paper print, 18.2 × 14.1 cm. RCIN 2500562
Fenton made at least four different self-portraits depicting himself dressed as a *Zouave*, sometimes identified as of the 2nd Division.

viewer who already has an existing knowledge of the war. Meanwhile, the large number of portraits and the variant poses in which the men were photographed can be explained within the context of the commission for Thomas Barker's painting.

Today, Fenton is primarily known to a wider audience for his work during the Crimean war. However his photographs produced there appear to be problematic for many photographic historians. There is perhaps a feeling that they are difficult to appreciate and not in keeping with the rest of his output in respect to the standards of care, quality and finish that are associated with his other work. Criticism is also thrown at the photographs for apparently misrepresenting the horrors of the war as experienced by the British troops, and the belief that Fenton was sent out by the British Government or by Queen Victoria and Prince Albert to take photographs that somehow whitewashed an appalling situation still persists. When the photographs are viewed as part of a commercial commission, to be seen by a Victorian public who had read about the war and its associated difficulties for over a year by the time they saw the images, our understanding and our interpretation has to shift.

FENTON BEFORE THE WAR

Although Fenton trained as a lawyer, his heart seems to have been that of an artist. He was in Paris for at least two years in the mid-1840s, possibly longer, studying to be a painter. By 1847, he was back in London to join the studio of the history painter Charles Lucy (**fig. 40**) who shared a studio with the now better-known

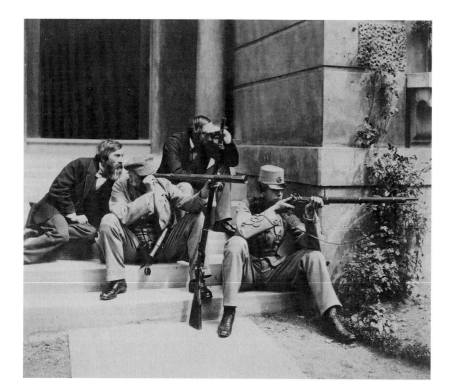

Fig. 40: Roger Fenton (1819–69), *Charles Lucy with Horatio and Edward Ross, and J. M. Parker*, 1860, albumen print, 23.7 × 27.9 cm. RCIN 2935169

Lucy and Fenton remained friends after Fenton made the move from painting to photography. He is included in this group alongside Horatio Ross (1801–86), the distinguished sportsman and pioneer photographer.

Fig. 41: Roger Fenton (1819–69),
Little Palace of the Kremlin, 1852,
salted paper print, 214.0 × 176.0 cm.
Wilson Centre for Photography

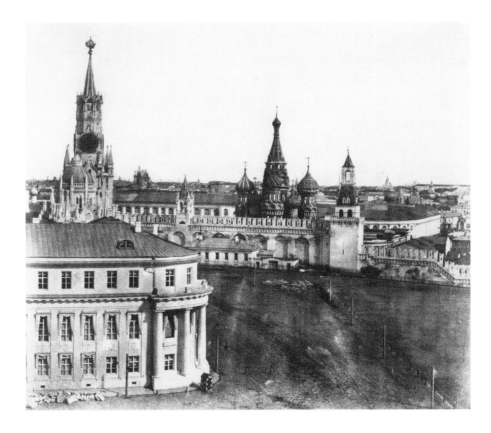

Ford Madox Brown.[2] Fenton exhibited examples of his painting at the Royal Academy annual exhibitions in 1849, 1850 and 1851, although he failed to attract much positive attention for his work. It was probably during these years, whilst a part of the London and Paris art world, that Fenton began to learn about photography, and started to practise it. The earliest surviving photographs that can be attributed to Fenton are dated February 1852. Throughout the year, Fenton continued to take photographs and also gathered support for the creation of a Photographic Society in Britain. On 19 June 1852, following a meeting at the Society of Arts, a provisional committee was created for a Photographic Society, with Fenton named as the Honorary Secretary. In a relatively short time, Fenton had thus established himself at the centre of the new and developing field of photography.

During 1852 Fenton participated in an expedition to Russia, accompanying his friend, the engineer Charles Blacker Vignoles (1793–1875), to Kiev. Vignoles was also a photographer and had been a founder member of the Photographic Society. He had been commissioned to construct a bridge across the River Dnieper and the bridge, which became known as the Nicholas Chain Bridge, brought Vignoles great attention as it was to be one of the largest bridges in existence. Fenton travelled out to photograph the bridge, and also took photographs in Moscow and Saint Petersburg, using a waxed paper negative process. The photographs were exhibited in Britain in December 1852 at the Society of Arts exhibition, which had been organised by Fenton, with Joseph Cundall (1818–95) and Philip Delamotte (1820–89), two important figures working in

Fig. 42: After Roger Fenton (1819–69), 'Russian Peasants, from a photograph by Fenton', *Illustrated London News*, 4 February 1854, p. 88. RCIN 1041767

the combined fields of photography, printing and design (**fig. 41**).

Fenton's Russian photographs are significant in respect to his Crimean work, which came three years later. Fenton would have been unusual amongst the British troops during the war through having an earlier experience of being in Russia, albeit under very different circumstances. His prior familiarity with Russia may have been one of the reasons that Fenton ended up going to the Crimea in 1855. Fenton's Russian views from 1852 are very early, however, in terms of his photographic style and aesthetic. When compared to the architectural and landscape views taken in Britain in 1853–4 and later, the Russian views seem rougher, less sophisticated and occasionally feel rather bleak. This is partly as a result of the photographic processes involved, and in part due to the decision not to depict Russia within a more Picturesque aesthetic.[3] The later topographical views for which Fenton is so greatly admired are often deliberately part of the Picturesque tradition, with ruins, trees and contemplative figures. This has been interpreted as part of a concerted effort to make photography respectable so that it would appeal to a 'discerning audience'.[4] In Russia, however, Fenton eschewed this way of seeing, favouring instead a more striking, graphic quality in his images, contrasting areas of dark and light, often with strong lines that cross both vertical and horizontal axes, creating dynamic yet deceptively simple images. Thus, Russia is presented in a very direct and unusual way, rather than using an aesthetic that would make the topography appear familiar and reassuring. The photographs are striking and modern, perhaps influenced partly by Fenton's association with the vast engineering project with which his acquaintance Vignoles was concerned, bringing the modern world to Russia.

After returning to England, Fenton was closely involved in the establishment of the Photographic Society and its first meeting, held on 20 January 1853. Throughout the year, Fenton made significant contributions to the society and by the end of the year, he was involved in the arrangements for the first society exhibition, which opened on 3 January 1854. Queen Victoria and Prince Albert attended and they were shown around the display by Fenton, amongst others. Several purchases were subsequently made by the royal couple, including,

it was reported, six of Fenton's views of Russia.[5] One of Fenton's 1852 Russian photographs was later to be published as an engraving, in February 1854, in the *Illustrated London News*, within the context of the Russian war (**fig. 42**). A lack of up-to-date images from Russia, despite the hunger for information about the war, meant that earlier, older works were republished within a new context. This would have brought Fenton's name into the press in connection with the build-up to war.

At this time, Fenton also received the first of many commissions from the royal family to photograph them at home. These sittings were private, with the results intended for the royal family and their immediate circle only.[6] The photographs show Queen Victoria and Prince Albert in a variety of poses and in different dress, from very formal court costume to day dress. The royal children were also photographed; one of the earliest commissions was to show the children

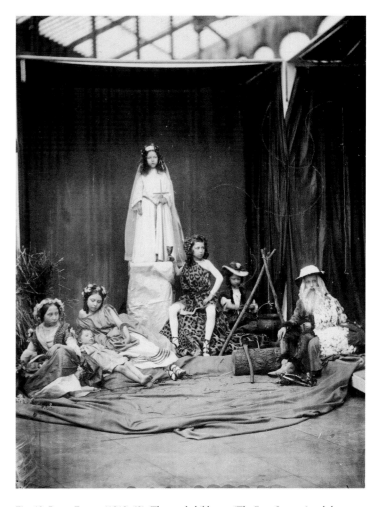

Fig. 43: Roger Fenton (1819–69), *The royal children as 'The Four Seasons' and the 'Spirits Empress'*, 10 February 1854, salted paper print, 20.7 × 15.8 cm. RCIN 2943818

dressed for a sequence of tableaux entitled *The Four Seasons*, which was based on a poem by James Thomson. The children had enacted the tableaux for their parent's wedding anniversary on 10 February 1854. Fenton's photographs of the event served as a souvenir and they were the basis of watercolours subsequently presented to the Queen by Prince Albert on 24 May, the Queen's birthday (**fig. 43**).[7]

Photography and Art

Fenton's royal photographs from 1854 were sometimes overpainted or used as source material for paintings, usually watercolours. Such works by Fenton, and by other photographers, survive today in the Royal Collection, including an album of watercolour portraits by Carl Haag, showing the royal children in copies of Fenton's 'Four Seasons' tableaux. One of Queen Victoria's photograph albums, titled *Crimean Officers' Portraits*, contains a number of photographs where the faces of the sitters have been delicately and very

Fig. 44: Unknown photographer, *George Charles Bingham,*
3rd Earl of Lucan, 1854–6, hand-coloured salted paper print,
17.9 × 15.0 cm. RCIN 2500011

Fig. 45: William Bambridge (1820–79) and Alfred Hitchens Courbould (1821–74),
'The Allies', Prince Arthur, Princess Louise and Princess Helena, 10 February–
24 May 1856, albumen print with watercolour, 14.0 × 14.6 cm. RCIN 2914266

precisely painted to give a very lifelike effect, even though the rest of the portrait remains unpainted (**fig. 44**).[8] The effect of having only the face painted is striking, almost disturbing. The portraits stand out from the unpainted works with what can be described as a hyper-real gaze.

Another example of works which combine photography and painting are the set of images made by William Bambridge in 1856, depicting three of the royal children, Princesses Louise and Helena and Prince Arthur, dressed respectively as a *cantinière* (or *vivandière*), a French soldier and a British soldier, representing the figures from the Crimean war. The original albumen print, titled *The Allies*, is overpainted in watercolour by Alfred Hitchens Courbould, leaving no trace of the photographic work beneath (**fig. 45**). An unpainted variant of the same group survives in one of Queen Victoria's albums of portraits of the royal children, whilst a third version exists by artist John Simpson as a painted enamel work on porcelain, clearly copied directly from Bambridge's painted photograph.[9]

In the early 1850s, however, this was not unusual. Photographs were often seen not as a finished artistic product, but as an image that could be repurposed or represented in a different medium. In particular photographs were frequently published as lithographs, a process that was easily published in a book or a large volume format. Lithographs did not appear to fade as photographs did, and above all, they could be

printed in colour. The photographs of Francis Bedford, Philip Henry Delamotte and Joseph Cundall were all widely published as lithographs, as part of a growing literature on art, design and manufacturing. A significant example of this was the publication of Bedford's photographs from 1853–4 of the furniture and decorative arts on display at the Marlborough House museum as a book of lithographs, titled *The Treasury of Ornamental Art* (*c.*1857).[10] In this context, the use of photography allowed the accurate depiction of detailed information about each work of art.

Photographs were also used by artists as preparatory studies for much larger works. Perhaps the best-known example of this is the painting known as the *Disruption Picture* (1866, Free Church of Scotland, Edinburgh), which shows 457 people gathering to found the Free Church of Scotland in 1843. It was painted by artist and photographer David Octavius Hill who, with Robert Adamson, made several hundred photographic portraits to be used as source material to aid the completion of the painting. Once the painting was finished, Hill commissioned another photographer, Thomas Annan (1829–87), to make a photographic record of the work and an accompanying key was produced to help viewers identify the many people in the picture (**fig. 46**). In the first half of the nineteenth century, it would have been usual to produce an engraving after such a painting rather than a photograph. The growing public interest in art and the increasing number of people who had the time and money to attend art exhibitions led to the creation of a highly lucrative market for reproduction prints copying popular paintings.[11]

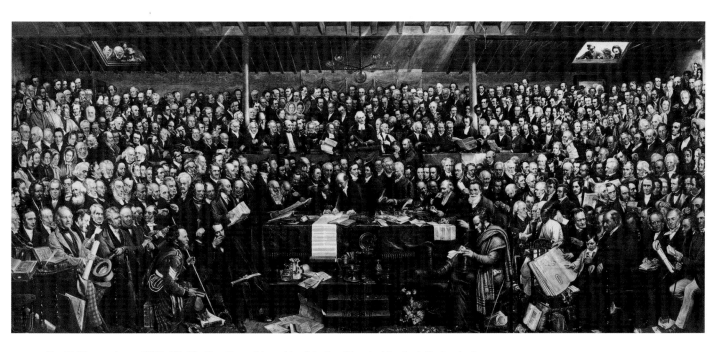

Fig. 46: Thomas Annan (1829–87), *The First General Assembly of the Free Church of Scotland: Signing the Act of Separation and deed of Demission, Tanfield, Edinburgh, 23 May 1843 by David Octavius Hill*, 1866, carbon print, 27.0 × 68.7 cm. RCIN 2149135

It was within this context that the art dealer and publisher Wiiliam Agnew made the decision to ask Roger Fenton to go to the Crimea to photograph the war. Agnew's was one of a small number of publishers who would commission artists to produce drawings or paintings which they would then purchase, also acquiring the copyright, in order to reproduce them and sell in a mass-produced format, usually as mezzotints or lithographs. Agnew's and its competitors (which in London principally included the printseller and dealer Ernest Gambart and the firm P. & D. Colnaghi & Co.) would also approach artists in order to acquire ownership of successful paintings and try to acquire the copyright so they could produce prints of the works. The larger printsellers and dealers also had their own galleries where the paintings and prints could be exhibited to an enthusiastic public to aid the sale of the works. The most important element in the transaction was the right to make an image that could be printed in thousands of copies and be distributed easily across the country.

In 1855 Fenton was not the only artist under commission in the Crimea. Ernest Gambart sent the history painter Edward Armitage (1817–96) to the war between January and April 1855 to make sketches. Armitage subsequently produced two large canvases titled *The Stand of the Guards at Inkerman* and *The Heavy Cavalry Charge at Balaclava*, which were exhibited at Gambart's French Gallery at 121 Pall Mall, in spring 1856. Also exhibited was the drawing *The Bottom of the Ravine at Inkerman*, shown at the Royal Academy in 1856 and notable for depicting the bodies of dead British soldiers. Rival firm Colnaghi's had sent out William Simpson to gather enough material to prepare two volumes that made up *The Seat of the War in the East* (1855–6), containing a total of 40 lithographs. Simpson's lithographs made the firm £12,000, the equivalent of roughly £220,000 today.[12] Perhaps surprisingly, 91 works by Simpson, described in the review as both drawings and engravings, were displayed alongside Armitage's paintings at Gambart's gallery, with a large portrait of Queen Victoria by Stephen Catterson Smith.[13]

Fenton was supported by Thomas Agnew and Sons during his expedition as he was expected to produce photographs which the artist Thomas Barker could use as source material for a large history painting depicting the senior officers in the allied forces. Barker was commissioned by Agnew's to produce the painting, and the firm would subsequently print a mezzotint copy of the work accompanied by a key. The enthusiasm that the public had for anything connected with the war must have made the commission seem highly lucrative, particularly as Fenton's photographs could also be exhibited to the public and themselves printed multiple times and sold.

PHOTOGRAPHY IN THE CRIMEA BEFORE FENTON

Although Fenton's work from the war remains the most substantial body of photographs to have survived, several photographers were sent to the Crimea both before and after Fenton's expedition. Before Fenton arrived in March 1855, the British Government had tried twice to send military photographers to document the conflict.[14] The first photographic team consisted of the photographer-artist Richard Nicklin from the firm Messrs Dickinson of Bond Street, assisted by Corporal John Pendered (1831–54) and Private John Hammond,

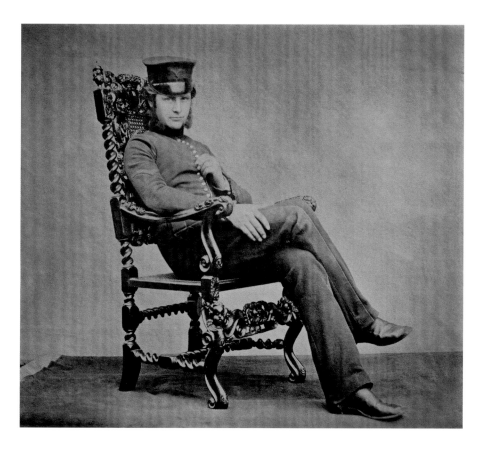

Fig. 47: Unknown photographer for Messrs Dickinson, *Corporal John Pendered*, negative 1854, printed *c*.1883 by Jabez Hughes, carbon print, 17.1 × 19.4 cm. RCIN 2500123

both of the Royal Sappers and Miners. They had been trained by Charles Thurston Thompson, who was also working for Dickinson's. The Sappers and Miners had set up a photographic unit in March 1854 at Chatham under the command of Captain Hackett. The Government's plans appeared to be widely reported, with notices appearing in several publications. *The Morning Chronicle* announced that 'it is understood that the Government are about to attach photographers to the expeditions proceeding to the seat of war, both naval and military'.[15] In Dublin, an article about the preparations for war connected Roger Fenton's name with war photography for the first time, 'the practicability of taking instantaneous views at sea as well as on land has been clearly proved by Mr. Roger Fenton.[…] On the occasion of the fleet leaving Spithead under Sir Charles Napier that gentleman took some excellent impressions of the scene from the deck of the Fairy'.[16] Fenton did not photograph from the *Fairy*, but he did record the departure of the fleet (**fig. 4**).

A set of photographs produced by the unit under the guidance of Messrs Dickinson were sent to Prince Albert depicting the men about to depart for the Crimea.[17] Amongst these portraits were two of Corporal Pendered, the assistant photographer on the team (**fig. 47**).[18] It is impossible to say who exactly was responsible for the portraits sent to the Prince, although on 29 May 1854 Nicklin was commissioned by the Sappers photographic unit to take another set of portraits of men about to depart for Russia.[19] Whether any of these were sent to the Queen is unclear, as is whether Nicklin was responsible for the first set of portraits.

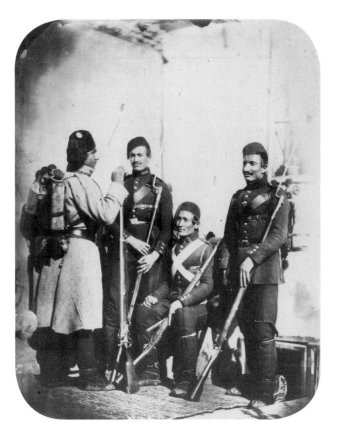

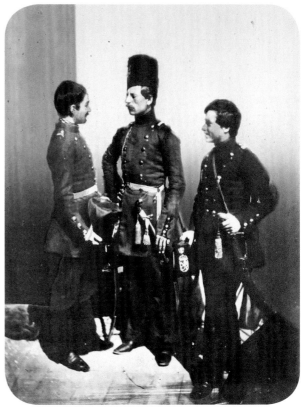

Fig. 48: Attributed to Carol Szathmári (1812–87), *Infanterie Turque en campagne* [Turkish infantry campaign], 1854, salted paper print, 29.6 × 22.2 cm. RCIN 2500623

Fig. 49: Attributed to Carol Szathmári (1812–87), *Volontaires russes (Bulgares)* [Russian volunteers (from Bulgaria)], 1854, salted paper print, 23.2 × 17.5 cm. RCIN 2500620

Nicklin, Pendered and Hammond reached Varna on 20 July 1854 and probably began taking portraits here. They followed the army to Balaklava where, unfortunately on 14 November 1854, they were on one of the ships that was destroyed during the hurricane. They were drowned, and all their equipment and photographs were lost.[20]

The second military team put together consisted of Ensigns Brandon and Dawson, who managed to complete their task in the spring of 1855, at the same time that Fenton was in the Crimea. Having been tutored by John Mayall, they sent successful photographs back to Britain, but the photographs were not exhibited and the Government appears to have made no use of the images. None are known to have been published in any format. After only a few years, it was reported that the photographs had faded and were 'in a deplorable condition'.[21]

Before the war even reached the Crimean peninsula, the professional artist and photographer Carol Pop de Szathmári (1812–87) began photographing the troops in the Wallachian and Moldavian provinces, after Russia threatened the region in June 1853. Szathmári was based in Bucharest, where he had a studio that was already patronised by military officers. From Bucharest he made an expedition to front lines where he managed

to photograph the opposing armies of Russia and the Ottoman Empire, becoming the first photographer of the Russian war.[22]

Szathmári produced about 200 photographs which were published and displayed in Paris in the summer of 1855.[23] The images were shown in the Ottoman section of the Exposition Universelle, and were also seen by the French Emperor. A set of Szathmári's photographs was acquired by Queen Victoria, although today only 13 prints from a potentially much larger group survive.[24]

Of the photographs that do survive, all are group portraits. A few show senior commanders, such as Omar Pacha; others are photographs of 'types', depicting representatives of different ranks across the Ottoman army, such as soldiers of the infantry and artillery, a major, a colonel, a captain, musicians, and Russian volunteers and Cossacks. It is unusual to have opposing sides depicted by the same photographer, but perhaps Szathmári, as an outsider and an already well-known artist, was given more freedom than might be expected (**figs 48–9**).

FENTON IN THE CRIMEA

Fenton began making preparations to leave Britain towards the end of 1854. During this period, reports of the war were published daily as news filtered slowly back.[25] Fenton would have read about Alma, Balaklava and the Charge of the Light Brigade and Inkerman prior to his departure. Whilst this information was appearing, Fenton was gathering his equipment and supplies for the expedition. In a talk given to the Photographic Society after he returned to London, Fenton described what he took with him.[26] He gathered five cameras of different sizes; 700 glass plates of three different sizes; chemicals, a stove, trays and dishes, various tools, and the 'travelling darkroom' (**see plate 56**). The darkroom was a converted wine merchant's van and in the autumn of 1854, Fenton set out with his assistant Marcus Sparling on a trial run with the van to photograph at Rievaulx Abbey in North Yorkshire.

This local expedition led to a few modifications in the van. With the preparations complete, Fenton departed on 20 February 1855 on board HMS *Hecla*, accompanied by 36 large chests, two assistants and his photographic van. Fenton's voyage took him to Balaklava, stopping en route at Gibraltar, Valletta, Cape Matapan and Constantinople. In Constantinople, Fenton visited the British Embassy to see Lord Stratford de Redcliffe, with a letter of introduction from Prince Albert, although he was unable to meet the ambassador who was ill at the time. Fenton finally disembarked at Balaklava on 8 March. The same day he wrote a letter to his wife Grace, in which he described the chaos and 'bedlam' of the port, likening it to 'the emptying of Noah's ark'.[27] In his letter to his publisher William Agnew, written the following day, Fenton was even less enthusiastic, describing the place as the worst 'of all the villainous holes that I have ever been in'.[28]

Although Fenton was carrying letters of introduction from Prince Albert to use in Constantinople and in the Crimea, he was not under instruction from the royal family or from the British Government in respect to his photographic work. The letters were a standard way for connections to be made between people who

had not previously met each other. They would confirm that Fenton was of an appropriate social standing to engage with the senior diplomats and military leaders that he would encounter and need to photograph. Once in Balaklava, Fenton networked with the officers, obtaining introductions to some from others whom he could approach. Fenton's work in the Crimea has been explained as an attempt to 'whitewash' the harsher realities that the British troops faced by not photographing the real conditions in which they were living, with the letters used as evidence that Fenton was a hired apologist for the war. It is true that Fenton's photographs do not provide explicit evidence of the army's situation as described in Russell's reports, but by the time Fenton had arrived in the Crimea the harsh winter was over, new supplies were arriving and health and sanitation at the front and in Constantinople was improving. Additionally, when Fenton arrived in the Crimea, there was a Government-sanctioned photographic team already present (Ensigns Brandon and Dawson), and there was no reason to assume that their work would not be successful. Fenton also makes a reference to his own 'non-official' status in one of his private letters to his wife. Describing a lengthy talk with General Bosquet after dinner, he describes how freely he is able to express his views, 'I see [&] hear many things here which I should never know had I been placed in any official position'.[29]

Even so, contemporary reports suggest that Fenton's photographs were interpreted as the visual equivalent of Russell's accounts. A notice in *Notes and Queries*, discussing the display of the photographs in London stated, 'It is a pictorial and running commentary on the graphic narrative of *The Times*' "Special Correspondent." The stern reality stands revealed to the spectator. Camp life, with all its hardships, mixed occasionally with some "rough and ready" enjoyments, is realised'.[30] This is perhaps because the audience came to the photographs with a significant (although probably not extensive) knowledge of the war to date. They were sophisticated enough to read the photographs and incorporate them into their existing second-hand experiences of the war.

Nevertheless, Fenton had a commercial commission to fulfil which demanded portraits of all of the senior officers in the field. The rest of his work, the topographical views in particular which were also for Agnew's to sell, was destined for a touring exhibition around Britain. Fenton, as an accomplished and careful photographer, would have known what was appropriate to photograph and present to the public, whilst keeping in mind the need for Agnew's to sell his photographs. The photographs thus become a subtle comment on the war, although perhaps not in the way that has been previously understood.

The Photographs

Fenton stated in his talk to the Photographic Society that he took around 700 glass plates to the Crimea. Approximately half this number were deemed to be successful exposures, being subsequently printed, exhibited and sold. Several reports in the press after Fenton's return gave the number as 360 photographs in total. The majority of these photographs which were printed up are individual portraits of the commanding and senior

officers and their assistants. There are also a number of regimental groups, which show something of camp life, including tents, the diverse dress in use amongst the soldiers, cooking, eating and drinking and animals, as well as the variety of mercenary troops, camp assistants and followers, and a few of the civilians that were to be found at any one time following the progress of the war.

It is likely that some glass plates were broken or did not survive the journey, and some exposures would not have been successful or acceptable to Fenton. Fenton writes in his letters about taking photographs in windy conditions or under fire, or not having the best light for a successful exposure. On 28 March he was at the Generals' Camp to make some views but the weather let him down, 'it was very windy and several pictures were spoilt'.[31]

Other plates would have been variants of the images that were eventually printed. Very similar photographs can be found when comparing images in surviving sets, which suggests that substitutions were made, perhaps because negatives got damaged or perhaps another composition was preferred.[32] This puts the total number of published photographs at more than 360 unique photographs.

The first photographs that Fenton took were architectural and landscape studies taken in Balaklava during the initial weeks following his arrival. Fenton's letters written to his wife and to his publishers give a good account of his movements after his arrival. On 15 March he wrote, 'I took a few pictures beginning with Her Majesty's post office' so **plate 64** can be assumed to be the first successful photograph that was made. It is an extraordinary image with which to begin his photographic work. The building is in a precarious state, with the external staircase looking shaky and the men standing on the balcony looking equally insecure. In the foreground lies evidence of the newly constructed military railway. The exterior of the building suggests it has been under attack, which is perhaps what the London viewers would want to see, but the title of *Old Post Office* would lead to the expectation of a formal, organised place, comparable with the Victorian institution in Britain. The juxtaposition of the title and the visual content works to set up both an expectation and the undermining of that expectation, and the consequent emotion should be, if not exactly shock, then a glimmer of understanding of how the war was experienced by those in Balaklava.

Several of the other photographs of Balaklava were taken in March and they show clearly the chaos and confusion that Fenton describes in his letters. He captures the crowded harbour, with numerous ships lined up at the water's edge, the railway under construction and the different buildings that have been commandeered by the British. Balaklava had previously been a quiet Russian port manned by Greek soldiers who surrendered easily to the British; many of the buildings had been in poor shape before the troops arrived, although one of Fenton's best known photographs shows a church not damaged from conflict, but in the midst of its construction (**plate 62**). Once the British set up their base, the harbour was filled with official and unofficial activity, with people from regions across the Black Sea area competing for space and commerce, with the army's activities poorly organised in the midst of it.

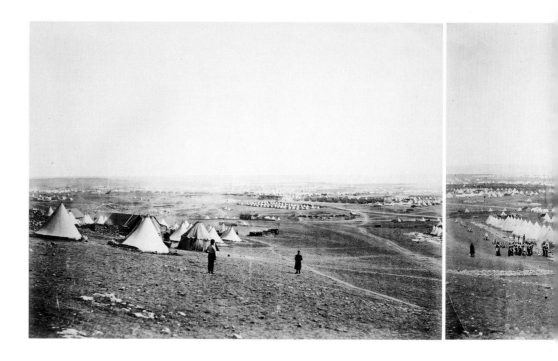

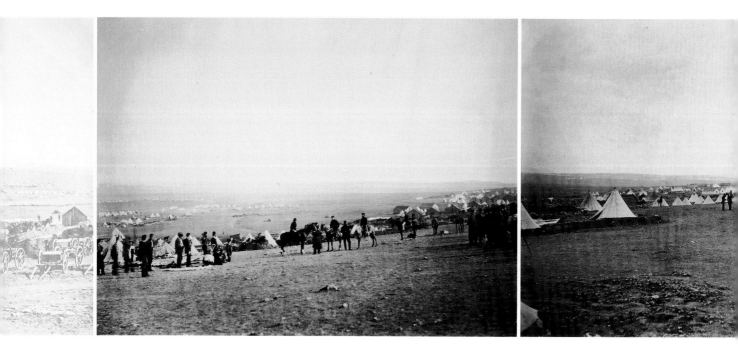

Fig 50: Above and overleaf: Roger Fenton (1819–69), *Panoramic Series [of the plateau of Sebastopol]*, April 1855, 10 albumen prints and 1 salted paper print, dimensions for individual works as given in the appendix. RCINs 2500516–26

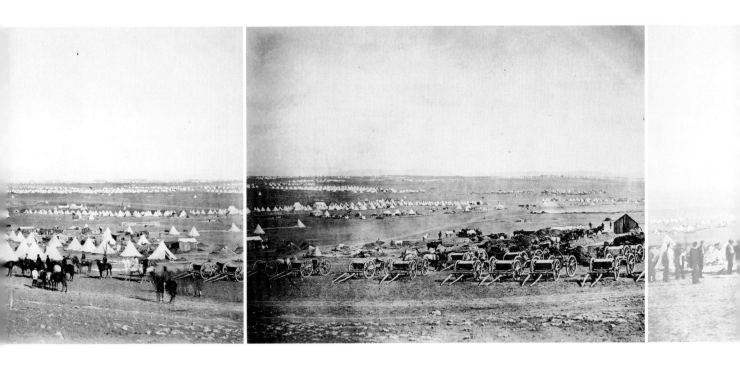

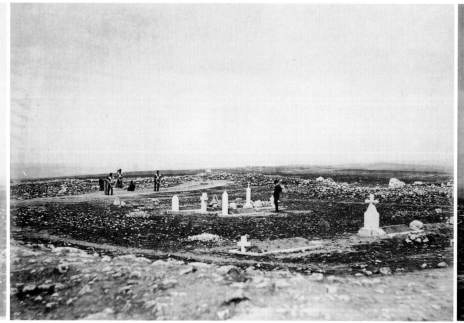

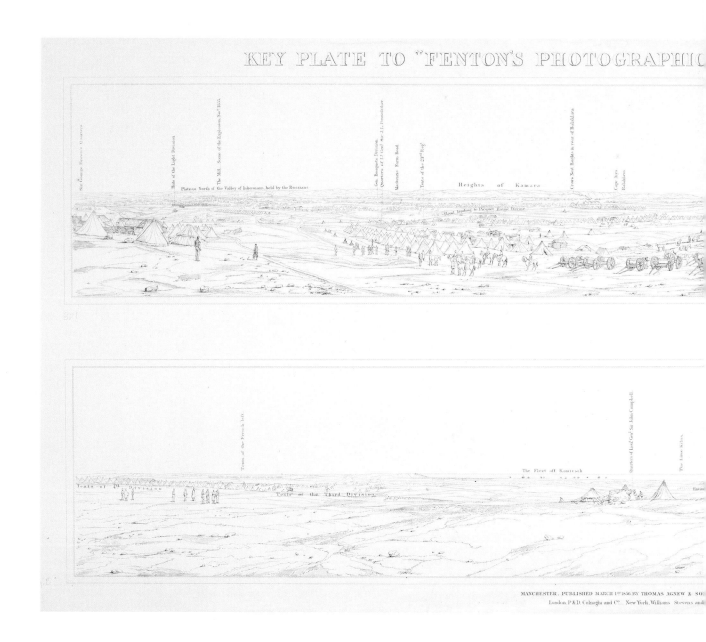

MANCHESTER, PUBLISHED MARCH 1ST 1856 BY THOMAS AGNEW & SON
London, P & D. Colnaghi and Cº.... New York, Williams Stevens and

Fig. 51: Thomas Agnew and Sons, *Key plate to 'Fenton's Photographic Panorama of the Plateau of Sebastopol'*, published 1 March 1856, engraving.
Harry Ransom Center

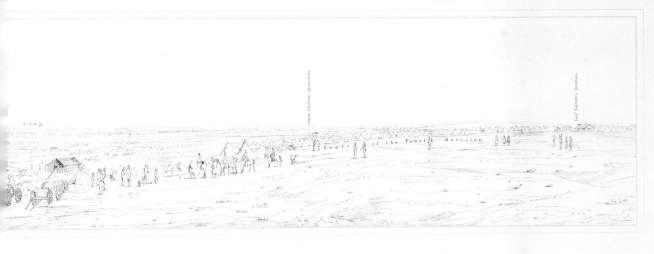

Camp — Tents of the Fourth Division — Senr Orrluas Quarters — Gen.l Garretts Quarters

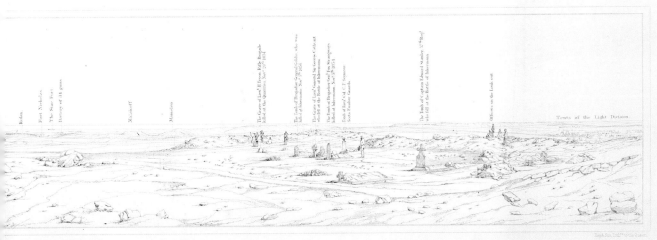

Redan — Fort Nicholas — The Star Fort — Battery of 34 guns — Malakoff — Mamelon — The Grave of Lord H. Percy Rifle Brigade killed at the Quarries Nov.r 20.th 1854 — The Tomb of Brigadier General Goldie who was killed at Inkermann Nov.r 5.th 1854 — The Grave of Lord General Sir George Cathcart who fell at the Battle of Inkermann — The Tomb of Brigadier Gen.l Jno. Strangways killed at Inkermann Nov.r 5.th 1854 — Tomb of Lieut. Col. C.S. Seymour Scots Fusilier Guards — The Tomb of Captain Edward Stanley 57.th Reg.t who fell at the Battle of Inkermann — Officers on the Look out — Tents of the Light Division

PUBLISHERS TO HER MOST GRACIOUS MAJESTY. EXCHANGE STREET.

23, Rue Richer.—— Florence, Guiseppe Bardi.—— Frankfort, C. Jugel.

The appearance of the Balaklava railway in several photographs is suggestive. The railway might typically be seen as a sign of progress and of strong British engineering skills, being the first railway to be constructed to serve a war in progress. Construction had begun in February 1855, and was not yet complete when Fenton arrived. Although a section of the track was in use within a few weeks ready to take guns and ammunition up to the lines before Sevastopol to prepare for the great bombardment which began on 9 April, the only photographs Fenton took of it show the uncompleted railway, with sleepers lying on the ground, surrounded by wooden planks, rubble and other evidence of construction (**plate 58**). He wrote in a letter dated 28 March that 'the railway is at work'.[33] A completed working railway would have been a perfect opportunity for Fenton to show the efficiency of the war effort, but instead he chose not to photograph this, and only made public those photographs which show Balaklava as a chaotic town. The man in charge of financing the railway, Sir Samuel Morton Peto, had helped finance Fenton's passage to the Crimea, which perhaps makes it more surprising that the railway wasn't shown to better advantage.[34]

For the first month, Fenton based himself on board his ship, making small excursions out of Balaklava and occasionally sleeping in an officer's tent if he made a longer trip towards the lines. At the beginning of April, he decided to begin 'his march' out of Balaklava, declaring it 'one great pigsty'.[35] Fenton made steady progress towards the general Head Quarters, occasionally taking a photograph in return for assistance in moving his photographic van. Closer to the front he stayed with officers in their tents and took numerous portraits and topographical views, as well as making an extraordinary eleven-part panorama (**figs 50–51**). The panorama, and several other views made at the same time (including variant plates for the panorama), show the landscape as seen from the point named by the British 'Cathcart's Hill', looking across the plateau with Sevastopol in the distance as the main focus of the army.[36] These views offer a glimpse at the full extent of the British camp, with tents stretching far into the distance, suggesting strength and orderliness. The panorama is technically a masterpiece as each section joins closely with the preceding image. The viewer, reading the images from left to right, is taken from the military camps, which spread across the plain into less populated areas that seem bleak, desolate and uninviting. Occasionally a solitary figure is silhouetted against the horizon. Fenton ends the sequence with two plates which incorporate the cemetery created by the British, a reminder of the potential fate for so many of the men seen in the previous images. A single figure stands contemplating the graves, whilst to the side a group of three soldiers continue their lookout. It is a sequence of images that begins as a heroic composition but ends with melancholy and sadness, all the more poignant for following so swiftly behind the initially impressive military encampment.[37]

After finishing the panorama, Fenton took his photographic van down to the ravine known as the 'Valley of the Shadow of Death' (**plate 68**). Here Fenton made his best-known photograph from the war, an image that demonstrates clearly the power that can come from a subtle and poetic composition rather than resorting to more explicit imagery for an impact on the viewer. The photograph is simple, placing the viewer at the bottom

of a ravine that stretches away towards the horizon. Two gently sloping hills on either side of the ravine, fall down onto the road below. We cannot see beyond the hills. Many cannonballs lie on the ground, suggesting the area has been under heavy fire. There are no figures in the image, so seeking an explanation the viewer turns to the title: *The Valley of the Shadow of Death*. The British soldiers gave this name to the ravine, and Fenton uses this particular phrase in a letter to his wife. This site is sometimes mistakenly described as the location of the Charge of the Light Brigade. This seems to be from the similarity between Fenton's title for this photograph and the phrase used in Tennyson's poem, 'The Charge of the Light Brigade', which includes the line 'Into the Valley of Death'. The phrase, which comes from Psalm 23, would have been well-known to a wide audience in the mid-nineteenth century. In the psalm, the full phrase is 'Yea, though I walk through the valley of the shadow of death'. The viewer is standing at the foot of the ravine, poised to walk through the valley. The image is intended to pull the viewer into the scene, and the thought of walking through the field of battle is meant to be frightening. References to death and the appearance of so many cannonballs intensify this emotion. The scene is perfectly still and almost empty, but it is heavy with suggestion. When the viewer combines the image with the title and his or her existing knowledge of war, the imagination is able to create a powerful interpretation, free from any detail in the picture. Thus, the photograph becomes one of the most emotive that Fenton ever produced.

Towards the end of April Fenton made a handful of views of Sevastopol in the distance (**see plate 71**). He did not consider them to be completely successful, writing, 'the views here were not very good pictures as nobody being in front I could make no foregrounds & the town is so far off that in itself it is no picture', but at least two views became part of the published series nonetheless. The photograph lacks detail, but is replete with atmosphere, as very minimal composition. The town is only just visible and a few ships' masts appear over the top of the plateau. Trying to see the town over the top of the hill, the viewer is placed in the position of a soldier, watching the besieged town for activity. Taking control of the town was the military goal for the allies and this action would effectively end the war. The photograph has all the melancholy wistfulness of someone gazing at an unattainable beloved.

In May and June the temperature began to rise significantly and Fenton was unable to take so many photographs as before; he could not work after 8 or 9am as the heat made the chemicals react unpredictably. He made a short expedition to the Valley of Inkerman to make a few negatives, depicting the battlefield and the location of the Guards' Battery (**fig. 52**). The landscape was dramatic and he also made a number of stereoscopic views and sketches, despite being very close to the Russian battery. Fenton was eventually forced to move on, having been fired at several times by the Russians. The photograph of the Guards' Battery is a very simple image, showing very little and relying entirely on the title to provide context and meaning. No real trace of the battle appears to remain. A Victorian viewer would know that the Battle of Inkerman was characterised by confusion caused by the thick fog and the contrast between this imagined scene of

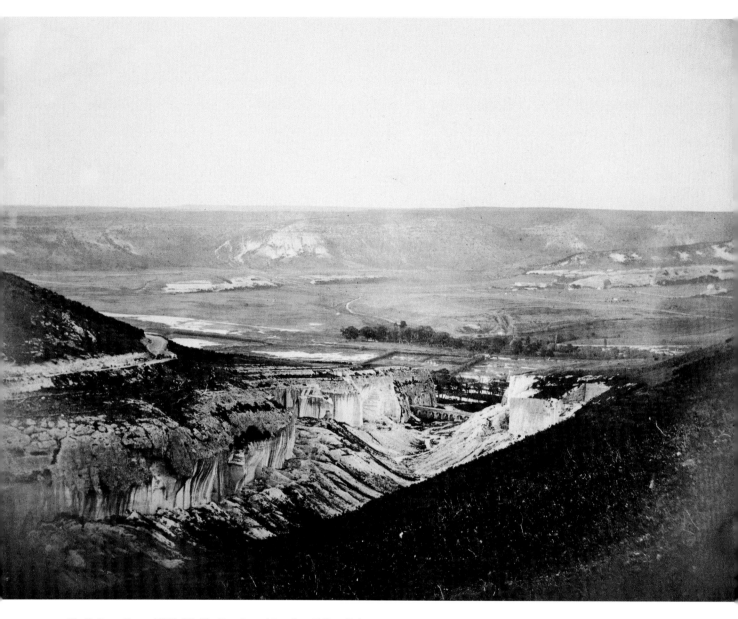

Fig 52: Roger Fenton (1819–69), *The Quarries and Aqueduct. Valley of Inkerman*,
May 1855, albumen print, 18.5 × 25.1 cm. RCIN 2500469

battle and the empty plain in the photograph would be striking.

In June Fenton began to think about returning home. He concentrated on obtaining portraits of
the few remaining people that he needed – Lord Raglan, General Pélissier and Omar Pacha. In the camp,
there was frequent talk about taking Sevastopol and Fenton believed this was imminent. He photographed
the three allied commanders together (**see plate 14**) in a work that was titled *The Council of War*. This
image shows the men gathered together to plan a combined assault on the Mamelon, which took place
on 6–7 June 1855. It seems unlikely that the men were prepared to have their photograph taken in the
early morning of 7 June before the fighting began. More probable is that this group was taken after
the event. Fenton describes the events of 6–8 June in detail in a letter to his wife, but there is no mention

of a gathering of the leaders. Lord Raglan is only mentioned when he later visits a wounded officer.

Showing the three allied commanders working together was an optimistic image, speaking of hope and victory for the allies. It was subsequently used as source material for a painting by Augustus Egg. The painting, which alters the scene set in Fenton's photograph only slightly, was exhibited in 1856 at Graves's Gallery, 6 Pall Mall, London. Graves & Co. soon issued a mezzotint after the painting. When the photograph was first exhibited in 1855 in London the fall of Sevastopol had just occurred and the image would have been seen as a precursor of overall success, although tinged with melancholy as Lord Raglan died on 28 June 1855, only a few weeks after the assault. The fact that the painting was closely based on a photograph was known at the time, and this was seen as a positive thing. Using photographs ensured that the image was based on 'historical truth'.[38] For Thomas Barker too, using Fenton's photographs was an indicator that his painting was truthful and accurate. The connection to Fenton was made explicit in the accompanying key, 'Painted by T. J. Barker Esq. K.L.H. from Photographs and Sketches taken in the Crimea expressly for the Picture by Roger Fenton Esq.' (see fig. 36).

Portraits for Thomas Jones Barker (1815–1882)

Throughout his time in the Crimea, Fenton made portraits of a wide range of individuals. In his letters home, he refers obliquely several times to his commission to obtain all the necessary portraits to supply to Thomas Barker. At the end of April he wrote, 'I am getting surfeited with good pictures now & want sadly to get back but must complete my task'.[39] Fenton recounts in different letters how, when he was at the front, he moved between the tents to make portraits, making acquaintance with the officers and often dining with them as well. In one letter to his wife, there is a reference to 'a picture'. Fenton wrote, 'As for your question about the name of the picture Genl Barnard says you are quite safe in calling it "The Seige [sic] of Sebastopol as there is little doubt that the south side will soon be taken'.[40] It is possible that this refers to Barker's picture, and that Mrs Fenton was wondering in a letter what it should be called.

In order to complete his portrait gallery, Fenton had to continue his Crimean series from his London studio in the late summer of 1855. Several significant individuals, including Burgoyne (plate 8), de Lacy Evans (plate 3) and the Duke of Cambridge (plate 20), had already left the Crimea by the time Fenton arrived. The Sanitary Commission – Rawlinson and Sutherland – had also left (plate 26); Fenton noted their departure in a letter to Thomas Agnew, implying, perhaps, that he had not yet photographed them. The details of the setting and props used in these photographs are different to any of the portraits from the Crimea. The studio is set up in a proper room, with floorboards, walls and skirting boards, with rugs and drapes very similar to those used in Fenton's later studio work. A covered table is used in several images, and the animal skin that appears in the Sanitary Commission portraits is also used in Fenton's self-portraits where he dresses up as a *Zouave*.[41]

RCIN 2500512

RCIN 2500237

RCIN 2500341

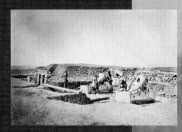

RCIN 2500509

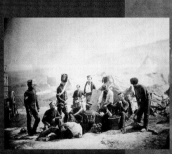

RCIN 2500384

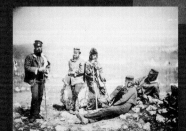

RCIN 2500456

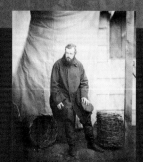

RCIN 2500285

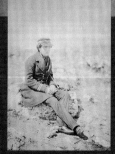

RCIN 2500288

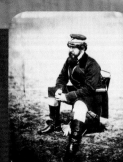

RCIN 2500306

RCIN 2500327

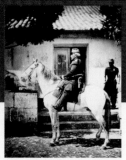

RCIN 2500314

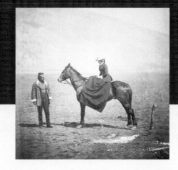

RCIN 2500405

RCIN 2500419

RCIN 2500253

RCIN 2500401

Fig. 53: A comparison between Barker's painting and Fenton's photographs showing a selection of the potential 'matches'. Barker does not always copy the photograph exactly, preferring to adapt elements or reverse poses in order to accommodate them in the painting.

At the time of the war, Barker was already known as a history painter, a genre which academic art regarded as the highest form of painting, but Barker was never wholly successful within his art. He did not join the Royal Academy despite regularly exhibiting at the annual exhibitions, but he eventually found commercial success through the publication of his work in print format, having by this stage specialised in military history painting. He worked with Agnew's for other, very similar, commissions, most notably with his painting *The Relief of Lucknow, November 1857* (1859; National Portrait Gallery, London). To complete this work, Barker relied on sketches supplied by the artist Egron Lundgren (1815–75) who had been sent to India by Thomas Agnew. In 1860 Agnew's produced a print of the finished work engraved by Charles George Lewis (1808–80), and exhibited in London the oil painting alongside Lundgren's sketches.

A wide range of imagery supplied by Fenton ended up being used by Barker in the finished painting. There are some very clear cases where the faces of the commander and other officers have been copied directly from the photographs. For example, General Sir Richard England's face is almost exactly the same as Fenton's portrait. Other faces which appear to be copies include Prince Napoleon; Omar Pacha; General Pennefather, and Colonel Adye.

Other figures who are copied from the photographs include *The Times*' reporter William H. Russell; the *vivandière* with the wounded *Zouave* (which reverses the original photographic composition); a man and his dromedary; an officer of the Spahis on the extreme right of the painting, and to the left of the painting, there is a group of men from the 8th Hussars cooking with a large pot that is a very close copy of Fenton's group. Next to the group stands a turbaned man, holding the reins of a horse. He is the same Spahi officer who is on the opposite side of the painting, but this time the image is reversed.[42]

Some figures appear to be based on, or inspired by, Fenton's portraits, such as the existence of a North African 'pipe bearer' for Ismael Pacha – Fenton made at least three group portraits showing Ismael Pacha, the commander of the Egyptian troops, receiving his pipe from his orderly. The only woman who appears in the painting is identified in the key as Florence Nightingale, seated on horseback. She appears to have been inspired by Fenton's photograph of Frances ('Fanny') Duberly, who accompanied to the Crimea her husband Henry, the paymaster to the 8th Hussars.[43] Fenton appears not to have photographed Nightingale (who is often described as being a reluctant sitter for the camera) even though she was in the Crimea in May 1855, in order to inspect the hospitals.

Some of Fenton's portraits were not used by Barker. One notable example is the tragic depiction of Captain Alexander Leslie-Melville, Lord Balgonie (**plate 42**) who, looking dishevelled and unfocused, appears to be suffering from shell-shock. Balgonie returned home at the end of 1855 and suffered from poor health for two years before dying on 29 August 1857 from an unspecified cause, although his illness is described as being caused by the hardships of the war. The portrait was included in the exhibition of Fenton's Crimean

photographs in London, with a similarly moving portrait, of Captain James Wardrop of the Grenadier Guards (**plate 41**).

Barker finished his painting sometime in the first half of 1856; the engraving by Charles Lewis was published in August 1856. Barker also completed a second Crimean painting for Agnew's, titled *The Capitulation of Kars, 26 November 1855* (1860; National Army Museum, London), although it is not connected with Fenton's photographs.[44]

According to one source, Agnew's had invested £10,000 in Fenton's expedition;[45] another source states that one engraving of a popular painting, such as this one, could make £10,000.[46] Agnew's had taken a huge gamble on the whole project, but apart from the engraving for the ever-expanding print market, there was also the prospect of Fenton's photographs as objects of interest in their own right.

RETURNING TO BRITAIN

Fenton sold much of his equipment and his horses before he left the Crimea. Sparling and William packed up the negatives, which were to travel with Fenton, and they left Balaklava on 22 June, taking a ship to Constantinople where they found passage with the *Orinoco*, arriving in England on 11 July. Fenton returned home, and he had two months in which to prepare the first exhibition of his work. The initial announcements appeared in August 1855, as advertisements placed by Agnew's in *The Athenaeum* and elsewhere.[47]

Before the exhibition, however, Fenton also presented his photographs for consideration to Queen Victoria. Having received such significant patronage from the royal family in 1854, Fenton hoped to maintain the link with the Royal Household whilst he was in the Crimea. He had asked his wife in one letter to show a photograph of the Croats to Dr Becker, who was employed in the Royal Household.[48] This photograph is most probably the image that appears in Queen Victoria's album *Crimean Portraits, 1854–1856*, rather than one of the prints from the main set of Crimean photographs (**fig. 54**). Becker was officially Prince Albert's librarian, but he played a significant role in building up the royal couple's photograph collection as well as instructing the royal children in practical photography. As a member of the Photographic Society, Becker was also probably responsible for connecting Fenton and Queen Victoria in early 1854. Fenton may have expected that Becker would show the photograph to Prince Albert and Queen Victoria. In asking Grace to show the photograph to Dr Becker, Fenton adds, 'take care no publisher sees it'.[49] A subsequent letter from Fenton acknowledges receipt of Dr Becker's 'note', although the subject of the note is not mentioned.

On 8 August, Queen Victoria wrote in her journal that she saw some of Fenton's work whilst at Osborne House on the Isle of Wight. She looked at 'some interesting photos, taken by Mr Fenton, in the Crimea, – portraits & views, extremely well done, – one, most interesting, of poor L^d Raglan, Pélissier & Omar Pacha, sitting together, on the morning, on which the Quarries were taken'.[50] It is not clear if the set (or at least, some of it) which is now in the Royal Collection is the material viewed by Queen Victoria on

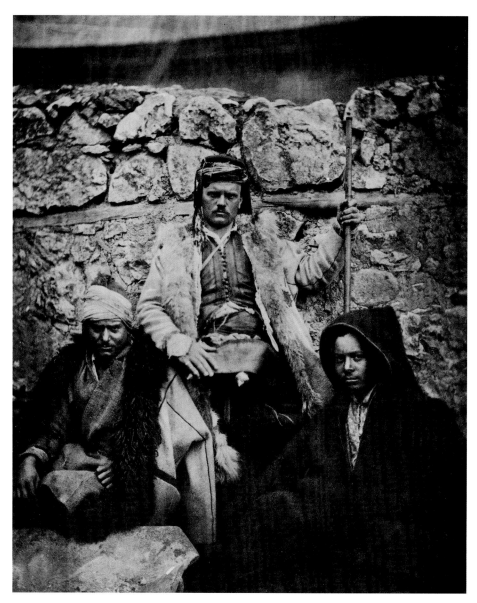

Fig. 54: Roger Fenton (1819–69),
Croats, March 1855, negative March 1855,
printed *c*.1883 by Jabez Hughes, carbon print,
19.3 × 15.6 cm. RCIN 2500179

Fig. 55: 'Croats: from a photograph
by R. Fenton in the Crimea Exhibition',
Illustrated London News, 29 December 1855,
p. 753. RCIN 1041770

8 August. There is no clear information regarding the acquisition of the 349 photographs which subsequently became part of the Prince of Wales's library at Sandringham (see Appendix).

Fenton, with William Agnew, also made the journey to France in early September to show the photographs to Emperor Napoleon III at Château de Saint-Cloud. The Emperor was reported to have approved of the photographs and requested a number of prints be made for him.[51]

While Fenton was in the Crimea he had made test prints whenever he could to send examples back to his publisher and others. He mentions sending portraits in particular to William Agnew and makes reference to obtaining those most likely to be 'historically interesting'.[52] Fenton also occasionally refers to making sketches, particularly in his letters to Agnew, which were also to be used by Barker, providing information about colour in particular. None of these sketches are known to have survived; likewise the stereoscopic photographs which Fenton mentions several times. He referred particularly to his excellent stereoscopic views of the Inkerman valley, but none have ever been identified.[53] Fenton was on the lookout for other sketches by others for Agnew, as he mentions that there were none worth buying, although he recommended the panorama by Major Edmund Hallewell that was sent to Queen Victoria in 1855, and is still in the Royal Collection today (**fig. 56**).

Fenton had urged Agnew to start making some engravings for publication straight away, presumably to make the most of the current interest in the war. Towards the end of Fenton's time in the Crimea, Agnew asked for the glass plate negatives to be sent to him, but Fenton refused to do this, stating that anyone Agnew employed to make the prints would ruin them. He added, 'Besides they are not all his' (i.e. not all of Agnew's).[54] It was not until Fenton returned to Britain that the photographs were made available to the public in a significant way.

Thomas Agnew and Sons mounted an exhibition in London at the Gallery of the Water Colour Society, at 5 Pall Mall, which opened in September 1855. The exhibition was accompanied by a catalogue listing every photograph on display and there was an order form at the back to allow visitors to purchase copies. The entire set would cost £63, although the photographs were also available in different sets and as individual prints, the cheapest being ten shillings and six pence. Agnew's grouped the photographs into sections consisting of 'Scenery, – Views of Camps', 'Incidents of Camp Life' and 'Historical Portraits'. Photographs from each section were released in batches from October 1855 until 12 May 1856. A small number of photographs were deemed to be more significant and thus cost more to acquire. Apart from the panoramas, this included *The Valley of the Shadow of Death*, *The Council of War* and *Tombs of the Generals on Cathcart's Hill* (**plates 68, 14 and 67**).

Once the exhibition opened in September notices began to appear in numerous publications. All were enthusiastic and often remarked on the necessary truthfulness of the photographs as a feature to recommend them. One notice in the *Daily News* described the photographs as 'a museum of fragments in miniature',

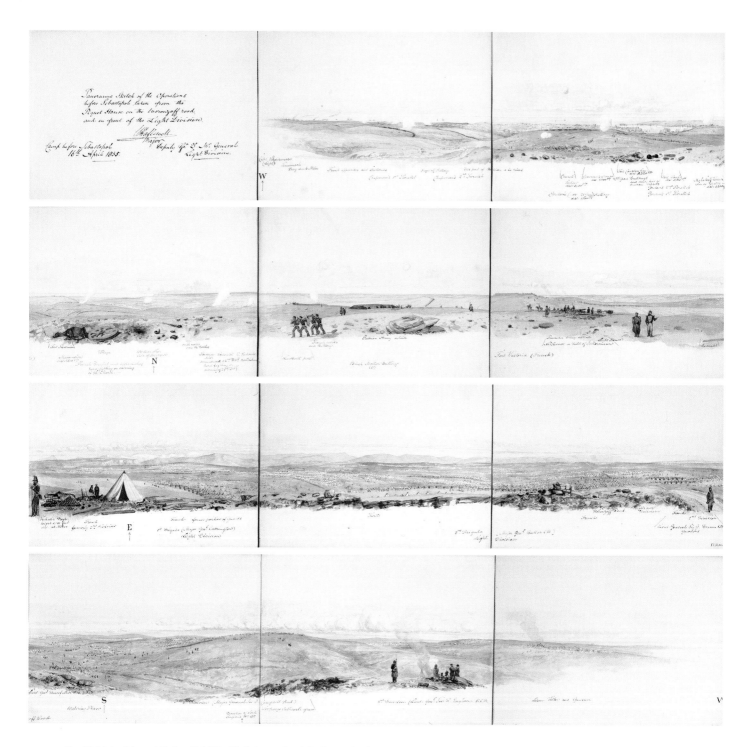

Fig. 56: Major Edmund Hallewell (1822–69), *Sebastopol and the Camps April 1855*, 1855, watercolour over pencil, 25.3 × 424.6 cm. RCIN 711112

assigning to the photographs an authenticity that can only come from objects. The public were described as being 'well prepared by reading', thus ready to understand and interpret what they were going to see.[55]

The exhibition was shown in four versions in London, finally closing in May 1856 at a gallery on Piccadilly where Fenton's work was shown alongside James Robertson's views. Robertson had visited the Crimea in September 1855, shortly after the fall of Sevastopol to the allies. He captured the final chapter in the narrative of the war, which had been missed by Fenton by a couple of months. Robertson's business partner and brother-in-law, Felice Beato, later returned to Sevastopol in March or April 1856 to make a further set of photographs.[56]

The exhibition of Fenton's photographs toured Britain to at least 26 different venues, possibly more, reaching Edinburgh, Glasgow, Exeter, Cardiff, Belfast and Dublin.[57] The exhibition in London had been reported widely across the country in newspapers, with extended reviews in journals such as *The Art-Journal* and *The Athenaeum*.[58] Many of the reviews employed highly emotive language, with religious metaphors used to heighten feelings: 'the very dust which hides the English dead should henceforward be as sacred to the Englishman as the dust of Jerusalem was to the Crusader [...] Such blood shed in such a manner fertilizes the most barren earth, and makes the vilest place indeed a Holy Land'.[59] Thousands of people who would have read about Fenton's work before it was on display were in this way prepared for what they would see and instructed on how they should think about it.

According to one report, by the end of March 1856, two million visitors had seen the exhibition, most of whom would have paid 1 shilling each as an entrance fee.[60] Even if this figure is somewhat hyperbolic, it is an indication that the exhibition was extraordinarily popular. The Prince of Wales made at least two visits to see Fenton's photographs, on 21 February 1856 and 28 June 1856.[61] Each venue had its own catalogue, each different but all modelled on the original September 1855 version. All the catalogues were printed by Thomas Brettell, of Haymarket, which suggests coordination between venues.

As many of the exhibitions were shown simultaneously, numerous prints would have had to be made for the displays. Just the material in the exhibitions would amount to several thousand works, if each display contained at least 200 works. With the additional material that was required to sell to the public, there would have been far more photographs being produced than one man could possibly print, suggesting that Agnew's were employing a studio to produce the photographs. In addition, each photograph sold by Agnew's was pasted onto a sheet of card with a letterpress caption, a photographer's and publisher's credit, and a date of publication, set within a plate-mark. The plate-mark was not a result of the printing process (as was the case with intaglio printing), but was added to the final work purely for aesthetic effect.[62]

The photographs, which were all made from glass plate negatives using the wet collodion process, were printed both as salted paper prints and as albumen prints. The same negative can be found printed as both processes in different sets, and ccasionally even within the same set as with some of the photographs in the

Royal Collection. Whichever process was employed, it seems that an attempt was made to produce uniformly similar photographs as it can be extremely difficult to distinguish the processes by eye alone. It seems possible that the commercial demands placed on Agnew's required the efficiency of albumen printing, but connoisseurship, even in the mid-1850s, preferred the appearance of salted paper prints. Consequently, the albumen prints may have been printed to appear as close in tone as possible to salt prints. During the 1850s, however, photographic printing was 'in transition'.[63] The gradual move from salted paper printing to albumen printing had begun, but each practitioner maintained their preferred methods of photographic production. In addition to the two printing processes, it was possible to print on albumenized paper which could be manipulated to give a very low sheen, making it much harder to distinguish between processes.

Fenton's photographs were clearly a critical and popular success, but whether this translated into sales of his photographs is harder to ascertain. The prices were extremely high, putting the photographs out of reach for many of the people who attended the exhibitions. It is unlikely that Fenton personally made any substantial money from the arrangement with Agnew's, although the firm, like its competitors, continued to issue prints after popular paintings for some years to come. In early 1857, rival firm Paul and Dominic Colnaghi & Co. announced that they had purchased Fenton's glass plate negatives and could provide prints at a much-reduced price.[64] The sale of the negatives, along with remaining prints, had taken place on 15 December 1856, alongside the remaining copies of William Simpson's *Seat of War in the East*.[65] Agnew's is unlikely to have sold an asset that was highly profitable.

James Robertson's photographs of Sevastopol taken after the fall of the city attracted far less interest than Fenton's work judging by the interest in the press. William Kilburn showed Robertson's photographs at his gallery on Regent Street in January 1856, whilst Fenton's photographs were on display on Pall Mall.[66] Robertson's work, despite being more recent, may have failed to engage emotionally with the British public. French photographers were also producing work following the fall of Sevastopol. The artist Jean-Baptiste-Henri Durand-Brager (1814–79) was already in the East with the army when he began taking photographs with a photographer known only as Lassimone. Their work, which clearly shows the wide-spread destruction of Sevastopol, was published in London by Gambart's firm, and examples were exhibited at the Manchester Photographic Society exhibition in 1856 (**fig. 57**). Another team, Jean-Charles Langlois (1789–1870) and Léon Eugéne Méhédin (1828–1905), was sent to the Crimea by the French Ministry of War to make studies for a large painted panorama. To achieve this, they took photographs which could be used as source material. Arriving in November 1855, they remained in the Crimea until June 1856, and produced a striking body of work (**fig. 58**). The photographs clearly show the absolute devastation experienced by the city, but Méhédin also produced a few surprising compositions which are more picturesque, concentrating not on the ruined buildings but on simpler elements such as carts and domestic huts which recall the role played by the ordinary citizen in the conflict (**fig. 59**).[67]

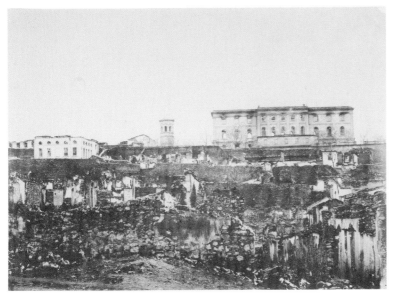

Fig. 57: Henri Durand-Brager and Lassimone, *Scenes of devastation in the Crimea*, 1855, salted paper print, 24.0 × 32.8 cm. Wilson Centre for Photography

Fig. 58: Léon Eugéne Méhédin, *Sebastopol and environs*, 1855, albumen print, 24.0 × 31.5 cm. Wilson Centre for Photography

Fig. 59: Léon Eugéne Méhédin and Jean-Charles Langlois, *Stables of the Chief of Defence*, 1855, salted paper print, 24.0 × 31.5 cm. Wilson Centre for Photography

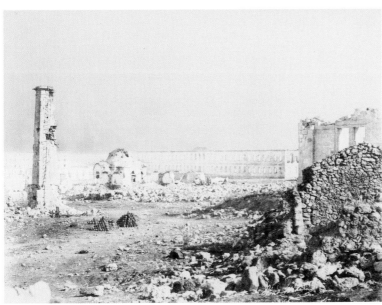

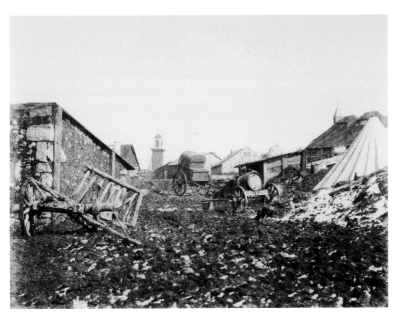

Fig. 60: Roger Fenton (1819–69), *Loch Nagar from Craig Gowan*, 1856, salted paper print, 23.5 × 27.9 cm. RCIN 2160039

FENTON AFTER THE WAR

After the war, Fenton continued his association with the Royal Family, travelling to Scotland in September 1856 where he photographed the royal children and made some landscape and topographical views of the scenery around the Balmoral estate.[68] Whether by design or not, several of the Scottish landscapes echo the simplicity and emptiness found in his earlier views of Sebastopol (**fig. 60**). Fenton was to have no further direct contact with the Royal Family after this date, but they continued to acquire examples of his work. The one notable exception in the royal family's patronage is their failure to acquire work from Fenton's 'Orientalist Suite' of 1858, despite Prince Albert's evident interest in very similar works by William Grundy from 1857, for example.[69] This series was not widely available, although examples were exhibited in public at the end of 1858. The work draws on numerous strands of experience, including Fenton's close association with artists and the art world, the use of his photographs as source material by painters, and his familiarity with 'the exotic', which is evident from his Crimean series. The portraits were made in Fenton's London studio, with friends and models acting various scenes to represent life in the East (**fig. 61**).

Fenton continued to photograph until 1860 but after this date little new work emerged, although he was exhibiting until May 1862. In a move that appears sudden and unexpected, Fenton sold his photographic equipment and negatives in London on 11 November 1862. Shortly afterwards, he formally returned to practice law as a barrister. He continued to work as a lawyer until his death on 9 August 1869, at home in Potter's Bar, Hertfordshire.

Fig. 61: Roger Fenton (1819–69), *Interior of the Hareem*, 1858, albumen print, 25.5 × 24.5 cm. Royal Engineers Museum, Chatham

Seven examples from the Orientalist Suite can be found in an album in the Royal Engineers Museum; much of the content of the album is devoted to the Crimean War.

PLATES

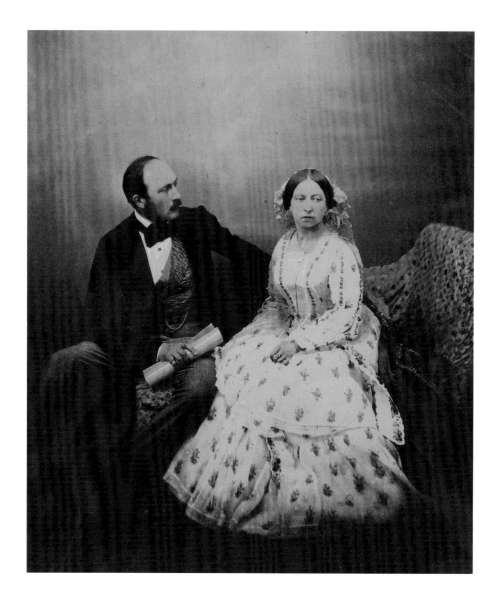

1. Roger Fenton (1819–69), *Queen Victoria and Prince Albert*,
1854, albumen print with watercolour, 27.6 × 18.1 cm. RCIN 923496

Queen Victoria was the Sovereign at the time of the Crimean War. She represented Britain in a triple alliance with France under Napoleon III and the Ottoman Empire under Abdülmecid I. In April 1855, the French Emperor made an important visit to Britain with the Empress Eugenie which publicly demonstrated the allies' commitment to one another and overturned decades of mistrust between the two countries. The Queen and Prince Albert made a return visit to Paris in August 1855. The first Ottoman Emperor to visit Britain and France was Abdulaziz, son of Abdülmecid I, who made the journey in 1867.

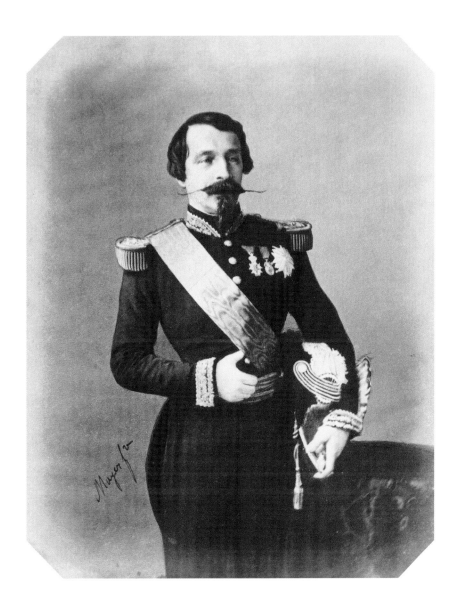

2. Mayer Frères (*fl.*1850s–70), *Napoleon III* (1808–73),
1854, albumen print, 18.7 × 14.5 cm. RCIN 2906588

Britain and France backed the Ottoman Empire in the war against Russia. Britain
declared war on 27 March 1854. France followed the next day.

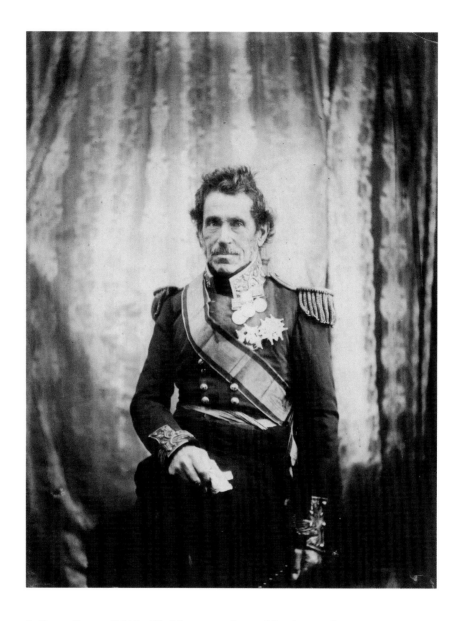

3. Roger Fenton (1819–69), *Lieutenant General Sir George de Lacy Evans*
(1787–1870), 1855, salted paper print, 19.6 × 15.1 cm. RCIN 2506570

De Lacy Evans was a prominent army officer before the Crimean War, and had also served
as a Member of Parliament for Westminster. He championed various reform causes,
particularly those of the army, at a time when such moves to reform were unpopular with
many, including the royal family. During the Crimean War, Evans was given command of the
2nd Division. He fought with distinction before being badly wounded at the Battle of Alma,
although he continued to serve until the Battle of Inkerman, after which he returned home
where he was hailed a national hero. As he returned to Britain before Fenton arrived in the
Crimea, this photographic portrait is one of the small number Fenton had to make in London.

4. Roger Fenton (1819–69), *Lord Raglan* (1788–1855),
4 June 1855, albumen print, 18.3 × 14.5 cm. RCIN 2500229

Fitzroy James Henry Somerset, 1st Baron Raglan, first joined the army in 1804. From 1811
he served the Duke of Wellington in various capacities. In 1815, at the Battle of Waterloo, he
was severely wounded in the right arm, resulting in its amputation. When war with Russia
seemed probable in early 1854, Raglan was selected to serve as the expedition commander,
even though he had never led troops in the field. He was later to be the focus of much criticism
against the war, particularly from *The Times* and its reporter W.H. Russell. It contributed to
the decline of his health and he died in the Crimea on 28 June 1855.

5. Roger Fenton (1819–69), *Sir Richard England* (1793–1883),
1855, albumen print, 18.7 × 15.1 cm. RCIN 2500237

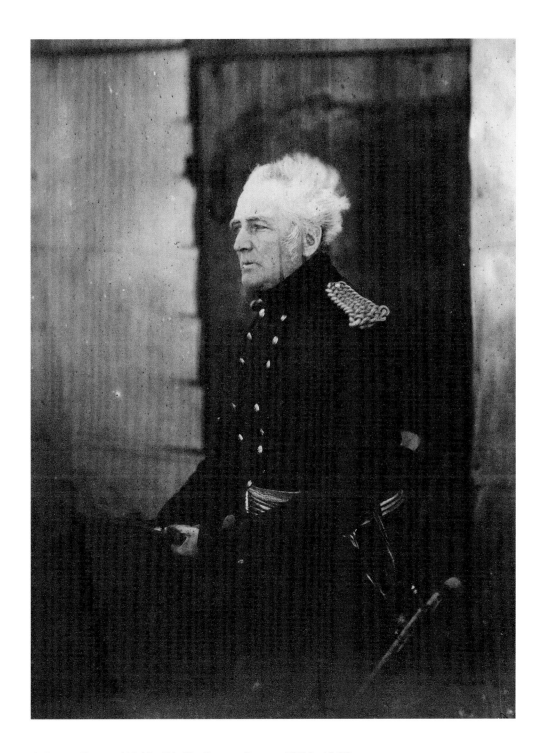

6. Roger Fenton (1819–69), *Sir George Brown* (1790–1865),
1855, albumen print 16.9 × 12.5 cm. RCIN 2500230

Above: 7. Roger Fenton (1819–69), *Sir Colin Campbell* (1792–1863),
1855, salted paper print, 21.2 × 16.3 cm. RCIN 2500548

Right: Fig. 62: Edward Upton (active 1855), after Roger Fenton (1819–69),
Sir Colin Campbell (1792–1863), *c*.1855–60, watercolour on ivory laid on card,
21.6 × 15.4 cm. RCIN 420868

Fenton's portrait of Colin Campbell was copied and adapted for this miniature painting, which was acquired for
the Royal Collection during the reign of Queen Victoria. In the Crimea, Campbell commanded the 2nd Highland
brigade of the 1st Division, reporting to the Duke of Cambridge. The brigade consisted of the 42nd, 79th and
93rd regiments. Following the death of Raglan, Campbell was seen as suitable to take overall command but he
lacked political support in Britain and the position went to Sir James Simpson instead.

8. Roger Fenton (1819–69), *Lieut Gen Sir John Burgoyne and Aide De Camp Lieut Stopford*, 1855, salted paper print, 21.9 × 17.6 cm. RCIN 2500553

Burgoyne had left the Crimea by the time Fenton arrived there in 1855. This portrait was taken in London after mid-July 1855.

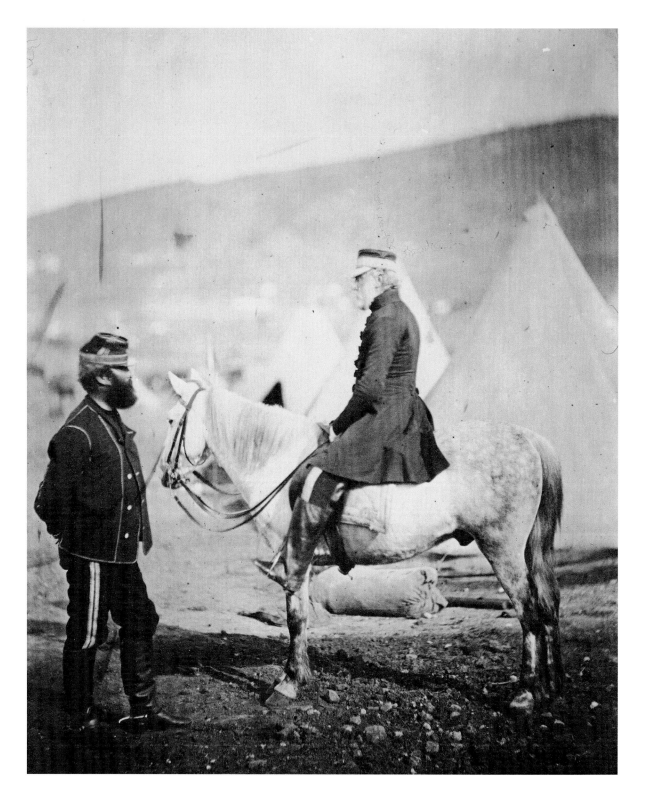

9. Roger Fenton (1819–69), *General Scarlett & Col Lowe – wearing a French jacket – not being on duty*, April 1855, albumen print, 19.5 × 16.0 cm. RCIN 2500250

10. Daniel John Pound (*fl*.1850–60), after John Watkins (1823–74), *Lord Lucan* (1800–88),
c.1856, steel engraving, 39.9 × 27.8 cm (sheet). RCIN 651020

George Charles Bingham, 3rd Earl of Lucan, had been placed in charge of the cavalry division in early 1854 as war approached.
He and his brigade commanders, Lord Cardigan and Sir James Scarlett, had no experience of war; additionally Lucan and Cardigan
hated each other – Lucan was married to Cardigan's sister, Lady Anne and Cardigan was unhappy with the match. Above all, Lucan
remains known today for his role in the miscommunication of the military order that led to the 'Charge of the Light Brigade'.

11. Daniel John Pound (*fl*.1850–60), after John Watkins (1823–74), *James Thomas Brudenell, 7th Earl of
Cardigan* (1797–1868), *c*.1856, steel engraving, 39.9 × 27.8 cm (sheet). RCIN 651516

James Thomas Brudenell, 7th Earl of Cardigan was given command of the Light Cavalry Brigade, reporting to Lord Lucan.
Cardigan led the charge against the Russians in the Battle of Balaklava which became known as the 'Charge of the Light Brigade'.
He returned home at the end of 1854 and was feted as a hero in Britain. He was subsequently involved in legal action against
Raglan's aide-de-camp, Lieutenant Somerset Calthorpe, who claimed Cardigan had retreated after the charge without
rallying survivors.

Neither Lucan nor Cardigan was photographed by Fenton, both having left the Crimea by the time he arrived there. It appears
that neither gave Fenton a sitting in London after his return. Both were photographed by John Watkins after the war, however,
and the photographs were published as engravings.

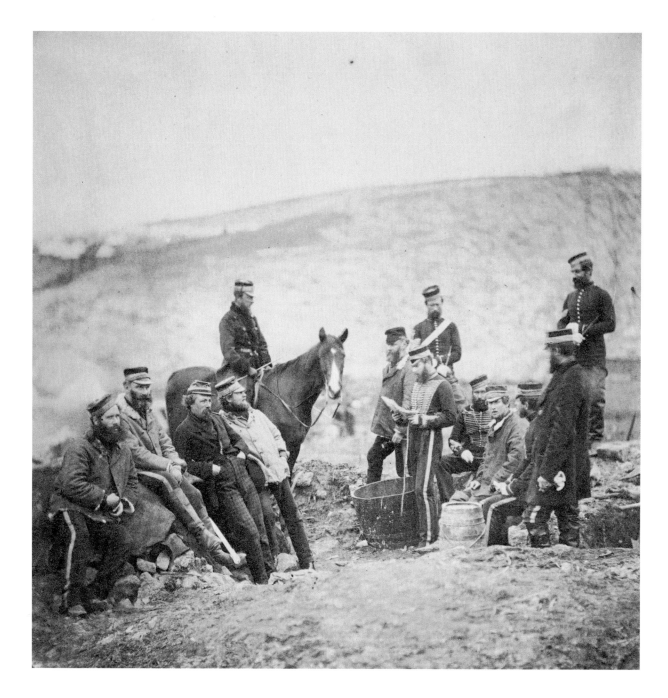

12. Roger Fenton (1819–69), *Officers 8th Hussars*,
April 1855, albumen print, 16.7 × 16.3 cm. RCIN 2500355

The 8th Hussars was one of the light cavalry regiments that had charged during the Battle of Balaklava. Fenton made a number of photographs of the five cavalry regiments involved in this particular action (the others being the 4th Light Dragoons, the 11th Hussars, the 13th Light Dragoons and the 17th Lancers). His potential audience in Britain would already have been familiar with the story of the charge and would know which regiments were involved. Because of the notoriety of the charge, any photograph relating to it would therefore be of great interest and perhaps financially more successful.

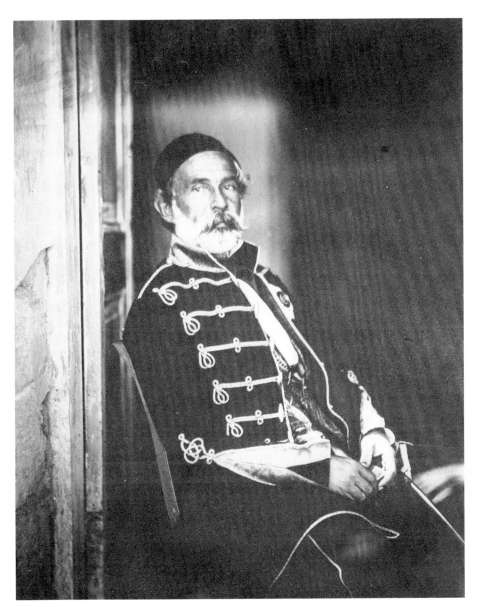

Above: 13. Roger Fenton (1819–69), *Omar Pacha* (1806–71),
1855, salted paper print, 17.6 × 14.2 cm. RCIN 2500341

Right: Fig. 63: After James Robertson (1813–88), 'Omar Pacha: from a photograph by Mr. Robertson',
Illustrated London News, 16 December 1854, p. 597. RCIN 1041768

Omar Pacha was born to Serbian Christian parents and named Mihailo Latas. He subsequently converted to Islam and joined the
Ottoman army. He was the commander of the Ottoman army in the Balkan region at the time of the Russian incursions there, and
led the Ottomans in the first skirmishes of the war. He later won a significant victory against the Russians at the Battle of Evpatoria
on 17 February 1855. Fenton's portraits of Omar Pacha are amongst his best-known Crimean photographs. James Robertson,
however, made an earlier photographic portrait of the general, which was published as an engraving in the *Illustrated London News*.

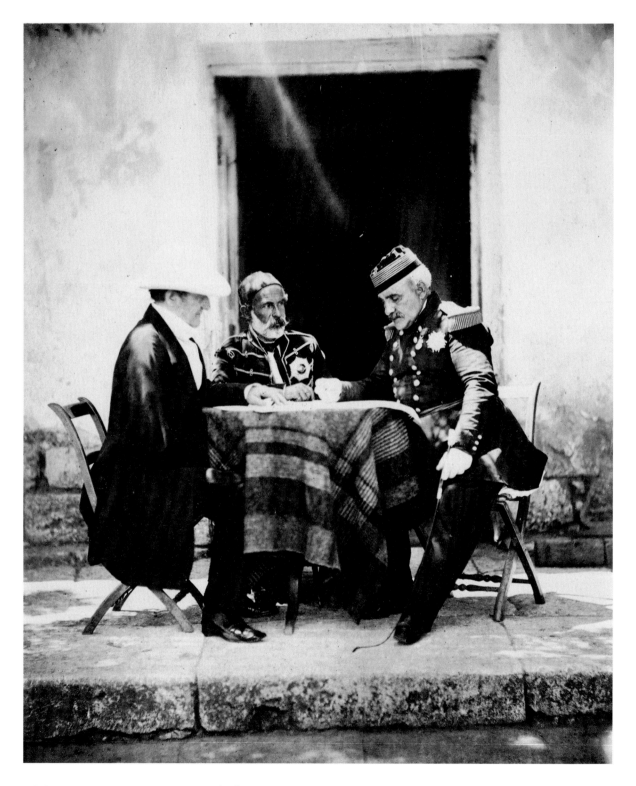

14. Roger Fenton (1819–69), *Council of War*,
June 1855, albumen print, 19.1 × 15.8 cm. RCIN 2500527

 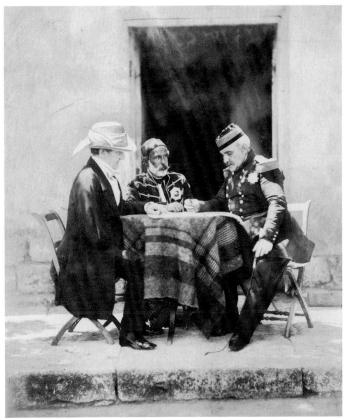

Above: 15. Samuel Bellin (1799–1894), after Augustus Egg (1816–63),
after Roger Fenton (1819–69), *Council of War*, 1857, mixed media mezzotint,
74.7 × 60.3 cm (plate); 76.2 × 62.1 cm (sheet). RCIN 661975

Right: 16. Roger Fenton (1819–69), *Council of War*,
June 1855, salted paper print, 18.3 × 15.5 cm. RCIN 2506595

The three allied generals, Raglan, Omar Pacha, and Pélissier, are shown planning the attack on the Mamelon (the newly constructed Russian defence for the Malakhov Bastion). The successful attack took place on 7 June 1855, which is the date usually given to this photograph, but it was more likely to have been taken later. It became one of the most popular of Fenton's photographs as it represented the triple alliance. After the photograph had been exhibited in 1855 in London, the artist Augustus Egg was commissioned to produce a painting based on the photograph. Egg made Pélissier appear more animated, depicting him standing and also added figures in the background. The tablecloth has also been removed. The painting was subsequently reproduced as a mezzotint in 1857 by Samuel Bellin.

Fenton's photograph lacked detail in its initial printing, so the image has been altered by painting the extra details onto the negative. The differences are clear when Raglan's hat and Pélissier's right hand are compared in plates 14 and 16.

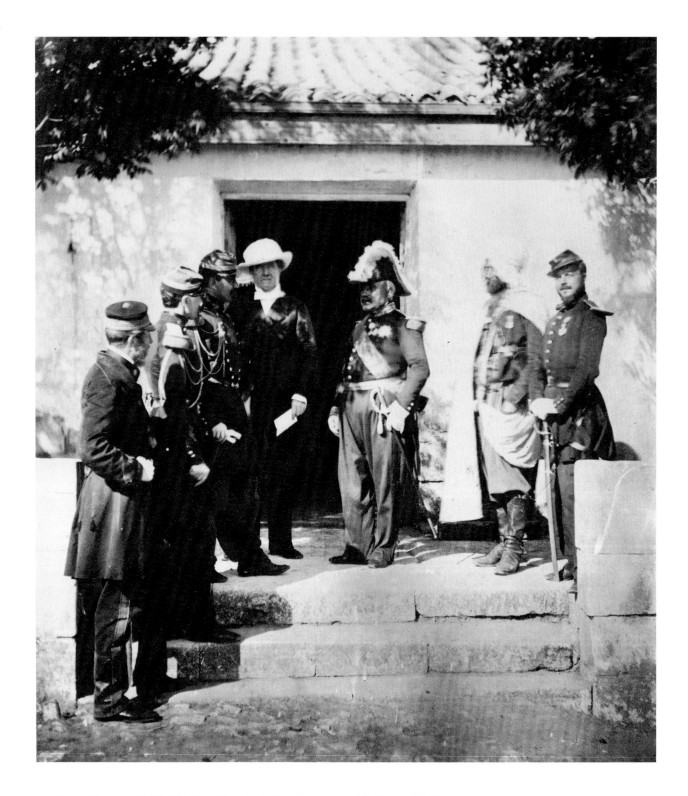

17. Roger Fenton (1819–69), *Lord Raglan's Headquarters with General Pelissier*,
1855, albumen print, 18.8 × 16.5 cm. RCIN 2500447

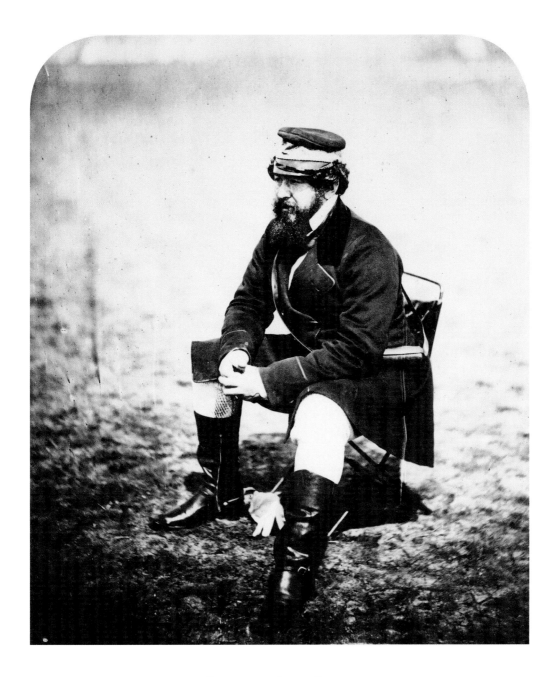

18. Roger Fenton (1819–69), *William Howard Russell* (1820–1907),
June 1855, albumen print, 18.1 × 15.3 cm. RCIN 2500306

William Howard Russell began working for *The Times* in 1841. He was sent to cover the Russian
war in February 1854, and he was to remain with the British troops for the next two years. His
reports of the conflict, as well as of the logistical problems faced by the army particularly during
the harsh 1854–5 winter, were dramatic and compelling. His words were powerful enough to contribute
to the fall of the government in January 1855 and to galvanise Florence Nightingale and her nurses.
His reporting also inspired Tennyson's famous poem, 'The Charge of the Light Brigade' (1854).

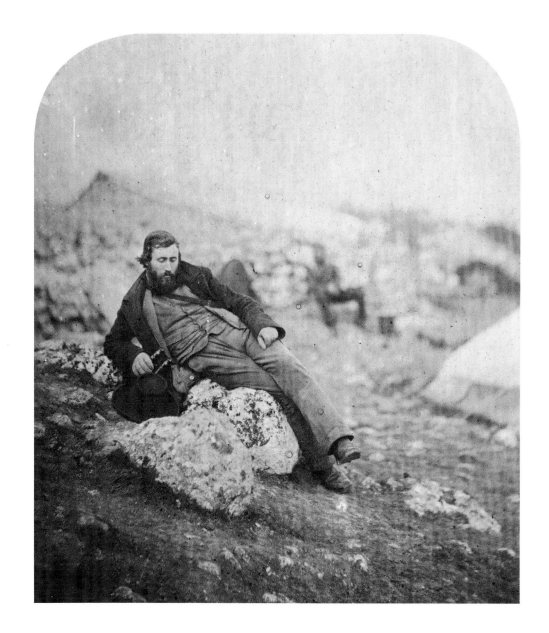

19. Roger Fenton (1819–69), *William Simpson* (1823–99),
1855, salted paper print, 14.2 × 12.4 cm. RCIN 2500301

William Simpson was working in London for the lithographers Day and Son when he was sent to the
Crimea by the art dealers and publishers Colnaghi and Son. He sketched many battles and skirmishes, as
well as documenting army life. His sketches were subsequently worked up into watercolours which were
then published in sets as lithographs, eventually comprising two volumes titled *The Seat of War in the East*
(1855–6). Simpson's work was exhibited at the French Exhibition Gallery, 121 Pall Mall in March 1856,
alongside work by Carlo Bossoli and Edward Armitage. Fenton's photographs were on display at
53 Pall Mall at the same time.

20. Roger Fenton (1819–69), *Prince George, Duke of Cambridge* (1819–1904), 1855–6, salted paper print, 23.1 × 18.2 cm. RCIN 604992

Prince George, 2nd Duke of Cambridge was a grandson of George III. Having served in the military from a young age, he was keen to join the forces in the Russian war. He was given command of the 1st Division, reporting to Lord Raglan. He was closely involved in fighting in the Battles of Alma and Inkerman, but exhausted, he left the Crimea on 25 November 1854 before being invalided home to Britain. He attempted to return to the war, but his proposal was rejected by the secretary of state for war. He was photographed by Fenton in London. Agnew's published this portrait on 12 May 1856, making it one of the last of Fenton's Crimean portraits to appear.

21. Roger Fenton (1819–69), *Colonel Adye* (1819–1900),
April 1855, albumen print, 20.7 × 15.4 cm. RCIN 2500256

Brevet Lieutenant-Colonel John Miller Adye of the Royal Artillery served as the Assistant Adjutant General in the Ordnance Department. He was present at all the major encounters of the war including the Siege of Sevastopol. He was an excellent amateur watercolourist; a number of his works were acquired for the Royal Collection during the reign of Queen Victoria.

22. Roger Fenton (1819–69), *General Pierre Bosquet* (1810–61),
1855, albumen print, 17.2 × 11.2 cm. RCIN 2506590

General Pierre Bosquet was a highly successful divisional commander in the French army
throughout the Crimean campaign. His skill and experience made him a popular figure with
the troops. He also had a poetic turn of phrase, the most famous of which, in response to the
Charge of the Light Brigade, was 'C'est magnifique, mais ce n'est pas la guerre; c'est de la folie'
('It's magnificent, but it's not war; it's madness').

In all of his portraits by Fenton, Bosquet poses with such complete confidence and self-assurance.
He is either gazing directly at the camera or presenting himself as a man of action by giving
orders to his subordinates. Unlike some of the other senior commanders who are happy to
present themselves reclining in a deck chair like General Estcourt (see plate 43), Bosquet
appears to be highly aware of the potential impact a formal photographic portrait could have.

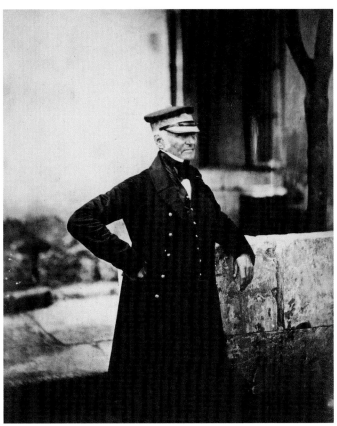

23. Roger Fenton (1819–69),
Mr Angell Postmaster, 1855,
albumen print, 18.8 × 16.0 cm. RCIN 2500304

24. Roger Fenton (1819–69),
General Simpson (1792–1868), 1855,
salted paper print, 18.5 × 15.1 cm. RCIN 2500231

Lieutenant-General James Simpson succeeded Lord Raglan as
Commander-in-Chief in the Crimea, following the latter's death
on 28 June 1855. He remained in charge until 10 November
when he handed over command to Major General William
Codrington.

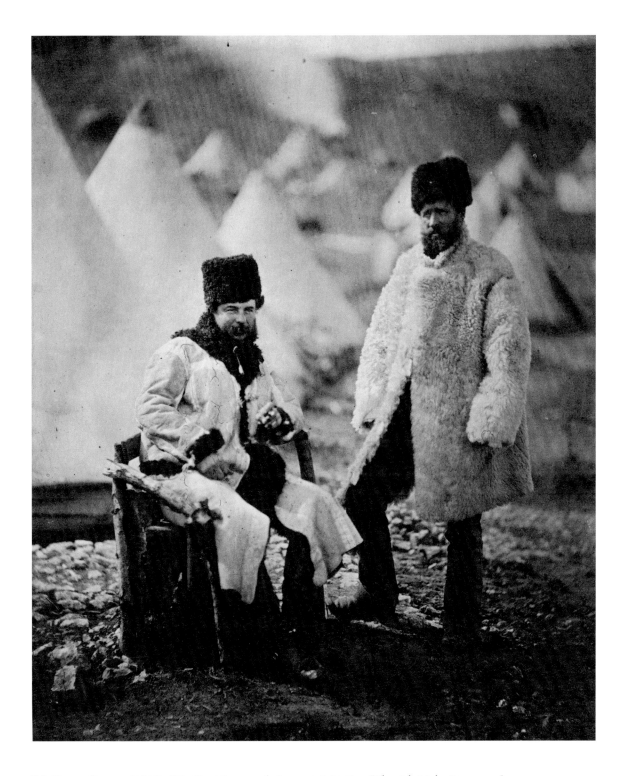

25. Roger Fenton (1819–69), *Capt Brown & Servant 4 Lt Drg* [The 4th Light Dragoons],
1855, albumen print, 19.3 × 16.0 cm. RCIN 2500537

The men are wearing their 'winter dress'.

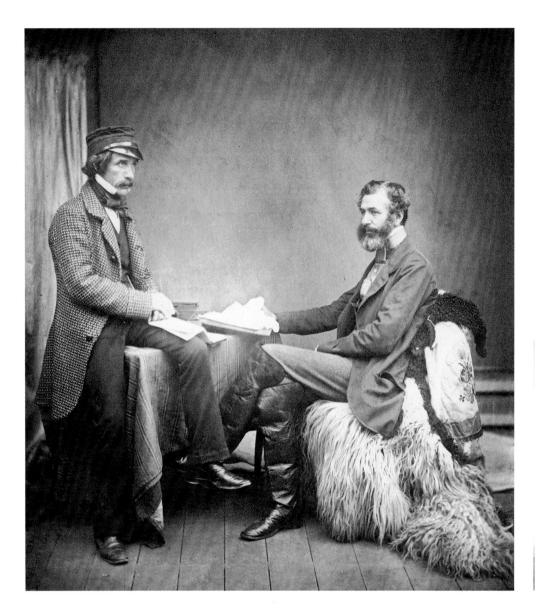

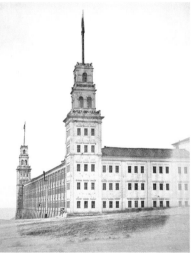

Above: 26. Roger Fenton (1819–69), *The Sanitary Commission*,
[Dr John Sutherland (1808–91) and Sir Robert Rawlinson (1810–98)],
1855, salted paper print, 17.8 × 16.0 cm. RCIN 2500550

Right: 27. James Robertson (1813–88), *Miss Nightingale's Tower*,
1855–6, salted paper print, 31.7 × 25.0 cm. RCIN 2500663

Robertson photographed the north-west corner of the Selimiye Barracks in Scutari
where Florence Nightingale had her private rooms.

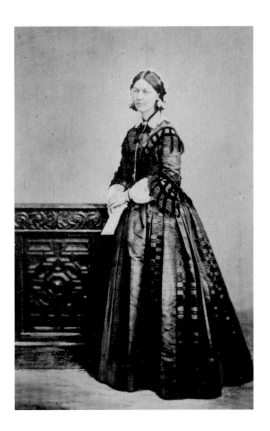

28. William Edward Kilburn (1818–91),
Florence Nightingale (1820–1910), *c*.1856,
albumen print, 10.1 × 6.5 cm. RCIN 2853480

Florence Nightingale arrived in Scutari (opposite
Constantinople) on 4 November 1854, where she
attempted, with her nurses, to improve the medical
care offered to the troops in four hospitals. She enlisted
the support of her contacts in London and gradually
conditions began to improve, significantly so after the
input of the Sanitary Commission in March 1855.
In May 1855, Nightingale made the first of three visits
to the Crimea to investigate the hospitals. While there,
she fell drastically ill with a condition that affected her
for the rest of her life. She returned to Britain in July
1856 where she continued to work unrelentingly for
reforms in army medical care. A Royal Commission
was established in April 1857 which was to put various
changes into effect. Nightingale privately printed and
circulated her evidence for the reforms in *Notes on
matters affecting the health, efficiency, and hospital
administration of the British Army* (1858). Nightingale
sent a copy to Queen Victoria, which remains in the
Royal Library at Windsor Castle (RCIN 1075240).

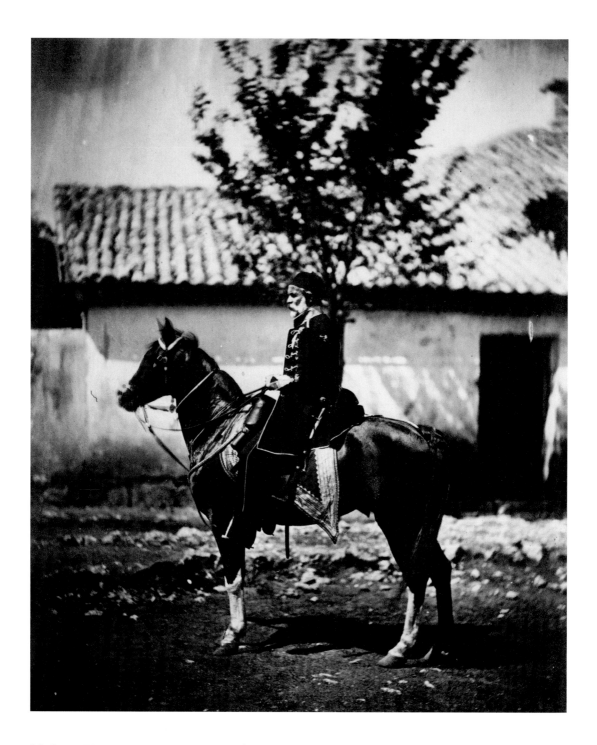

29. Roger Fenton (1819–69), *Omar Pacha* (1806–71),
1855, albumen print, 18.5 × 15.2 cm. RCIN 2500342

These two profile portraits, showing the generals on horseback, would have been made with the commission
for Thomas Barker's history painting in mind (fig. 36). Several similar poses appear in the finished work.

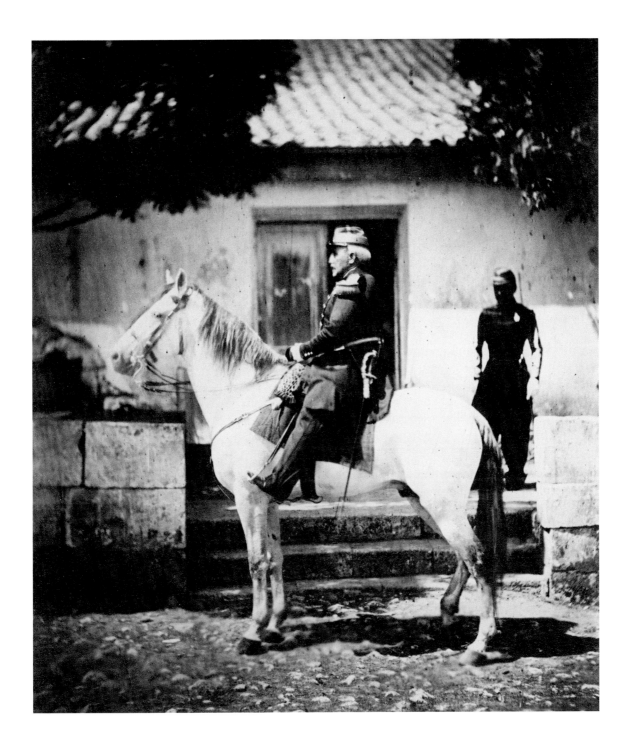

30. Roger Fenton (1819–69), *Genl Pelissier* (1794–1864),
June 1855, albumen print, 17.9 × 15.5 cm. RCIN 2500327

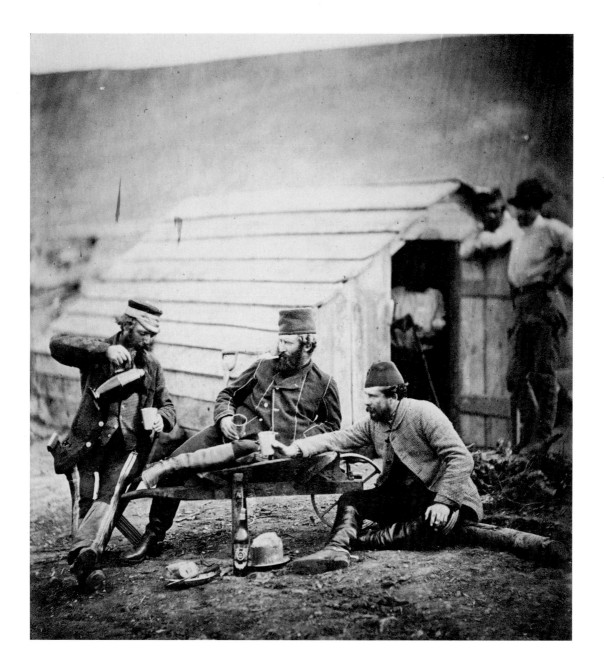

31. Roger Fenton (1819–69), *Hardships in the Crimea* [From left to right: Captain John George Brown, Brevet Lieutenant-Colonel Alexander Low, and Captain George Thorne George, all of the 4th Dragoons], 1855, albumen print, 17.6 × 16.2 cm. RCIN 2500388

These photographs (plates 31 and 32) are often used to support the argument that Fenton's brief in the Crimea was to present an alternative narrative about the war, one that refuted the reports of hardship, disorganisation and appalling care provided to the troops. The portrait of Hallewell (plate 32) is sometimes found with the title, *His day's work done* or *His day's work over*. There may be some irony involved in the titles allocated by Fenton, who knew well the truth of the situation for most of the men during the war. Whilst senior officers did have access to far superior living conditions and food, everyone endured the brutality of the conflict and experienced injury, disease and death.

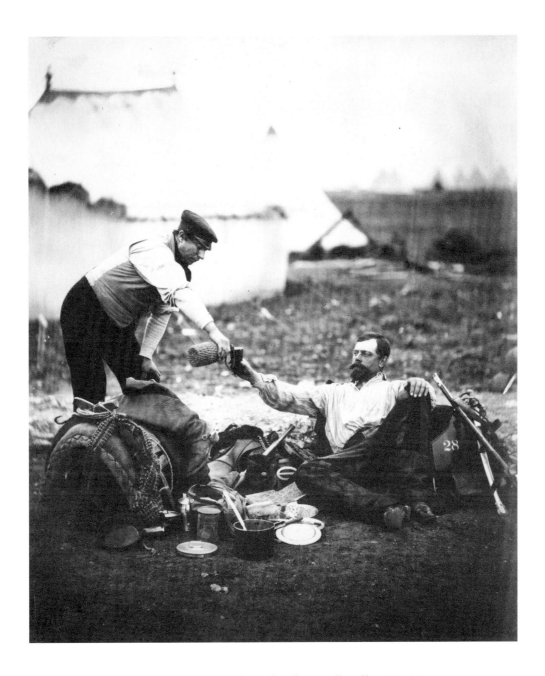

32. Roger Fenton (1819–69), *Major Edmund Gilling Hallewell* (1822–69),
1855, salted paper print, 19.4 × 16.3 cm. RCIN 2500376

Hallewell was a distant relation of Grace Maynard, Fenton's wife. The families shared ancestry going
back to the early eighteenth century. Hallewell served as Deputy-Assistant Quartermaster General to
the Light Division, under Sir George Brown. Hallewell is occasionally confused with Edmund Gilling
Maynard (1821–96) of the 88th regiment who was Grace's brother, and also serving in the Crimea.
Both are mentioned in Fenton's letters.

33. Roger Fenton (1819–69), *Sebastopol from front of the Mortar Battery*,
April 1855, salted paper print, 18.2 × 34.7 cm. RCIN 2500512

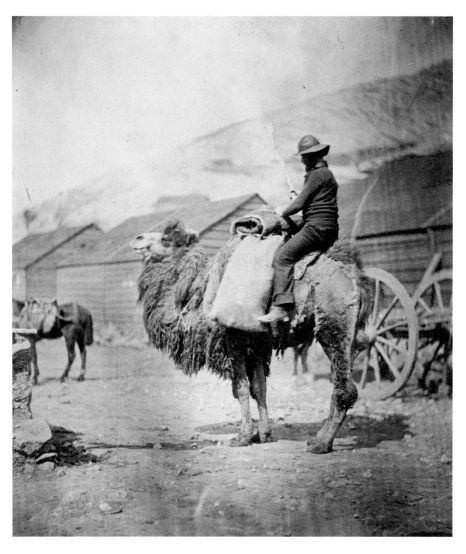

34. Roger Fenton (1819–69), *Dromedary*,
1855, albumen print, 18.2 × 15.9 cm. RCIN 2500419

35. Roger Fenton (1819–69), *Group 4th Draggon [sic] Guards*,
1855, albumen print, 16.1 × 16.4 cm. RCIN 2500368

The group of men from the 4th Light Dragoons are shown attended
by one of the British sutlers.

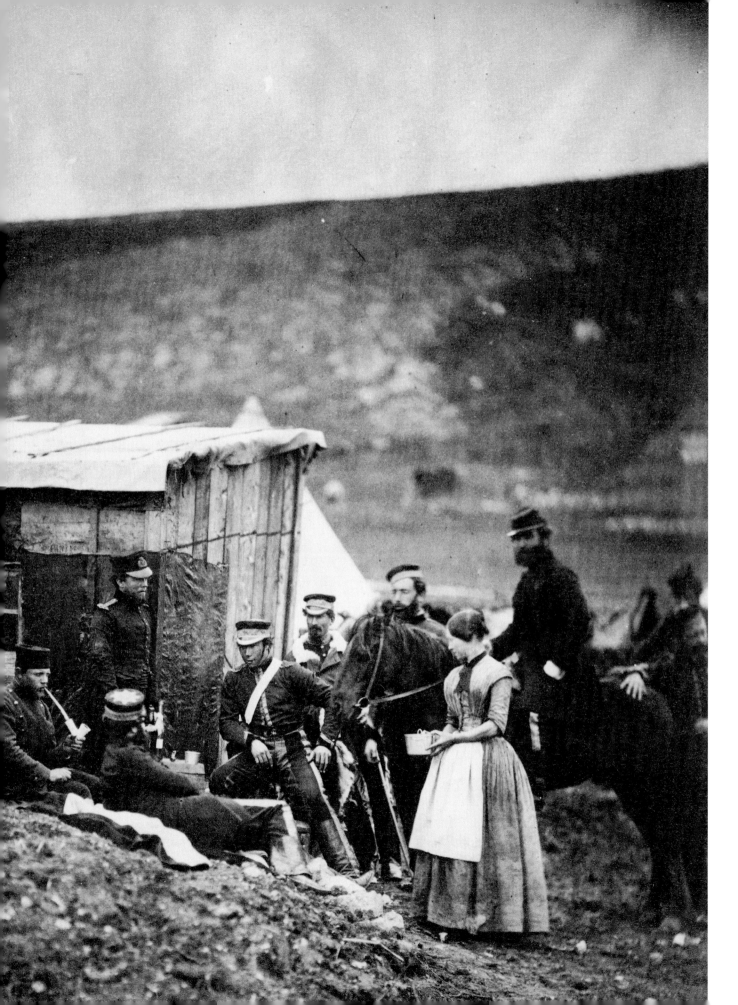

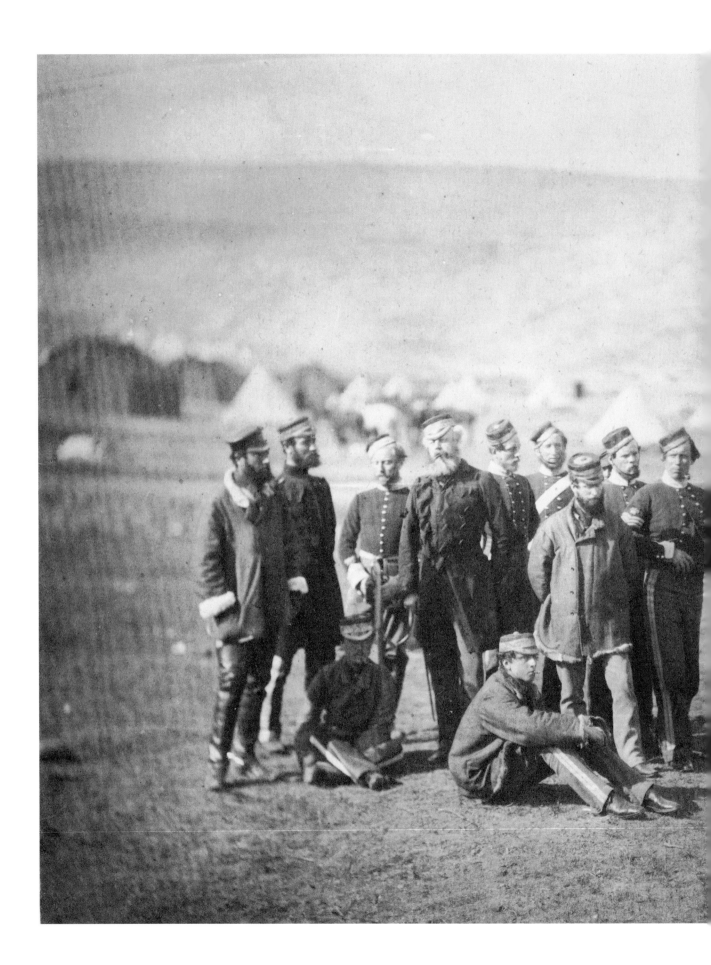

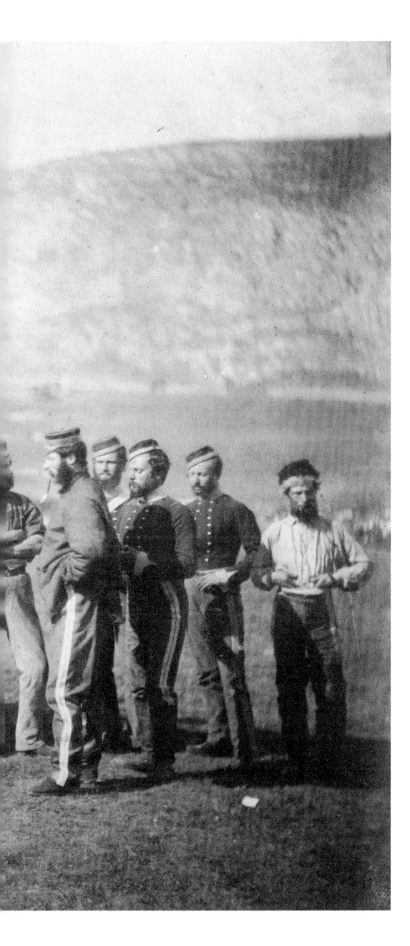

36. Roger Fenton (1819–69),
Col Doherty, Officers and men – 13th,
1855, salted paper print, 14.6 × 19.0 cm.
RCIN 2500354

The '13th' refers to the 13th Light Dragoons, one
of the Light Cavalry regiments that participated in
the infamous charge on 25 October 1854.

37. Roger Fenton (1819–69),
*View from Cathcarts Hill man
in white coat in front*, 1855,
albumen print, 24.1 × 33.7 cm.
RCIN 2500534

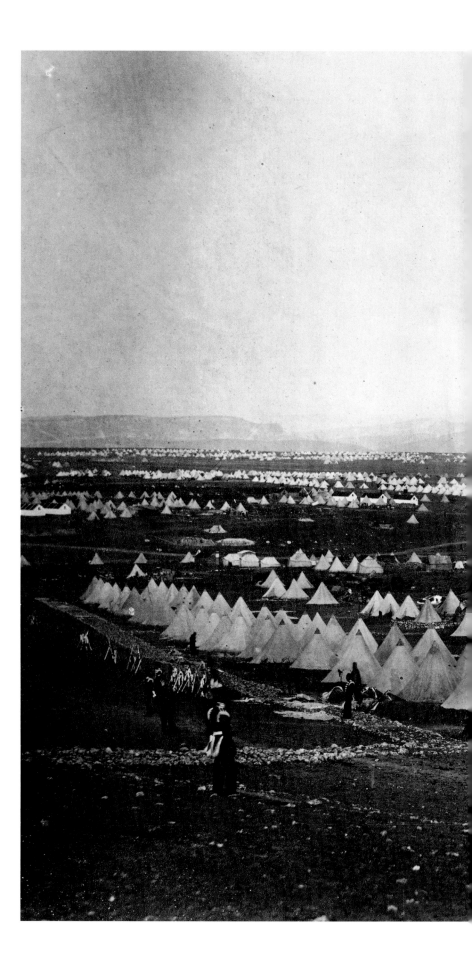

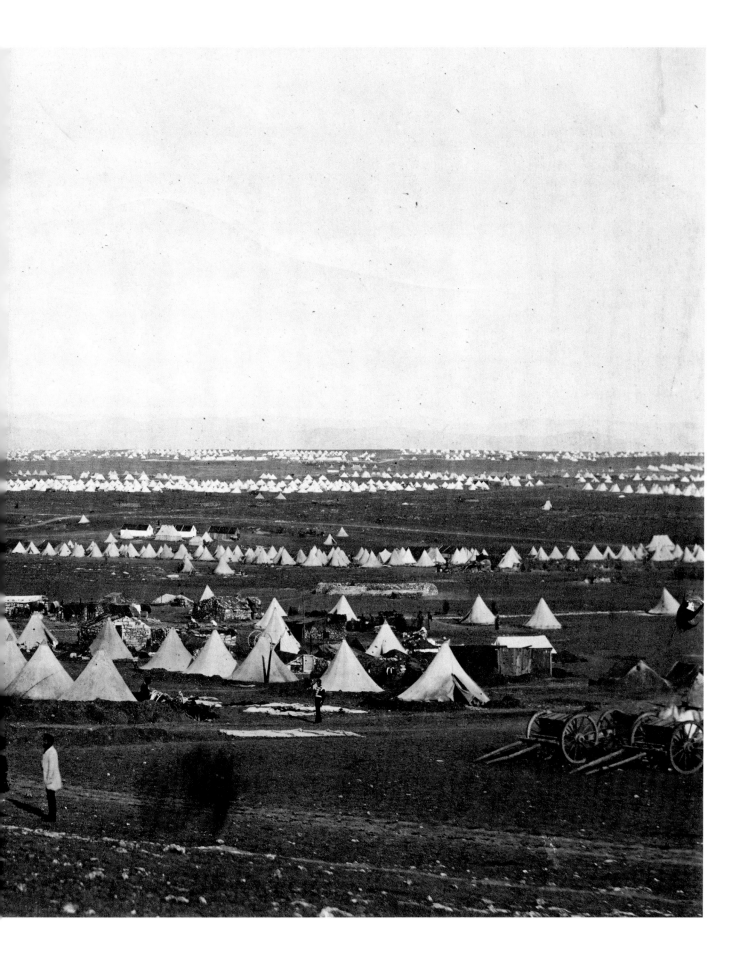

38. Roger Fenton (1819–69), *Looking towards Balaklava artillery waggons in the foreground*, 1855, salted paper print, 25.1 × 34.3 cm. RCIN 2500565

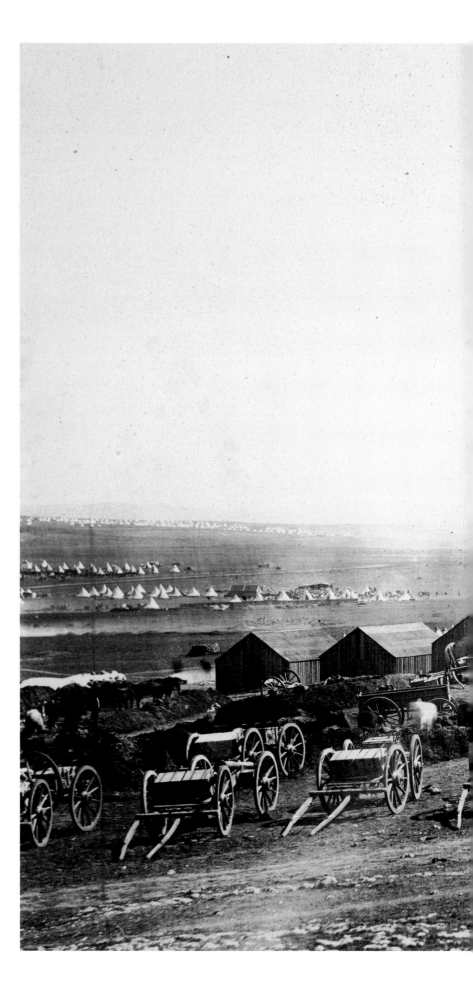

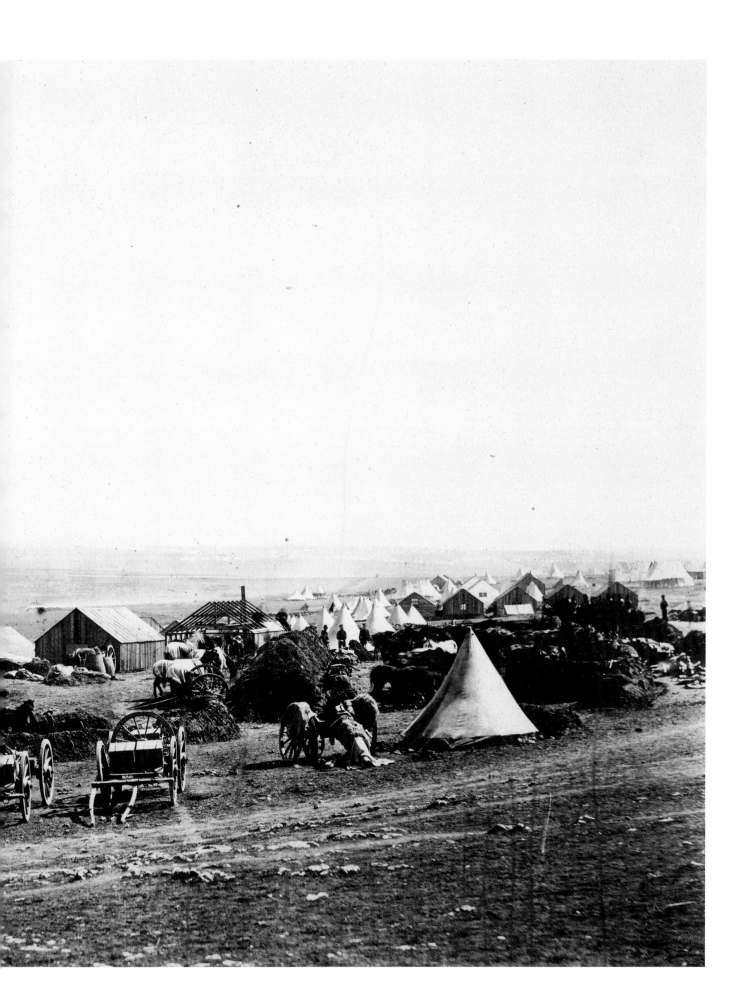

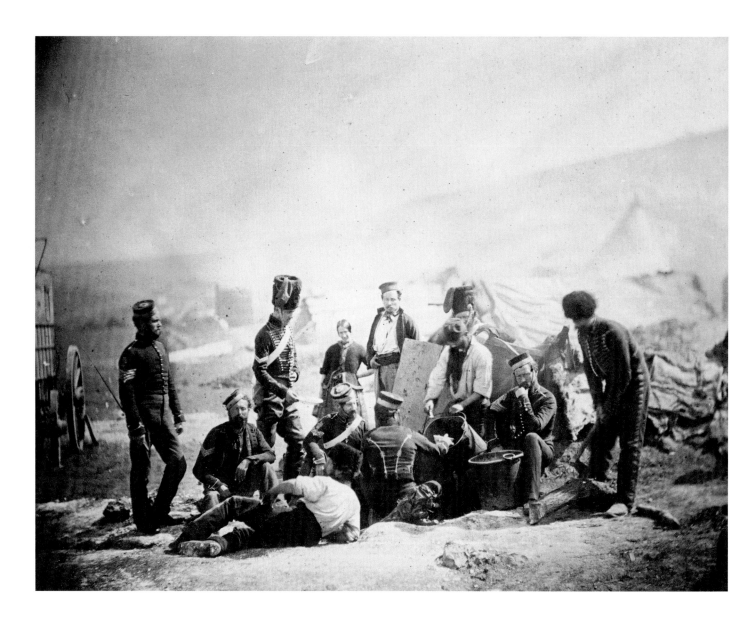

39. Roger Fenton (1819–69), *8th Hussars Cooking Hut*,
1855, albumen print, 15.3 × 19.6 cm. RCIN 2500384

This beautifully posed group was incorporated almost entirely into Barker's
painting, although the woman standing behind the group was not included.

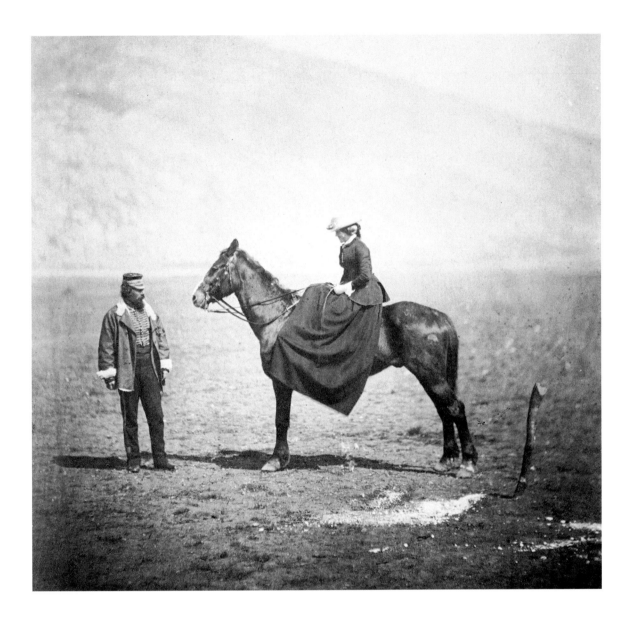

40. Roger Fenton (1819–69), *Mr and Mrs Duberly*,
April 1855, albumen print, 15.2 × 16.0 cm. RCIN 2500314

Frances Isabella Duberly (1829–1902), known as Fanny, accompanied her husband Henry Duberly of the 8th Hussars
to the war against the orders of Lord Raglan. She kept a diary of her experience, including witnessing the Battle of Balaklava
and entering Sevastopol shortly after it fell to the allies. She attempted to dedicate the published version of her journal to
Queen Victoria, but this was refused.

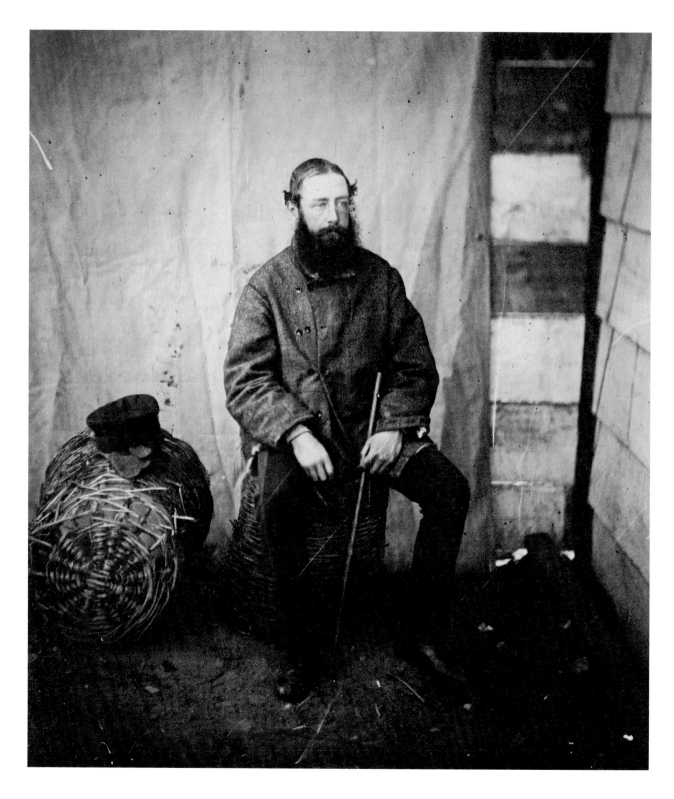

41. Roger Fenton (1819–69), *Captain Wardrop*,
1855, albumen print, 17.5 × 15.3 cm. RCIN 2500315

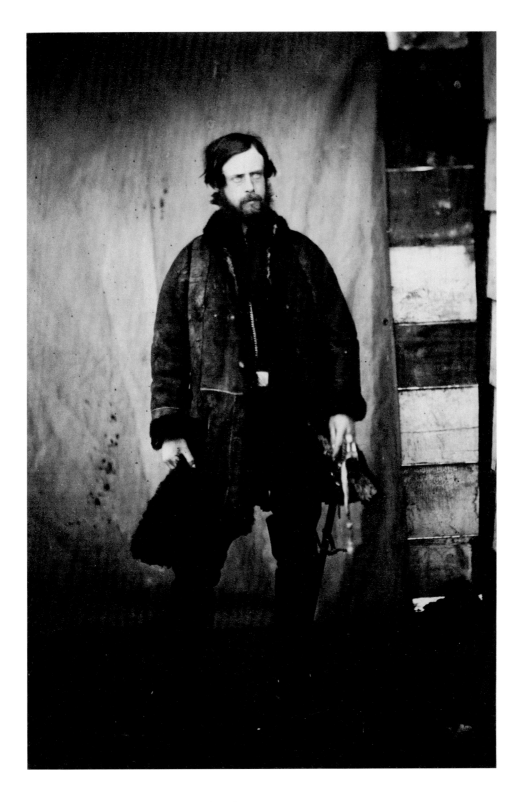

42. Roger Fenton (1819–69), *Lord Balgonie* (1831–57),
1855, albumen print, 17.7 × 11.7 cm. RCIN 2500273

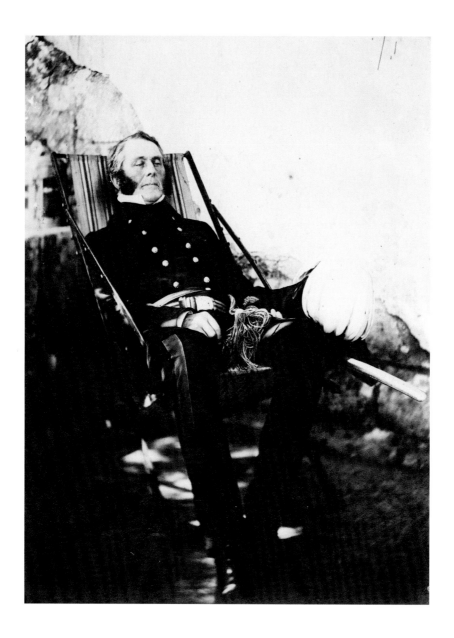

43. Roger Fenton (1819–69), *General Estcourt* (1802–55),
1855, albumen print, 20.5 × 15.2 cm. RCIN 2500239

James Bucknall Estcourt accompanied the Russian expedition as Adjutant-General,
in which post he was responsible for much of the administration that accompanied
the war. Lord Raglan was urged to dismiss him more than once but refused. Estcourt
contracted cholera in the Crimea and died on 24 June 1855. The photograph is
hard to interpret. It can be seen as someone taking a break from military concerns
but it could also be a portrait of illness and exhaustion.

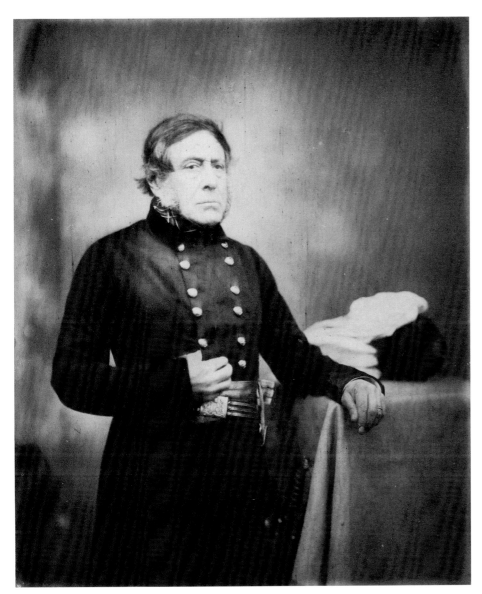

Above: 44. Roger Fenton (1819–69), *Lieutenant General Bentinck* (1796–1878),
18 January 1855, salted paper print, 17.8 × 14.7 cm. RCIN 2506573

Right: Fig. 64: Frederick Cruickshank (1800–68), after Roger Fenton (1819–69),
Major General Bentinck (1796–1878), 1855, watercolour and bodycolour with gum arabic,
18.8 × 15.0 cm. RCIN 913410

Major General Henry Bentinck of the Coldstream Guards was appointed major general of the guards brigade in the 1st Division,
reporting to the Duke of Cambridge. His right arm was severely wounded during the Battle of Inkerman and he returned to England
on 28 November 1855. On 18 January 1855, the artist Cruickshank wrote that Bentinck was sitting to Fenton that same date and
that he, Cruickshank, was to make a drawing from the results. Although the uniform is different, this would appear to be the photograph
and resulting portrait. Bentinck subsequently returned to the Crimea where he was given the local rank of Lieutenant General.

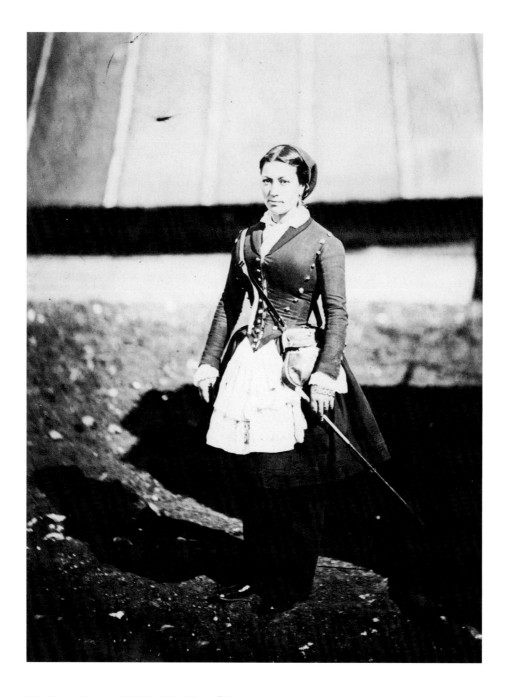

45. Roger Fenton (1819–69), *Vivandière*,
5 May 1855, albumen print, 17.4 × 13.1 cm. RCIN 2500338

The *vivandières* were attached to French regiments to supply the troops with food
and drink beyond the standard rations. The term was frequently used interchangeably
with *cantinière* as the women would run canteens for the soldiers. The women would
often dress in a feminised version of the uniform of the regiment to which they
were attached.

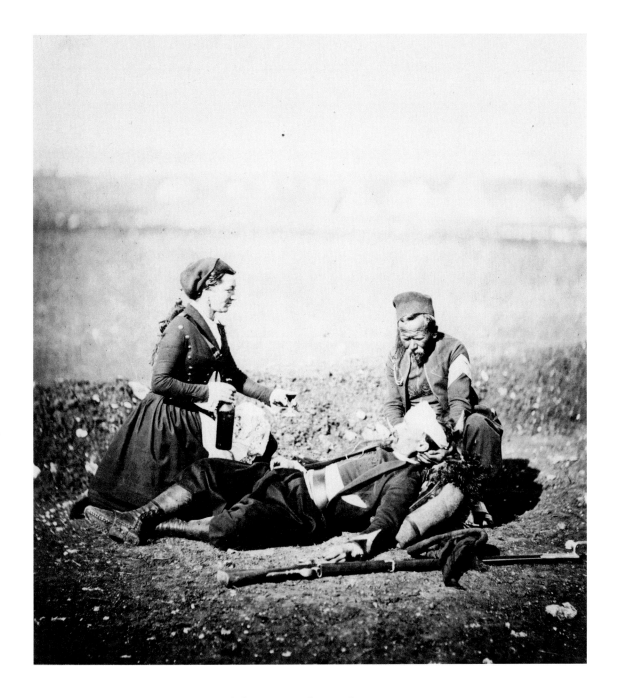

46. Roger Fenton (1819–69), *Wounded Zouave and Vivandière*,
5 May 1855, albumen print, 17.4 × 15.8 cm. RCIN 2500401

This is a very posed composition, which was copied almost exactly into Thomas Barker's
painting *The Allied Generals* (fig. 36).

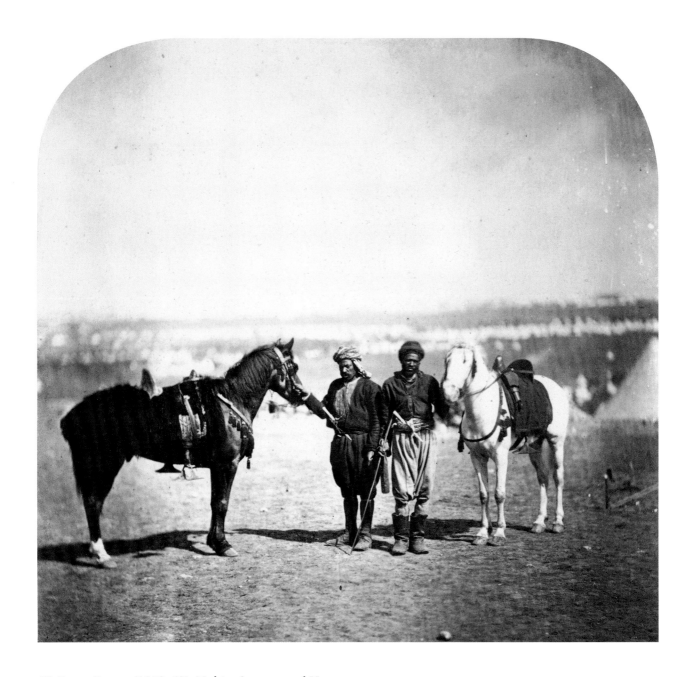

47. Roger Fenton (1819–69), *Nubian Servants and Horses*,
27 April 1855, salted paper print, 14.7 × 15.6 cm. RCIN 2500416

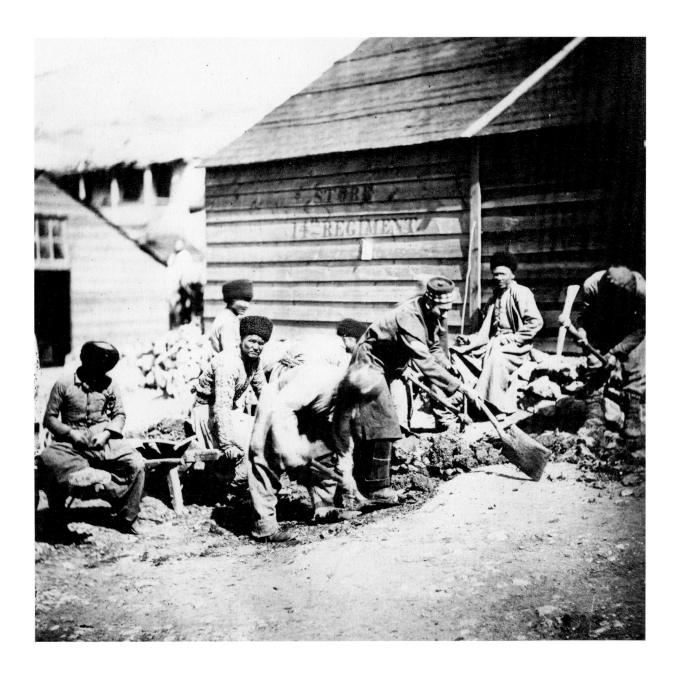

48. Roger Fenton (1819–69), *Tartar labourers*,
1855, albumen print, 16.2 × 16.9 cm. RCIN 2500402

The Tartars, (or Tatars), came to the Crimea in the mid-thirteenth century, in the wake of
the Mongol armies, known as the Golden Horde. In the Crimea the group gradually
incorporated other diverse ethnic peoples, becoming defined by their adoption of Islam
and use of a Turkic language. During the Russian war, thousands of Tartars fled the Crimea
for the Ottoman Empire.

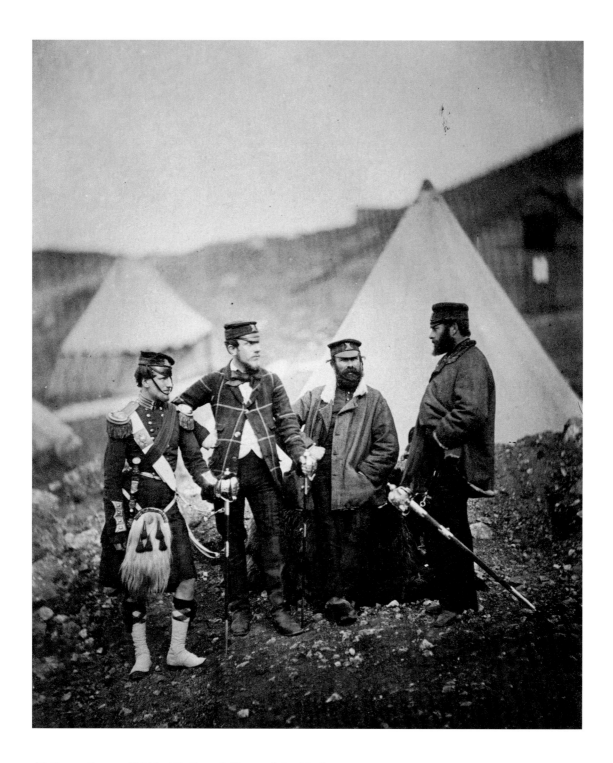

49. Roger Fenton (1819–69), *Four Officers of the 42nd*,
1855, albumen print, 19.3 × 16.0 cm. RCIN 2500387

The 42nd regiment, also known as the Black Watch, formed part of Campbell's
Highland Brigade, notably serving at the Battle of Alma (20 September 1854).

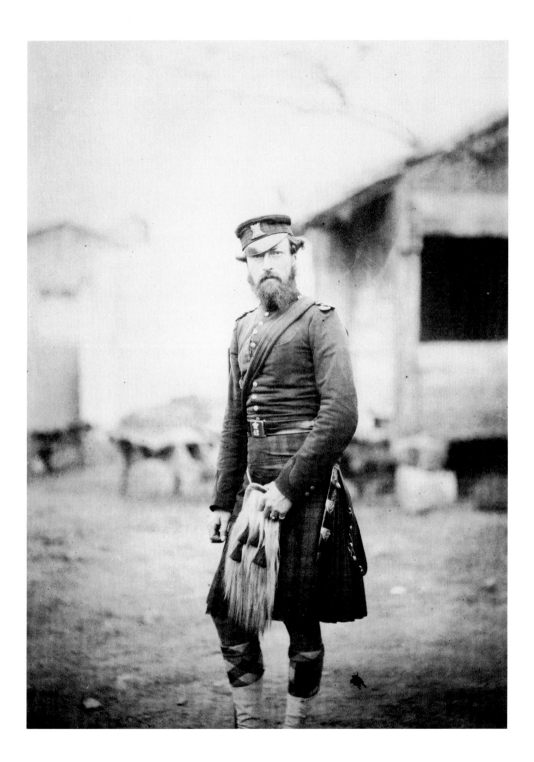

50. Roger Fenton (1819–69), *Col Grant 42nd*,
1855, albumen print, 18.4 × 13.3 cm. RCIN 2500267

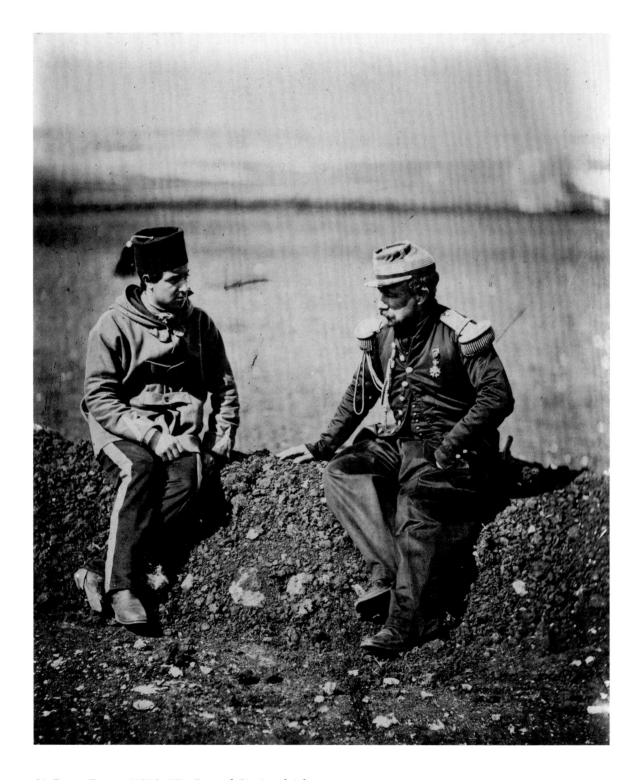

51. Roger Fenton (1819–69), *General Cissé and Adc*,
1855, salted paper print, 17.9 × 14.9 cm. RCIN 2500332

Cissé was aide-de-camp to General Bosquet (plate 22), one of the French divisional commanders.

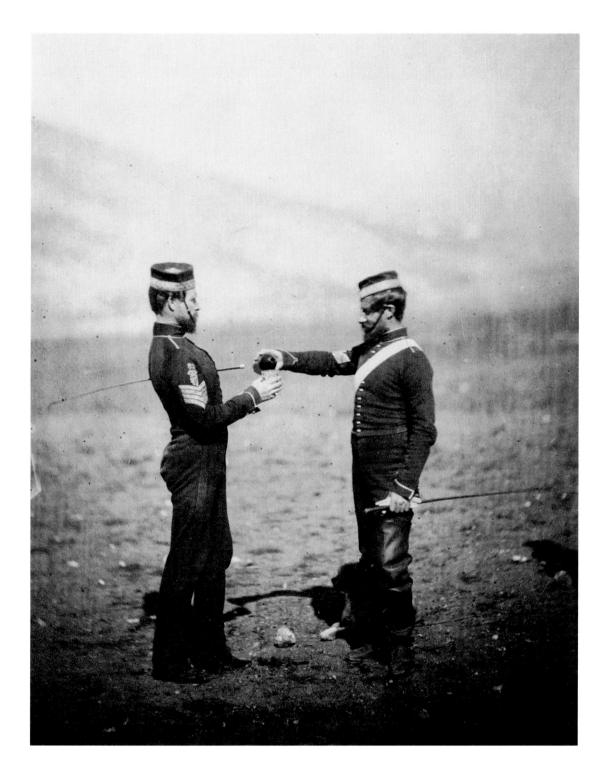

52. Roger Fenton (1819–69), *Sergeants 8th Hussars*,
April 1855, albumen print, 17.4 × 13.8 cm. RCIN 2500385

53. Roger Fenton (1819–69),
*Colonel Brownrigg and the two Russian boys
Alma and Inkermann*, 1855, albumen print,
16.8 × 15.5 cm. RCIN 2500375

In a letter dated 29 April to his wife, Fenton mentioned
two Russian boys:

'Tell Annie there are two Russian boys here who both
would like to come to England which will she have Alma
or Inkermann, such are their new names. One is an orphan
the other has or had his parents in the town. They went
out nutting last autumn and were taken, cried sadly
but now would cry to go back.'

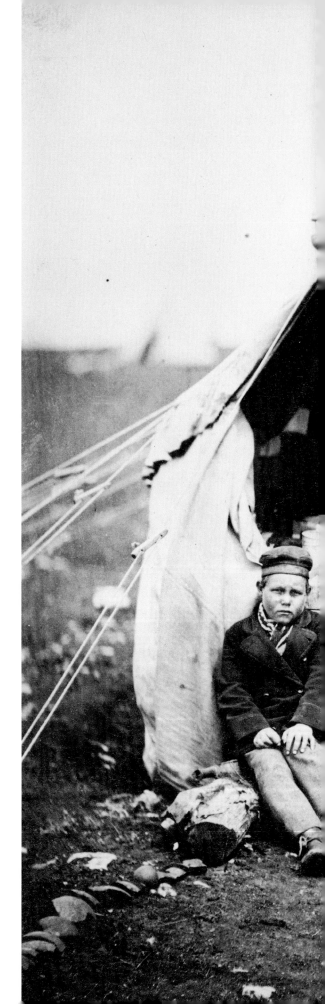

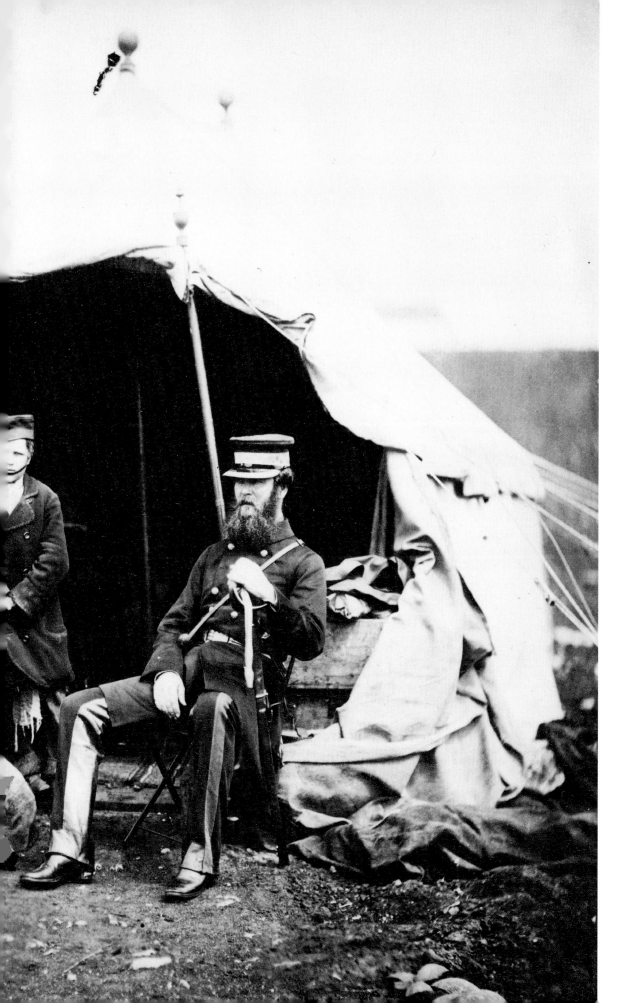

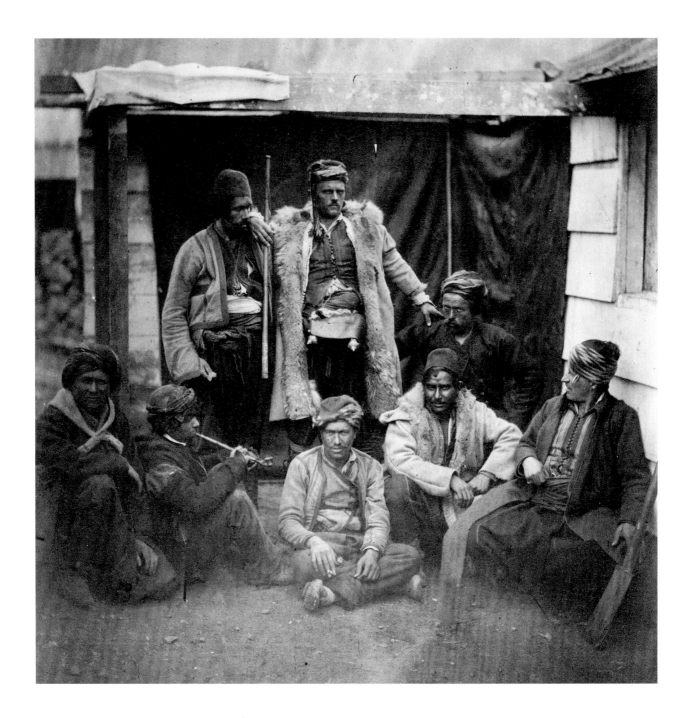

54. Roger Fenton (1819–69), *Group of Croats*,
March 1855, albumen print, 15.7 × 16.8 cm. RCIN 2500422

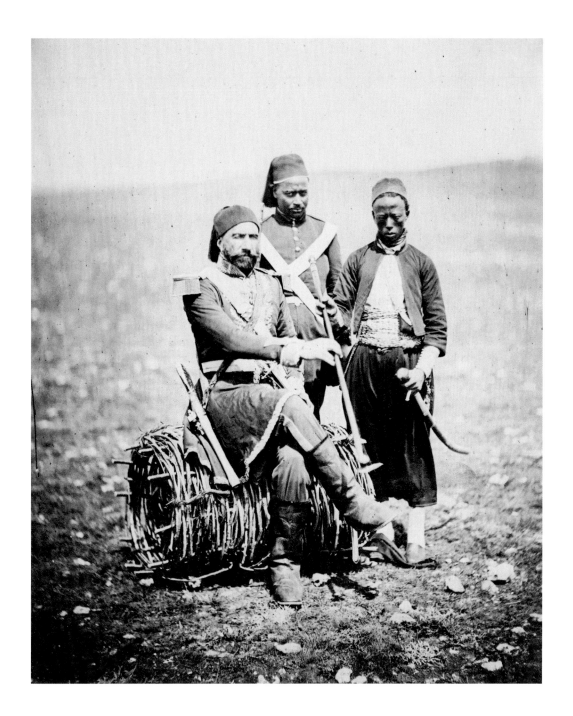

55. Roger Fenton (1819–69), *Ismael Pacha* (1813–65) *his pipe put out*,
27 April 1855, albumen print, 18.0 × 14.7 cm. RCIN 2500429

Ismael Pacha, also known as György Kmety, fought against the Russians in the Hungarian Revolution
of 1848. After its failure and the harsh Russian reprisals, he joined the Ottoman army. Fenton photographed
him with his 'Nubian servant'; they are both depicted in Barker's painting *The Allied Generals*. Kmety retired
from military life in 1861, and died in London a few years later.

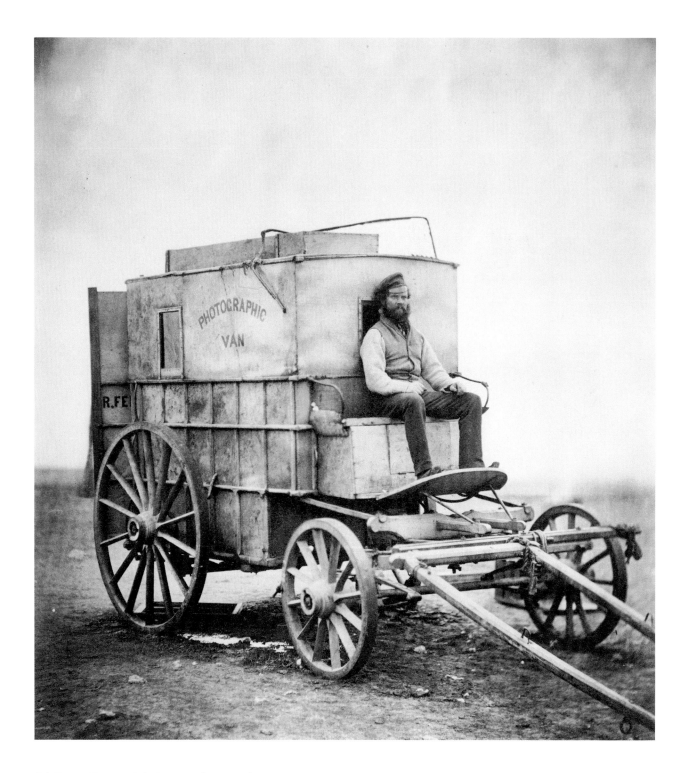

56. Roger Fenton (1819–69), *Photographic Van*,
1855, albumen print, 17.4 × 15.9 cm. RCIN 2500439

Fig. 65: After Roger Fenton (1819–69), 'Mr Fenton's Photographic Van –
From the Crimean Exhibition', *Illustrated London News*, 10 November 1855, p. 557.
RCIN 1041770

Marcus Sparling, one of Fenton's two assistants in the Crimea, is shown seated at the front of Fenton's photographic van. There was also a second assistant, referred to as 'William' in Fenton's letters. The van would have served as a mobile darkroom where glass plates were sensitised prior to exposure and subsequently developed and fixed afterwards. Fenton also would have used the van to sensitise paper for making prints from his negatives. He sent sample prints to his publishers with his letters.

Marcus Sparling published a treatise on photography in 1856, titled *Theory and Practice of the Photographic Art; including its Chemistry and Optics*. The author is incorrectly identified on the title page as 'W. Sparling'.

57. Roger Fenton (1819–69),
Balaklava Ordnance Wharf, March 1855,
albumen print, 20.5 × 25.2 cm. RCIN 2500461

In 1854, Balaklava was a small port which the British
thought to be a suitable place to establish themselves whilst
they besieged the city of Sevastopol. Fenton arrived at
Balaklava by sea on 8 March 1855. He began photographing
a week later on 15 March, and for the next two weeks
made a number of views in the town before heading out to
the military camps nearby.

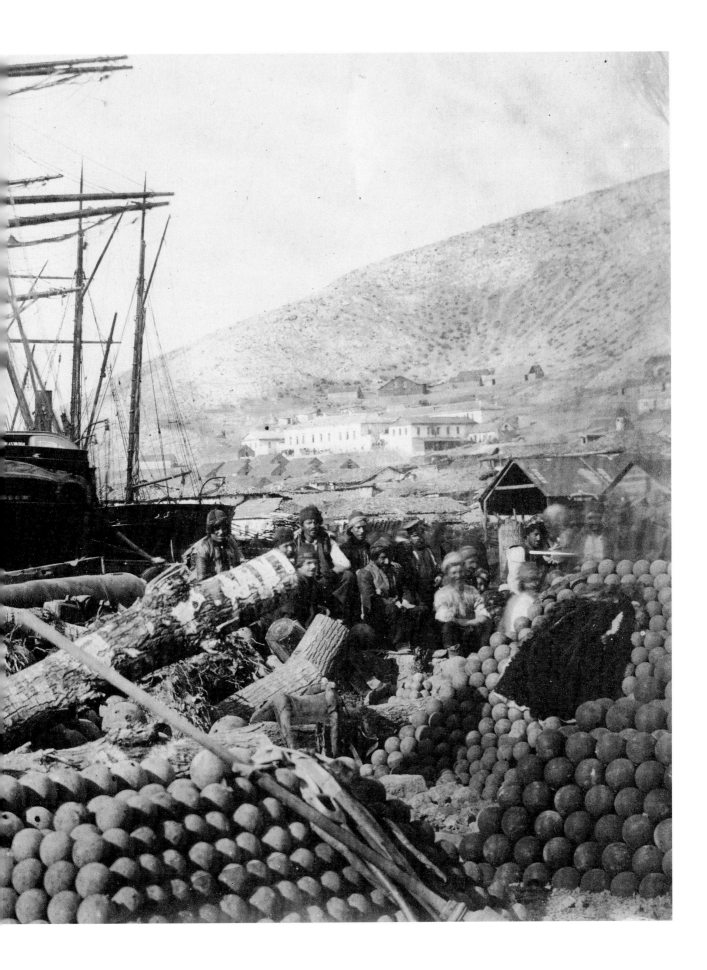

58. Roger Fenton (1819–69),
Railway sheds and workshops at Balaklava,
15 March 1855, albumen print, 20.5 × 25.2 cm.
RCIN 2500463

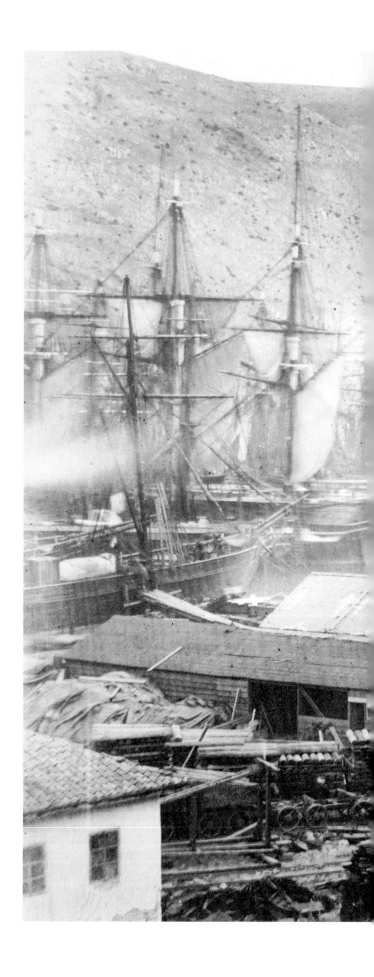

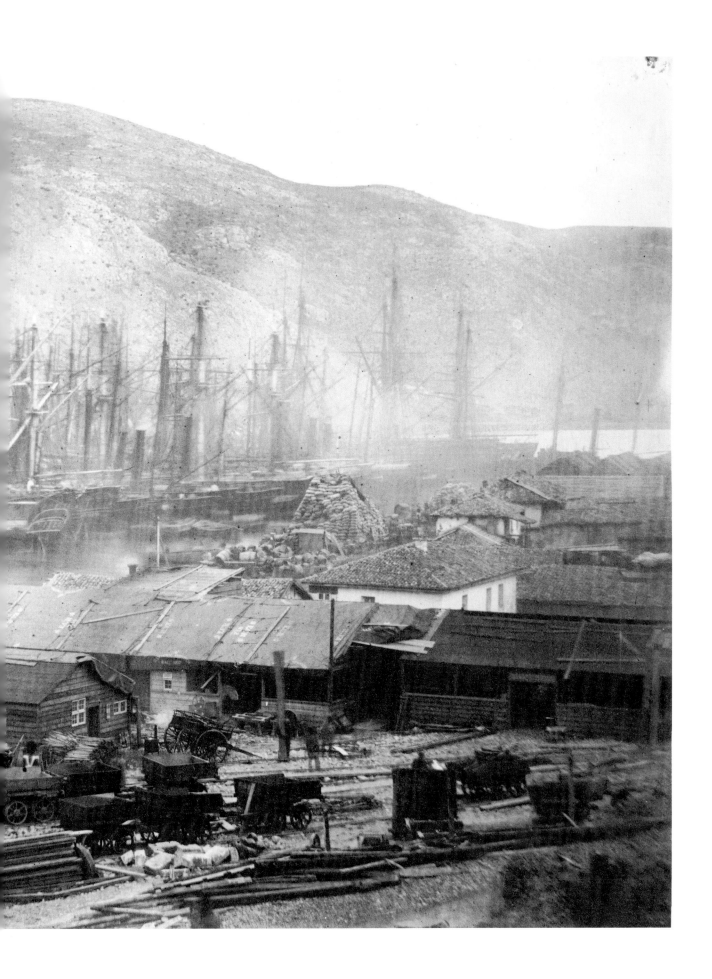

59. Roger Fenton (1819–69),
Cossack Bay, Balaklava, March 1855,
albumen print, 26.8 × 35.6 cm.
RCIN 2500498

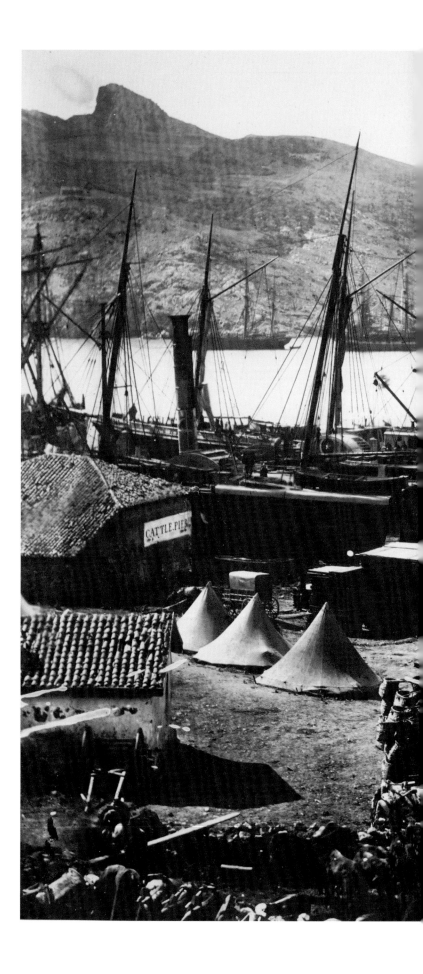

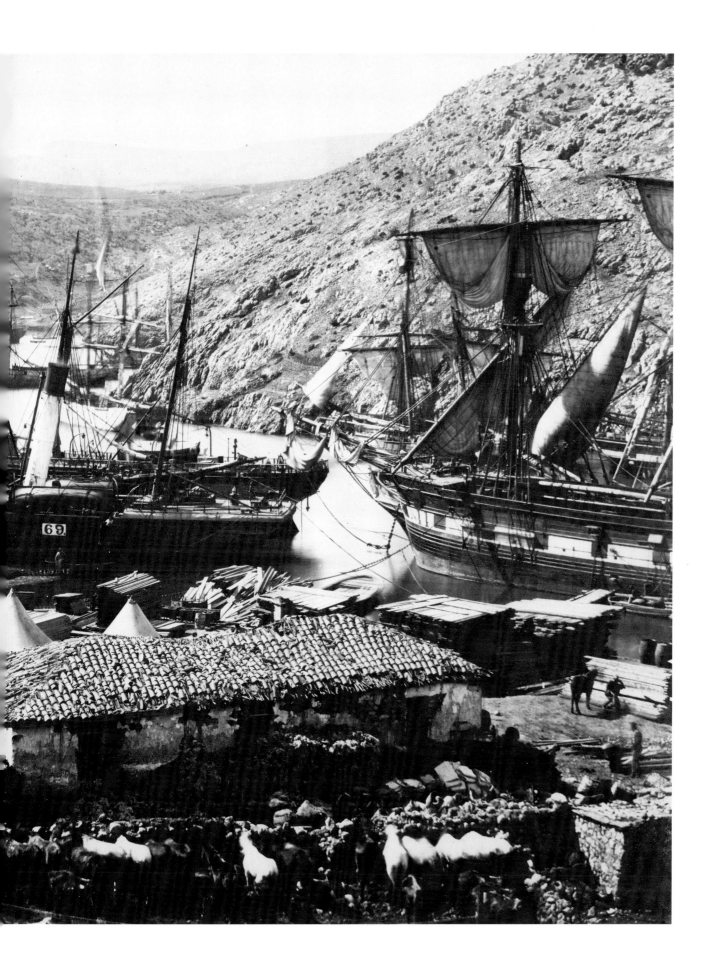

60. Roger Fenton (1819–69),
Balaklava Ordnance Wharf, March 1855,
albumen print, 26.8 × 35.0 cm. RCIN 2500488

Fenton was working with glass plate negatives in the Crimea,
using the wet collodion process. From his negatives, he could print
either salted paper prints or albumen prints. Many of the images
exist in both formats, even within the same set of prints belonging to
the royal family. Sometimes it can be particularly hard to distinguish
between the processes, especially as it was also possible to make salted
paper prints on albumenised paper. Prior to 1860, there was still
much experimentation in the production of photographic prints,
but as larger print runs were required more quickly due to commercial
necessities, the albumen print became the preferred medium. Fenton
or his publishers would have employed others to make the prints to
fulfil the orders that followed the exhibition of his work across Britain.

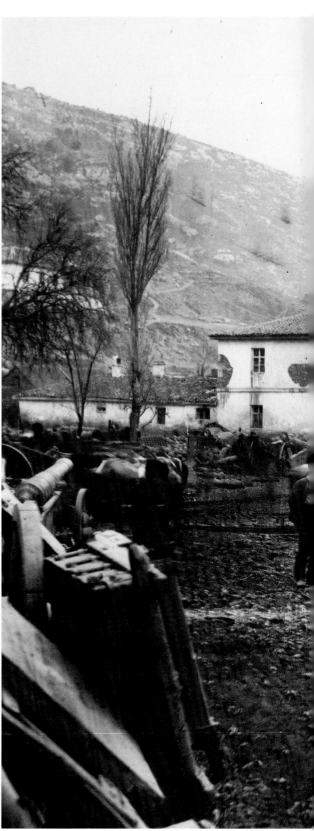

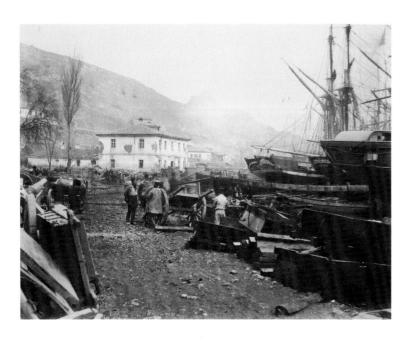

61. Roger Fenton (1819–69),
Balaklava Cattle Pier, March 1855,
salted paper print, 27.4 × 35.3 cm. RCIN 2500497

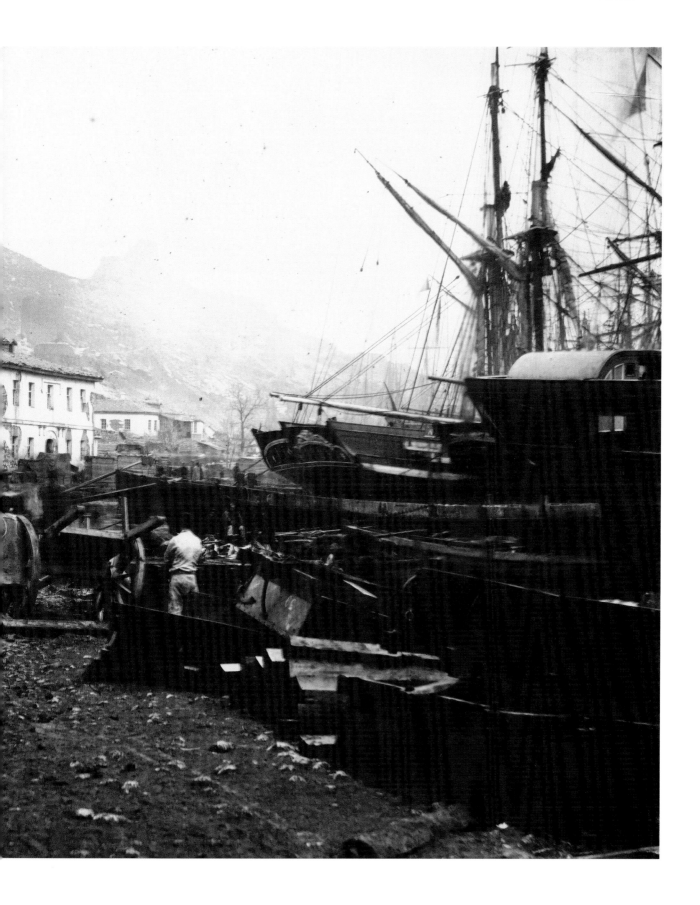

62. Roger Fenton (1819–69),
Balaklava from above the Russian Church,
March 1855, salted paper print,
26.9 × 35.2 cm. RCIN 2500487

The building on the right is a Russian Orthodox
church, which was under construction when the
British took over the port of Balaklava. The harbour
can be seen to the left.

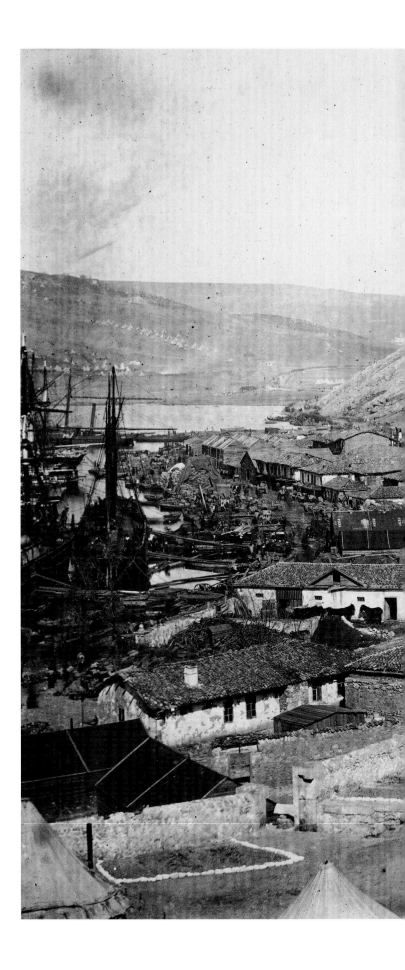

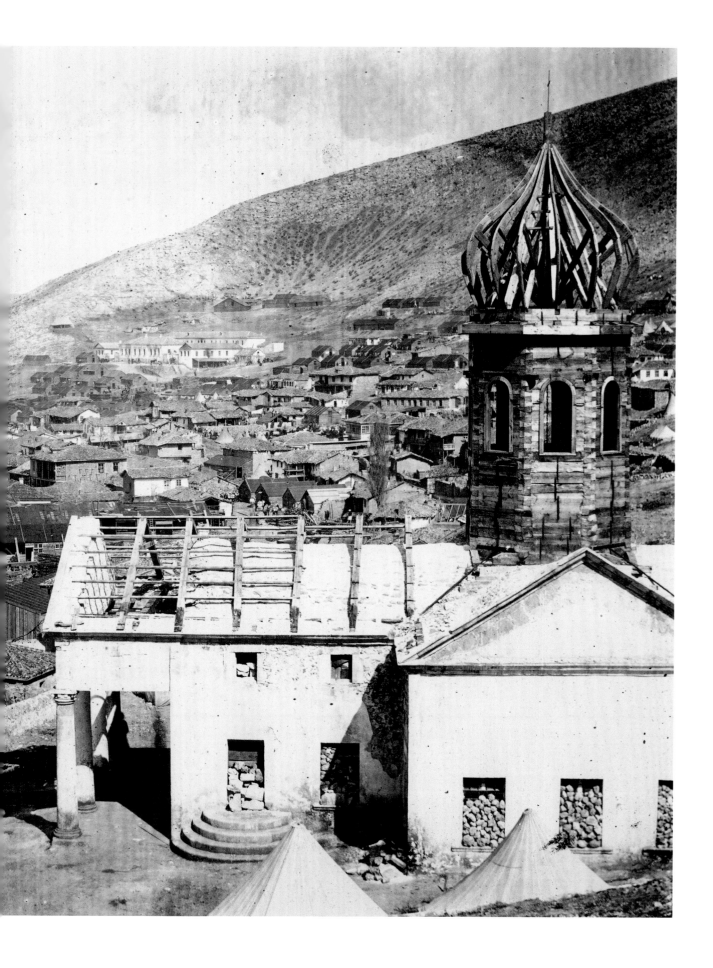

63. Roger Fenton (1819–69),
Railway yard at Balaklava, 15 March 1855,
salted paper print, 20.6 × 26.0 cm. RCIN 2500570

The construction of the military railway was a privately
undertaken enterprise, built at cost by Sir Samuel
Morton Peto (1809–89). The railway was to assist
the troops by conveying whatever was required between
Balaklava and the lines besieging Sevastopol. Construction
began in February 1855 directed by the engineer James
Beatty and the line was in use within weeks whilst work
still continued further along the track. In 1856 after the
end of the war, the railway was dismantled.

According to Fenton's own account of his expedition,
Peto provided his passage from Britain to the Crimea.

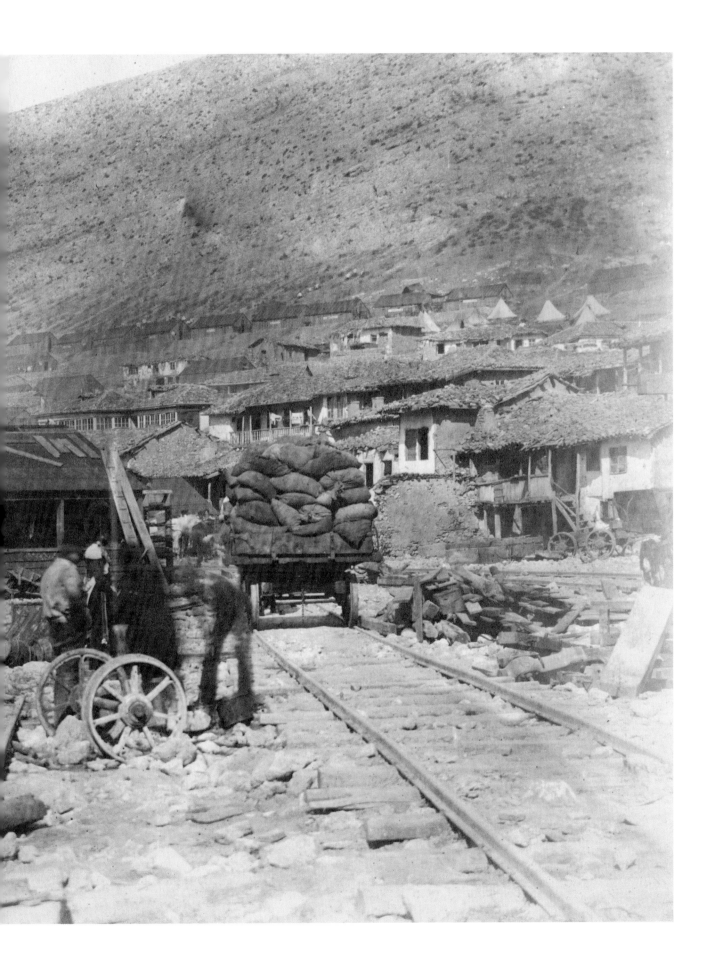

64. Roger Fenton (1819–69),
Old Post Office, 15 March 1855, salted paper print,
19.9 × 25.4 cm. RCIN 2500464

The Old Post Office was the first photograph that Fenton
said he took after he arrived in the Crimea. The rubble
would have been created by the destruction of existing
buildings to make way for the military railway, visible in
the foreground, constructed by the British in 1855.

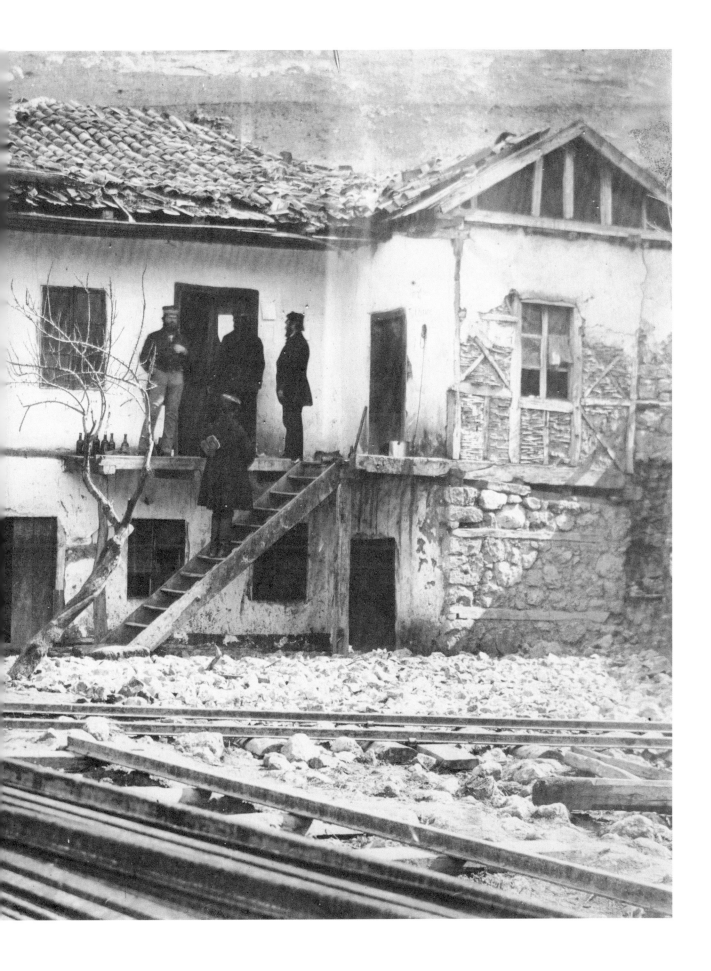

65. Roger Fenton (1819–69),
*Guards Hill Church Parade Balaklava
in the distance*, 1855, salted paper print,
26.1 × 35.3 cm. RCIN 2500530

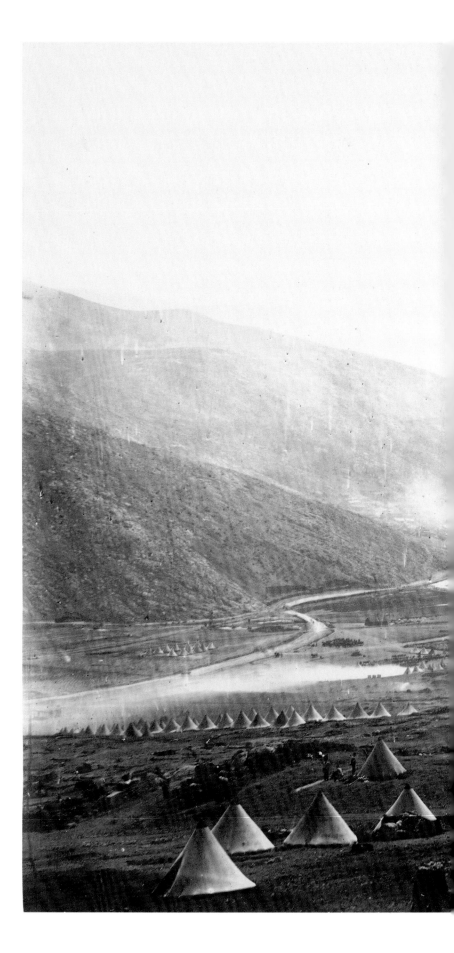

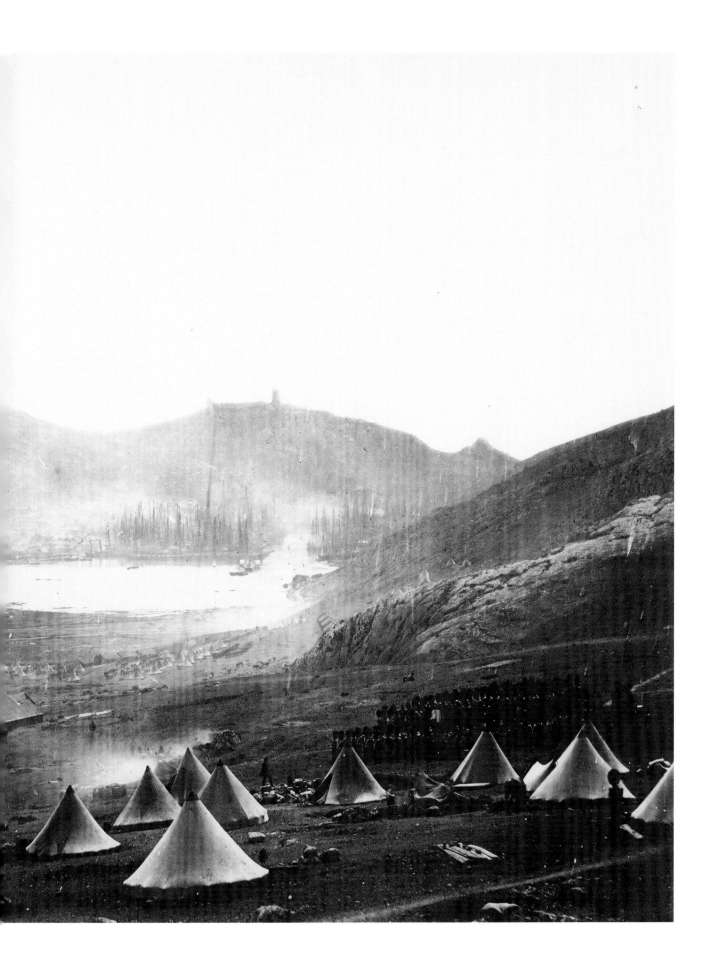

66. Roger Fenton (1819–69),
The Diamond and Wasp Balaklava Harbour,
March 1855, albumen print, 20.8 × 26.9 cm.
RCIN 2500465

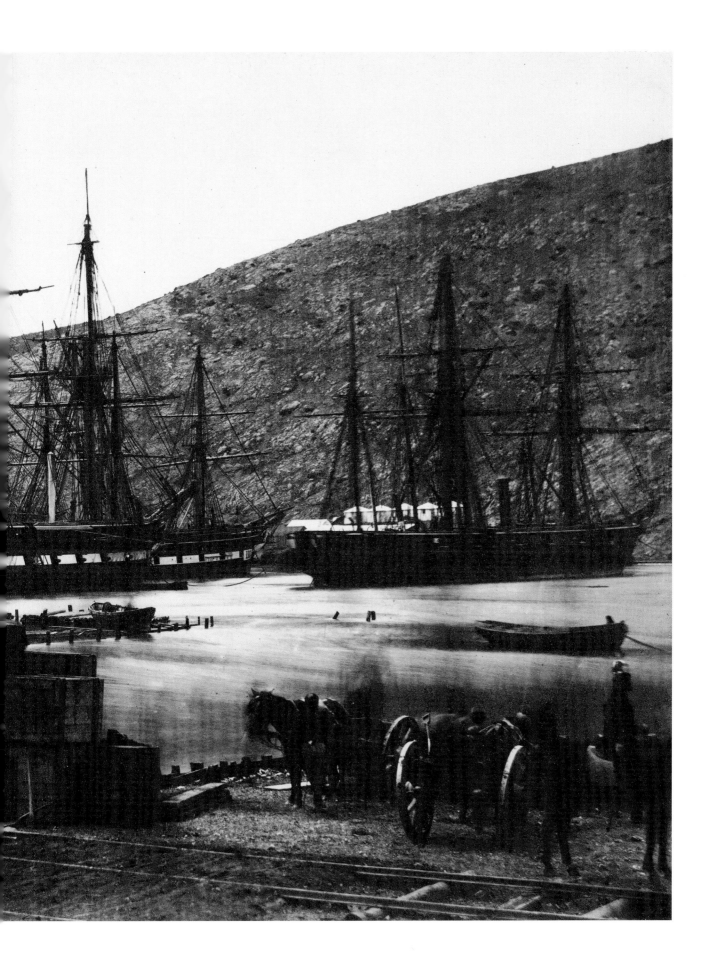

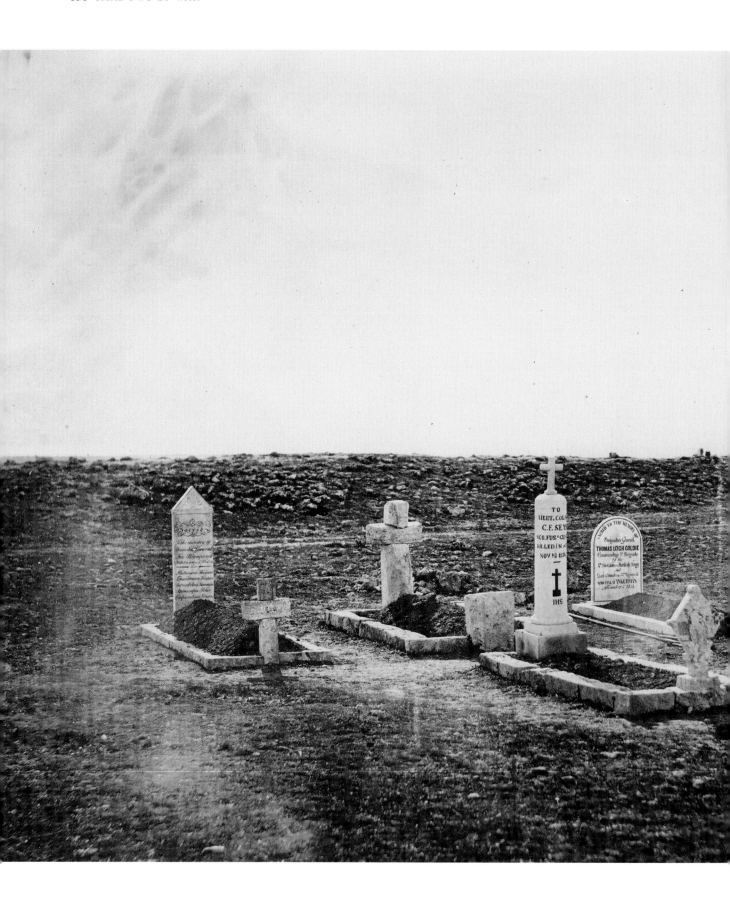

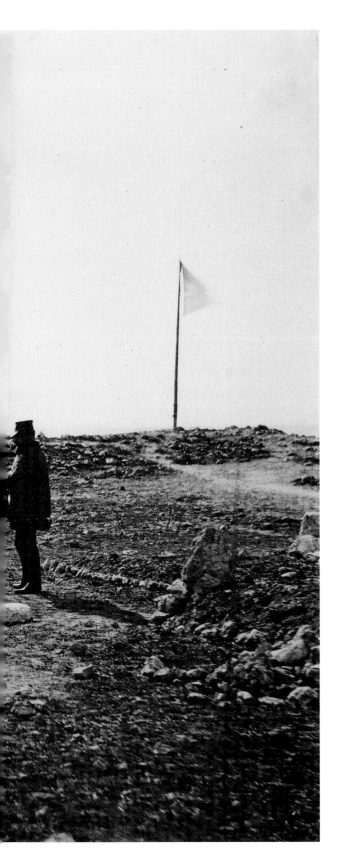

67. Roger Fenton (1819–69),
Tombs of the Generals on Cathcart Hill,
1855, albumen print, 24.9 × 34.7 cm.
RCIN 2500510

Fig. 66: After unknown artist, 'Tombs of the Generals',
Illustrated London News, 16 June 1855, p. 162.
RCIN 1041769

68. Roger Fenton (1819–69),
The Valley of the Shadow of Death,
23 April 1855, albumen print,
25.7 × 35.0 cm. RCIN 2500514

Fenton took his van to this shallow ravine
on 23 April. The arrival of enemy shot and
shelling forced him to retreat slightly and later
when preparing to take the photograph, more
shot came close. Two views of the valley were
subsequently made public, one with shot and
the other without (fig. 67).

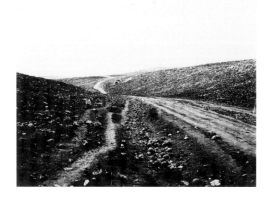

Fig. 67: Roger Fenton (1819–69),
The Valley of the Shadow of Death,
1855, salted paper print,
28.4 × 35.7 cm. Paris, Musée d'Orsay

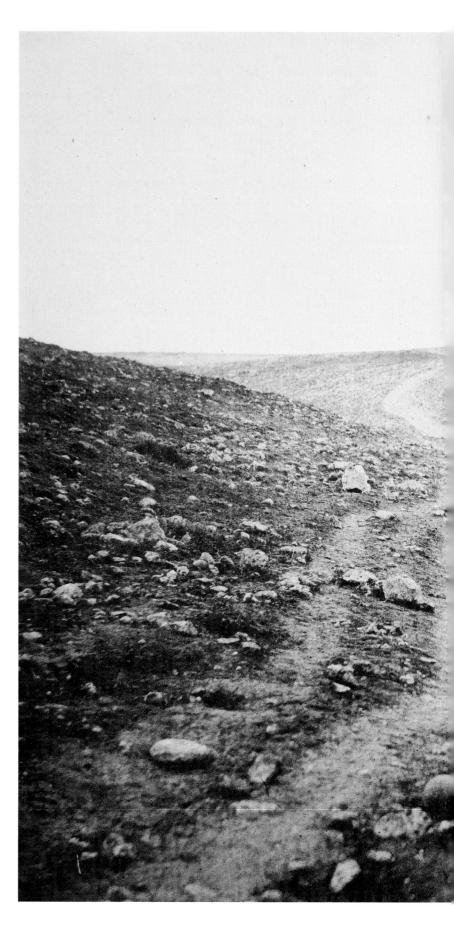

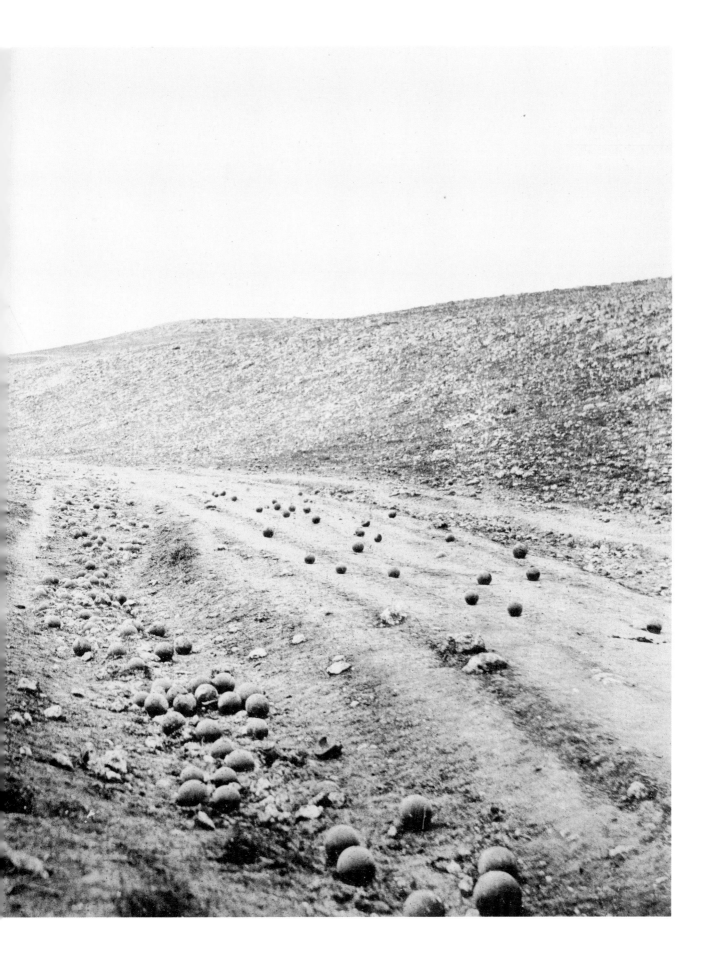

69. James Robertson (1813–88),
The Valley of the Shadow of Death,
1855, salted paper print,
22.3 × 29.2 cm. RCIN 2500723

Despite the title, this photograph does not
show the same location depicted in Fenton's
photograph (plate 68) or Simpson's lithograph
(plate 70). Here the viewer looks towards
Sevastopol on the far right with the harbour
beyond. The Vorontsov Ravine, which
Robertson photographed separately and also
titled *The Valley of the Shadow of Death*,
is the lower ground seen the the left.

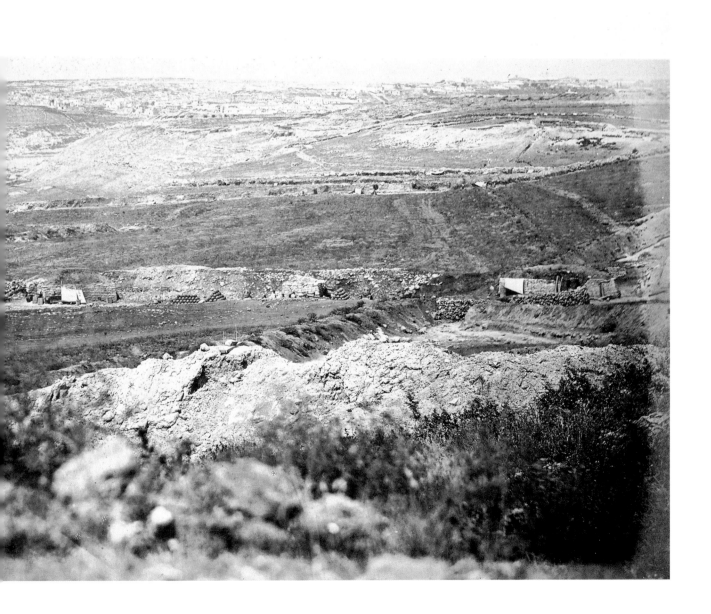

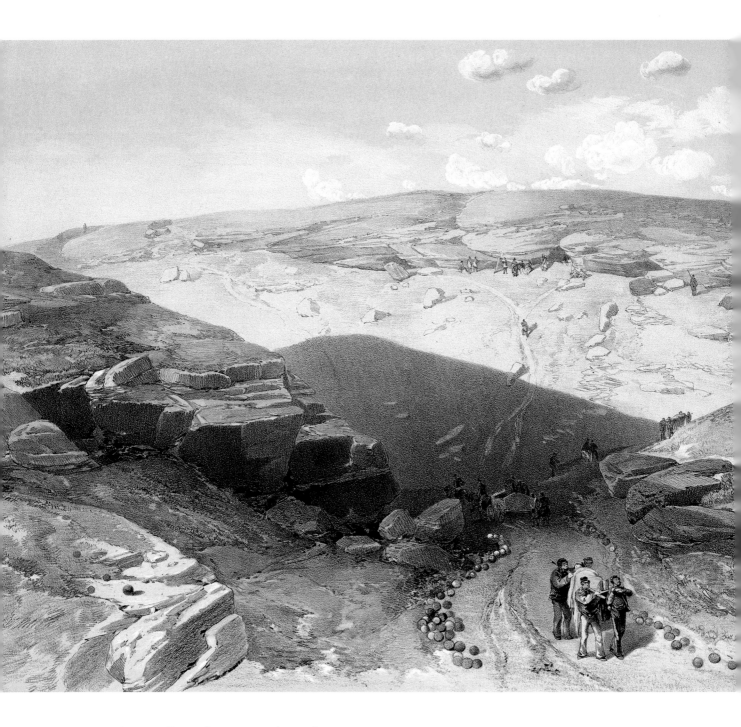

70. Jonathan Needham (*fl.*1850–74), after William Simpson (1823–99),
The Valley of the Shadow of Death, 1855, colour lithograph, 33.0 × 48.7 cm (sheet). RCIN 750984.ad

This view of the Vorontsov Ravine is very similar to one of Robertson's photographs, but it is not the same location photographed by Fenton. However, the presence of round shot fired by the enemy creates a visual link with Fenton's photograph of the same title. The men in foreground are carrying a wounded companion on a stretcher reminding the viewer of the consequences of the war.

Fig. 68: After unknown artist, '"The Valley of Death", before Sebastopol', *Illustrated London News*, 30 June 1855, p. 668. RCIN 1041769

71. Roger Fenton (1819–69), *Sebastopol from the Redoubt des Anglais*,
1855, salted paper print, 14.4 × 23.8 cm. RCIN 2500482

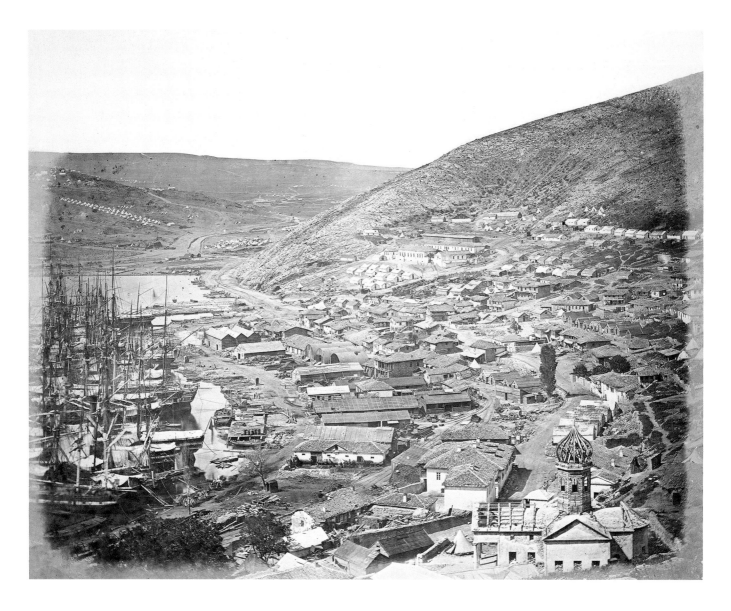

72. James Robertson (1813–88),
Balaklava, 1855, salted paper print, 24.1 × 30.0 cm. RCIN 2500731

James Robertson made an expedition to the Crimea in September 1855. He made a series of views in
and around Sevastopol and Balaklava after the fall of the city on 8 September. This view includes the same
Russian church photographed by Fenton (plate 62). His photographs were on display and for sale in
London and Paris by the end of the year. A second set of photographs was taken in April and May 1856
when the docks were destroyed (plate 76). Although the later photographs were issued by James Robertson,
the photographer was his brother-in-law Felice Beato.

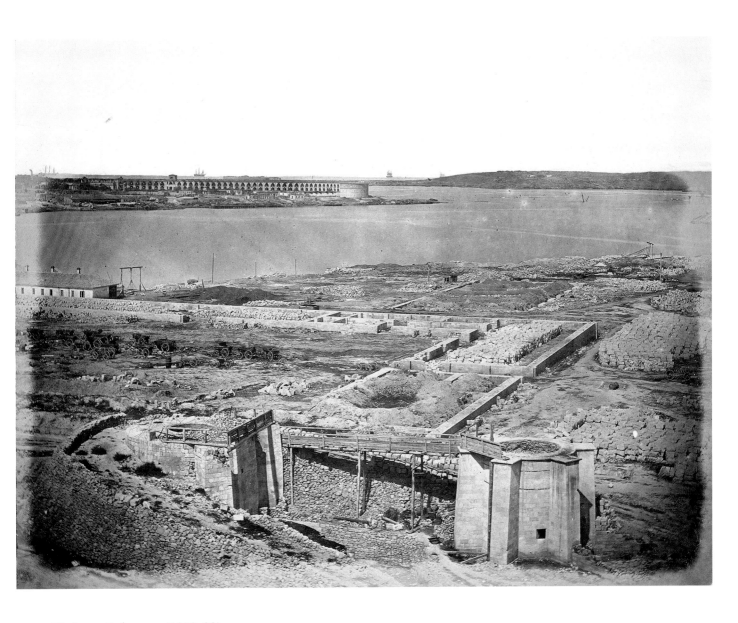

73. James Robertson (1813–88),
Fort Nicholas [Sevastopol], 1855, salted paper print, 22.7 × 29.3 cm. RCIN 2500759

Fort Nicholas sits across the South Harbour while in the foreground the ruins of the Arsenal are clearly seen.

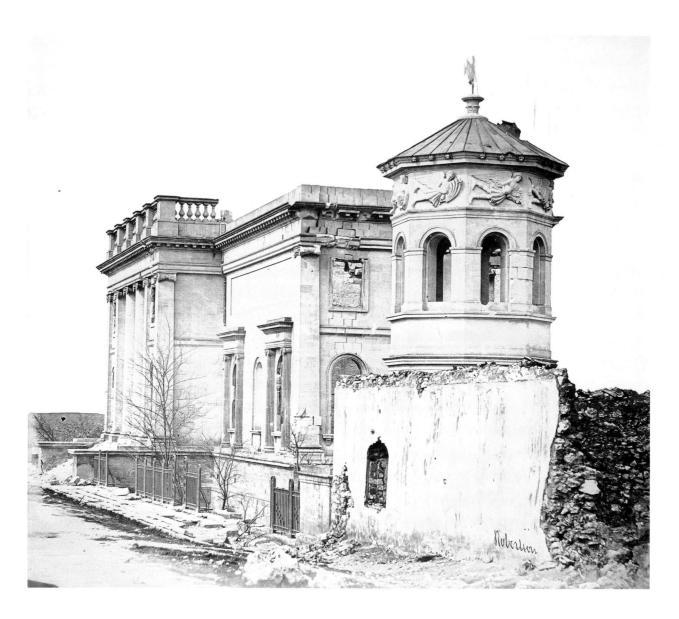

Above: 74. James Robertson (1813–88),
The Library [Sevastopol], 1855, salted paper print, 24.9 × 28.0 cm. RCIN 2500664

Right, top: 75. James Robertson (1813–88),
The Docks [Sevastopol], 1855, salted paper print, 21.0 × 29.4 cm. RCIN 2500682

Right, below: 76. Felice Beato (1832–1909) for James Robertson (1813–88),
The Docks after the explosion [Sevastopol], April–May 1856, salted paper print, 23.7 × 28.7 cm. RCIN 2500683

Two English engineers, John Upton and his son, also called John, worked in Sevastopol for many years, designing and improving the harbour and water supply. The dry docks were completed by the younger Upton just before the war began. The British and French troops destroyed the docks in spring 1856.

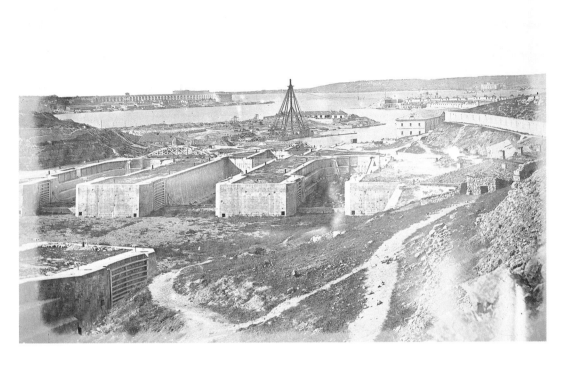

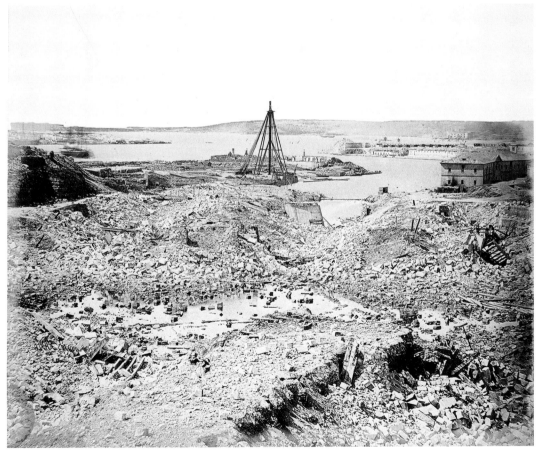

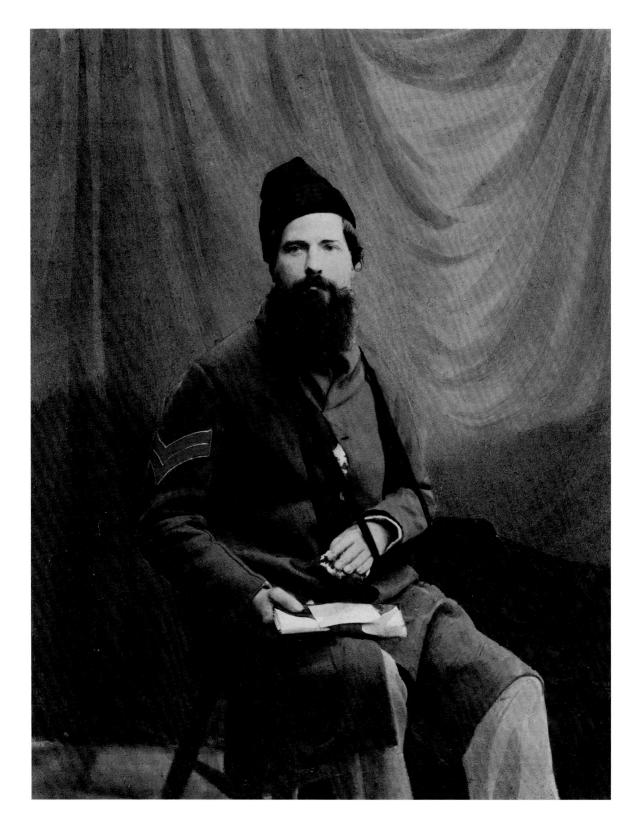

77. Joseph Cundall (1818–95) and Robert Howlett (1831–58),
Corporal Michael McMahon, 1856, salted paper print with watercolour, 20.3 × 15.7 cm. RCIN 760219

McMahon was shot through the neck on 24 August 1855. He was one of the veterans seen by Queen Victoria at Chatham.

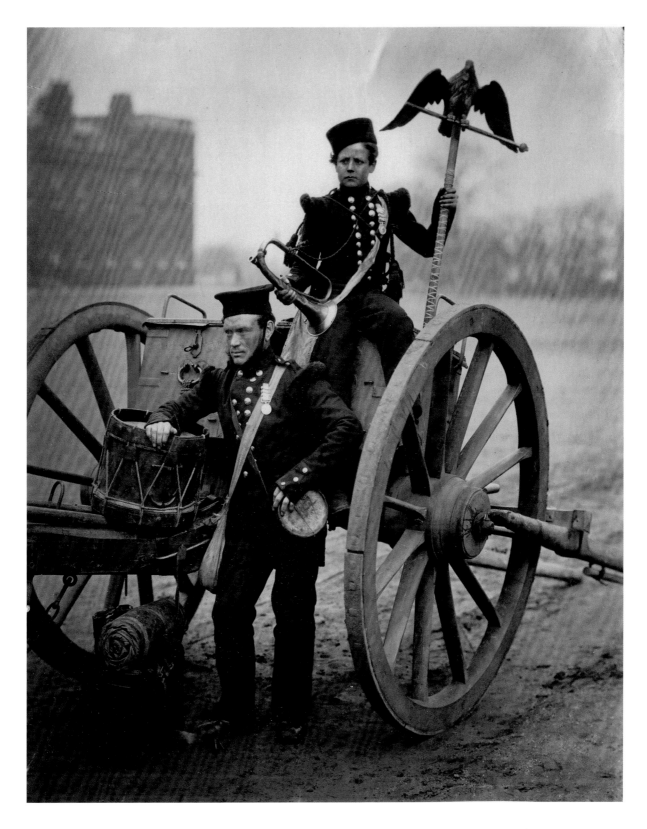

78. Joseph Cundall (1818–95) and Robert Howlett (1831–58), *Trumpeter George Gritten and Trumpeter William Lang*, negative 1856, printed 1883 by Jabez Hughes, carbon print, 22.9 × 18.5 cm. RCIN 2500185

Trumpeter Lang was said to be only 13 years old at the start of the war.

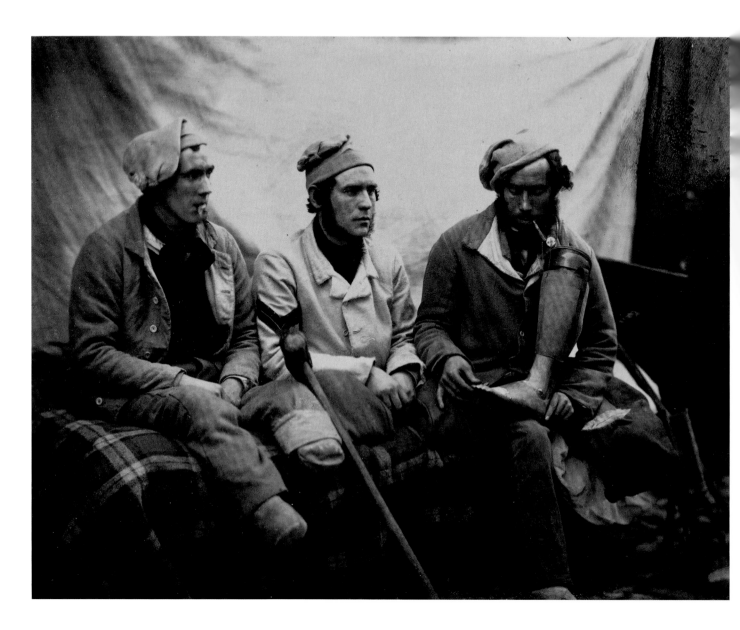

79. Joseph Cundall (1818–95) and Robert Howlett (1831–58),
Amputees at Chatham Military Hospital, negative 1856,
printed *c*.1883 by Jabez Hughes, carbon print, 18.1 × 23.7 cm. RCIN 2500189

The men are, from left to right, William Young, Henry Burland and John Connery. Young lost his legs
in an explosion on 18 June 1855 while Burland and Connery were victims of frostbite.

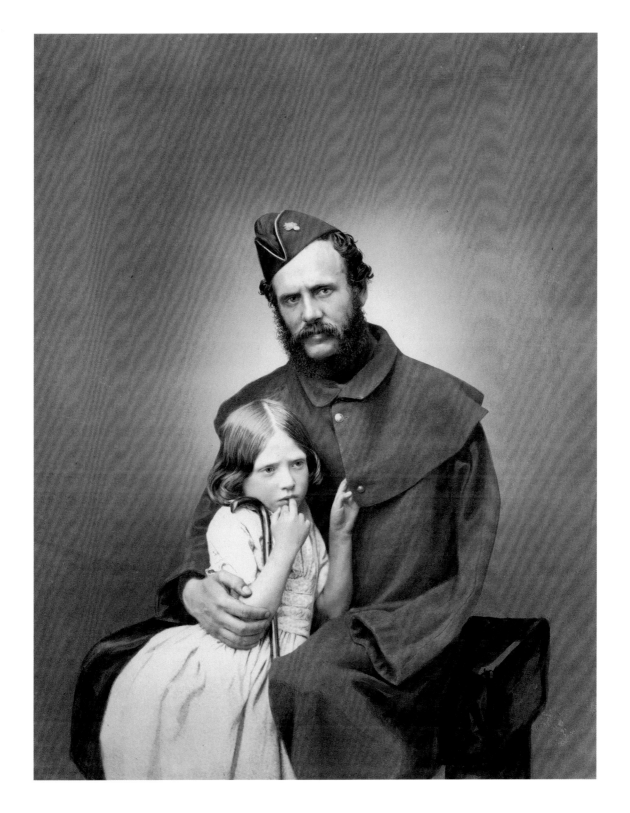

80. John Jabez Edwin Mayall (1813–1910),
Sergeant Thomas Dawson with his Daughter, *c*.1855–6, salted paper print, 25.3 × 19.7 cm. RCIN 2500126

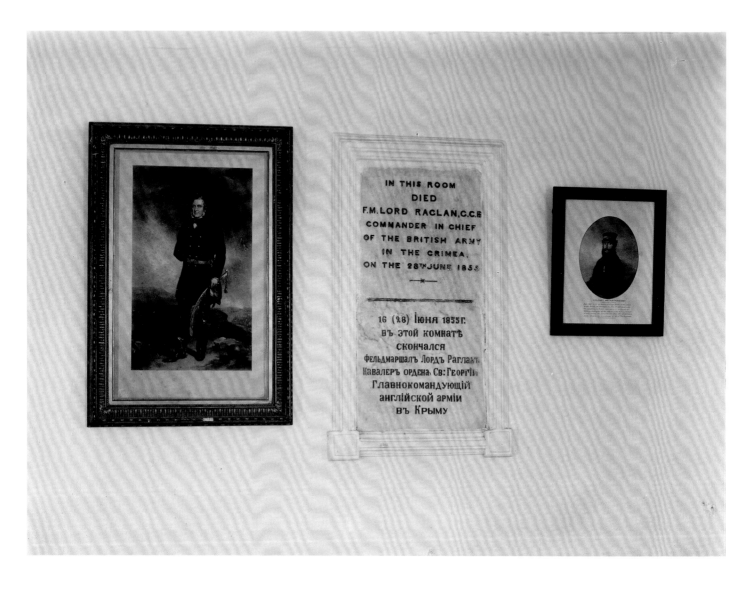

81. Ivan Ermolaevitch Grigoriev (active 1900),
The memorial wall in the room where Lord Raglan died, 28th June 1855,
*c.*1900, gelatin silver print, 17.0 × 23.0 cm. RCIN 2500803

82. Ivan Ermolaevitch Grigoriev (active 1900),
The field of Balaklava: The scene of the Charge of the Lights Brigade,
*c.*1900, hand-coloured gelatin silver print, 17.0 × 23.0 cm. RCIN 2500797

POSTSCRIPT – AFTER THE WAR

The Crimean War became part of the Victorian public consciousness in a way that no other conflict had done before. Roger Fenton's photographs were seen by thousands and, alongside prints, paintings, books, poems, reports and other imagery, they contributed to creating a lasting memory of the war. The royal family also played a key role in keeping the conflict in the public eye, both during the war and once it had ended. This unprecedented coverage focused attention on the impact of the war both on the ordinary soldier and on civilians. Although the decision to enter into the conflict was not widely questioned, the effectiveness of the way it had been organised and fought was frequently scrutinised in the press. The soldiers fighting for their Queen and country were regarded as noble heroes, and their treatment in the field and as veterans became a key topic for debate. Photography in particular raised the profile of wounded soldiers as it forced the public to consider the men as individuals and the stories of their injuries were highly emotional (**plates 77–80**).

The Prince of Wales, later King Edward VII, was 12 years old when war was declared. Although his diaries from 1854–6 are sparse, he religiously noted every meeting with a Crimean veteran and described every visit made or event attended in connection with the war. This included visits to photographic exhibitions by Fenton and Robertson and a display of drawings by Simpson and Armitage. The Prince's interest in the conflict was clear, and perhaps to be expected from a young boy being educated to become head of the armed forces one day.

The long-term impact of the war on the Prince was considerable. When in 1862 he was sent on an educational tour of the Middle East, he had hoped to visit the Crimea to see the sites of the battles, about which he had read and heard so much. The timing, however, was deemed to be too soon after the end of the war for a visit. Russia controlled the Crimean peninsula after the war with the Treaty of Paris on 30 March 1856 returning to them all captured towns and cities in exchange for Kars in eastern Anatolia, which returned to Ottoman control. The treaty also prevented any military presence in the Black Sea or on its coast by any nationality.

Fig. 69: Abdullah Frères, *Albert Edward Prince of Wales* (1841–1910), 1869, albumen print, 14.1 × 9.8 cm. RCIN 2107171

Fig. 70: Unknown photographer, *Site of the Old Town, Sebastopol*, *c*.1869, albumen print, 25.5 × 31.5 cm. RCIN 2700831

When the Prince made a second journey to the Near East in 1869 to visit Egypt and Constantinople, he was allowed this time to travel to the Crimea (**fig. 69**). His ship the *Ariadne* arrived at Sevastopol on 12 April, where the royal party was met by the British Ambassador. Also accompanying the Prince was William Howard Russell, *The Times*' reporter during the war.

The Prince spent three days visiting sites associated with the war, including Balaklava and the scene of the Charge of the Light Brigade, Alma, Inkerman, the Redan, the Malakoff Tower and the house where Lord Raglan had died. Time was also spent exploring the ruins of Sevastopol, guided by several Russian officers. The Prince wrote, 'I felt deeply for them, showing us over the ruins of one of their finest sea port towns – altho' they may indeed be proud – to have defended the Town for so long agst. the Allied Armies!'.[1] The Prince clearly found the visit to be an emotional experience, 'It is too sad to see the havoc & devastation

that has taken place. Nothing but bare walls, riddled with shot & shell meet your view at every turn - & it only brings the horrors of war too vividly before you […] one cannot but feel sad to think that over 800,000 men perished – for what? for a political object' (**fig. 70**).[2]

Over time, evidence of the battles disappeared and the towns were rebuilt. By the turn of the century, diplomatic, political and dynastic relations between Britain and Russia had significantly shifted, although memories of the war remained strong. In 1900 the British Vice-Consul Charles Cooke commissioned a Russian photographer, Ivan Grigoriev, to make a series of views of sites associated with the war. Cooke had intended to present the photographs to Queen Victoria, but they did not reach the Royal Family until 17 years later, in 1917, when they were gifted to King George V instead. 1917 also marked the year of the Russian Revolution and the beginning of a very different era (**fig. 71 and plates 81–82**).

Fig. 71: Ivan Ermolaevitch Grigoriev, *Part of the Battlefield of the Chernaia*, *c.*1900, hand-coloured gelatin silver print, 17.0 × 23.0 cm. RCIN 2500799

'The Charge of the Light Brigade'
Alfred, Lord Tennyson
(1854)

I
Half a league, half a league,
Half a league onward,
All in the valley of Death
Rode the six hundred.
'Forward, the Light Brigade!
Charge for the guns!' he said.
Into the valley of Death
Rode the six hundred.

II
'Forward, the Light Brigade!'
Was there a man dismayed?
Not though the soldier knew
Someone had blundered.
Theirs not to make reply,
Theirs not to reason why,
Theirs but to do and die.
Into the valley of Death
Rode the six hundred.

III

Cannon to right of them,
Cannon to left of them,
Cannon in front of them
Volleyed and thundered;
Stormed at with shot and shell,
Boldly they rode and well,
Into the jaws of Death,
Into the mouth of hell
Rode the six hundred.

IV

Flashed all their sabres bare,
Flashed as they turned in air
Sabring the gunners there,
Charging an army, while
All the world wondered.
Plunged in the battery-smoke
Right through the line they broke;
Cossack and Russian
Reeled from the sabre stroke
Shattered and sundered.
Then they rode back, but not
Not the six hundred.

V

Cannon to right of them,
Cannon to left of them,
Cannon behind them
Volleyed and thundered;
Stormed at with shot and shell,
While horse and hero fell.
They that had fought so well
Came through the jaws of Death,
Back from the mouth of hell,
All that was left of them,
Left of six hundred.

VI

When can their glory fade?
O the wild charge they made!
All the world wondered.
Honour the charge they made!
Honour the Light Brigade,
Noble six hundred!

APPENDIX

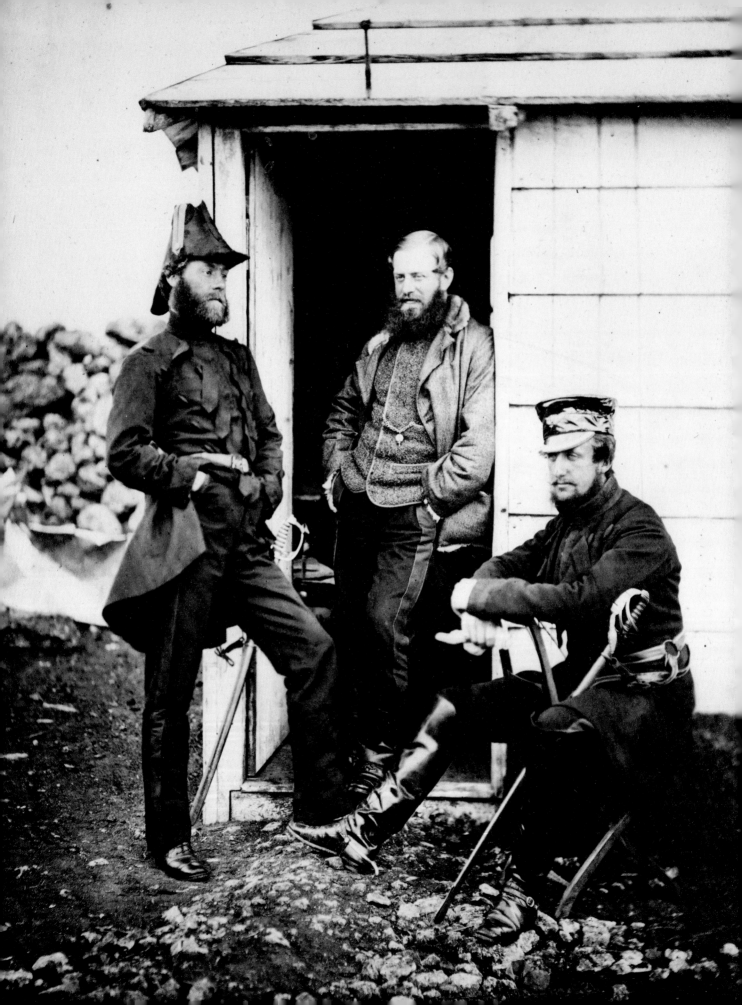

ROGER FENTON'S PHOTOGRAPHS OF THE CRIMEAN WAR, 1855

Louise Pearson

The Royal Collection contains 428 photographs by Roger Fenton of the Crimean War, of which 88 are duplicates.

The majority of the photographs come from a loose set acquired during the reign of Queen Victoria, which became part of the collection of the Prince of Wales, later King Edward VII. This set consists of 349 photographs, each pasted onto an individual mount measuring 57.3 × 44.6 cm, which were stored in three portfolios. Most have a title written on the mount directly below the photograph, but some have a title written in the lower left corner, probably added during the reign of King Edward VII. These later titles are shown here as <u>underlined</u>. The set is arranged in the order listed in a handwritten catalogue, which is thought to have entered the Collection with the photographs in *c.*1855 (RCIN 2958048.a, see page 187). At the end of the set there is a small group of photographs not listed in this catalogue, along with a group of duplicate prints.

In addition to the main set, Fenton's Crimean War photographs appear in three photograph albums and as loose prints in other parts of the Collection. These albums are *Crimean Portraits* (RCIN 1039814), *Crimean Officers' Portraits, 1854 to 1856* (RCIN 2500000) and *Crimean Portraits, 1854 to 1856* (RCIN 2500122). The sequence reproduced here is presented in the order listed in the handwritten catalogue and uses photographs from the main set wherever possible, though the extra photographs which do not appear in the main set have also been included. The titles given are those used on the mounts, with information and corrections given in square brackets when clarification is required. The Royal Collection Inventory Number (RCIN) is given for each copy of the print, as is the plate number for the present publication.

The photographs are a mixture of albumen and salted paper prints. The vast majority were taken while Fenton was working in the Crimea between March and June 1855. More specific dates are given where these can

Roger Fenton (1819–69), *Col Ponsonby etc.* (detail), 1855, 19.4 × 15.8 cm, albumen print, RCIN 2500403.

be established from Fenton's letters to his family, and other sources. A small number of the portraits were taken at Fenton's London studio in autumn 1855 and perhaps elsewhere after he returned from the Crimea (see p. 65).

The photographs have been matched, where possible, to the numbers given in the catalogue published to accompany the first public exhibition of Fenton's Crimean War photographs held at the Gallery of the Water Colour Society, Pall Mall East, in September 1855 (RCIN 2947508; shown on pp. 227–43). These numbers differ slightly from those in later exhibition catalogues. The photographs were available to purchase through subscription and were issued in thematic groups over the course of several months, although single prints could also be obtained.

Key to abbreviations:

Names

ADC / Adc – Aide-de-camp

Brigadr / Bde / Brd / Brg – Brigadier

Capt / Captn – Captain

CB – Companion (Order of the Bath)

Col – Colonel

Color Sargt – Colour Sergeant

Comdr – Commander

Comdt – Commandant

D q mgl – Deputy Quartermaster-General

Esqr / Esq – Esquire

GCB – Knight Grand Cross
(Order of the Bath)

Genl / Gen – General

Honbl – The Honourable

KCB – Knight Commander
(Order of the Bath)

KG – Knight of the Garter

Ld – Lord

Lieut / Lt – Lieutenant

Lieut Gen / Lieut Genl –
Lieutenant General

Lt Col – Lieutenant Colonel

MD – Doctor of Medicine

Offr – Officer

Military units

Buffs – 3rd (The East Kent)
Regiment of Foot (The Buffs)

Commist – Commissariat

Gds / Grds – Guards

Lt Division – Light Division

RA – Royal Artillery

RE – Royal Engineers

RHA – Royal Horse Artillery

Scots Greys / S Greys –
2nd (Royal North British) Dragoons

S F gds / SFGds / S F Guards –
Scots Fusilier Guards

1st Royals – 1st (The Royal) Regiment

4th Dgns / 4th Dragoon Guards –
4th Dragoon Guards

**4th Lt Dgns / 4th Lt Dr / 4th Light
Dragoons / 4th Lt Dg / 4th Lt / 4 Lt Drg**
– 4th (Queen's own) Light Dragoons

5th D Gds / 5th Dragoons / 5 Ds Gds
– 5th (Princess Charlotte of Wales's)
Dragoon Guards

8th / 8th Hussars –
8th (King's Royal Irish) Hussars

9th – 9th (East Norfolk) Regiment
of Foot

11th / 11th Hussars – 11th Hussars
(Prince Albert's Own)

12th – 12th (The East Suffolk) Regiment
of Foot

13th – 13th Light Dragoons

14th – 14th (The Buckinghamshire)
Regiment of Foot

17th Regiment – 17th (The Leicestershire)
Regiment of Foot

20th – 20th (The East Devonshire)
Regiment of Foot

21st – 21st Regiment of Foot
(Royal North British Fusiliers)

23rd – 23rd Regiment of Foot
(Royal Welsh Fusiliers)

28 Regt / 28th – 28th (The North
Gloucestershire) Regiment of Foot

30th – 30th (The Cambridgeshire)
Regiment of Foot

33rd – 33rd (Duke of Wellington's)
Regiment of Foot

38th – 38th (1st Staffordshire)
Regiment of Foot

39th – 39th (Dorsetshire)
Regiment of Foot

42nd – 42nd (Royal Highland)
Regiment of Foot

47th – 47th (Lancashire)
Regiment of Foot

50th Regiment / 50th Regt –
50th (Queen's Own) Regiment of Foot

57th – 57th (West Middlesex)
Regiment of Foot

68th – 68th (Durham) Regiment of Foot
(Light Infantry)

71st – 71st (Highland) Regiment of Foot
(Light Infantry)

77 Regt / 77th / 77 – 77th
(East Middlesex) Regiment of Foot

88 – 88th Regiment of Foot
(Connaught Rangers)

89th – 89th (The Princess Victoria's)
Regiment of Foot

Handwritten catalogue listing Roger Fenton's photographs of the Crimean War.
RCIN 2958048.a

This catalogue is believed to have entered the Royal Collection with the three portfolios of Fenton's Crimean War photographs in c.1855.

Crimean negatives

1, Lord Raglan
2, Sir George Brown
3, General Simpson
4, Sir George Brown, No 2
5, General Pennefather
6, do — do No 2
7, do — do — 3
8, do with orderly — 4
9, Sir Richard England
10 Sir John Campbell and Capⁿ Hume his Aid du Camp
11, General Estcourt
12, do — do No 2
13, do — do — 3
14, General Pennefather small in tent 1855
15, General Barnard
16, do Jones
17, do Codrington

18, General Codrington & horse
19, do — Buller
20, do — do — No 2
21, do Lockyer —
22, do Scarlett and col Low wearing a french jacket not being on duty.
23, Brigadr Garrett
24, do Lord G Paget
25, Lord Burghersh
26. Col Gordon . R.E.
27, do Tylden . do
28, do Adye . R.A.
29 Lt Col. Prince Edward Sax W
30, Col. Reynardson
31, do Moorsom S. F. gds
32, do Woodford Rifles
33, do Wilbraham
34, do Hamilton gds
35, do Dickson R E
36, do Airy D. Q M gl

37 Col Blair
38 do Harding Com dt
39 do Grant 42nd
40 Hon Major Cathcart wl
41 Major Halliwell
42 Major Cathcart Do 2
43 Lord Kirkwall
44 Major Keane ×
45 Lord Balgonie
46 Hon Capn Clifford
47 Col Leyman S F gds
48 do Shewell
49 Capn Baring
50 do Banbury g gds
51 do Turner do
52 do Lucas 77 lgt
53 Major Piper 20 lt
54 m. Capn Andrews 28
55 do
56 Capn Calder

Overleaf: Portfolio cover for volume 2 of Fenton's photographs of the Crimean War, c.1855, half-bound blue leather and cloth with gold tooling, 23.0 × 19.0 × 1.0 cm.
RCIN 2958069

This is one of three portfolios which originally housed Fenton's Crimean War photographs. All three have a Sandringham bookplate in the inside cover.

PHOTOGRAPHIC VIEWS
& PORTRAITS
OF
CRIMEAN CAMPAIGN

2

Lord Raglan
4 June 1855
18.3 × 14.5 cm
Albumen print. Plate 4
RCINS 2500229, 2506565, 2500002
Cat. no. 269

Sir George Brown
1855
16.9 × 12.5 cm
Albumen print. Plate 6
RCINS 2500230, 2506568, 2500004
Cat. no. 132

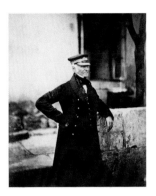

General Simpson
1855
18.5 × 15.1 cm
Albumen print. Plate 24
RCINS 2500231, 2506566, 2500069
Cat. no. 268

Sir George Brown
1855
18.8 × 15.3 cm
Albumen print
RCIN 2500232

General Pennefather
April 1855
19.4 × 15.6 cm
Albumen print
RCINS 2500233, 2506574
Cat. no. 224

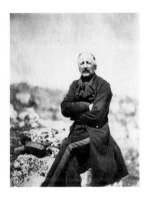

General Pennefather
April 1855
19.0 × 14.9 cm
Albumen print
RCIN 2500234

General Pennefather
April 1855
16.3 × 14.2 cm
Albumen print
RCIN 2500235

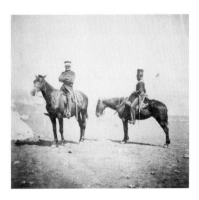

General Pennefather with orderly
1855
14.7 × 15.3 cm
Albumen print
RCIN 2500236
Cat. no. 106

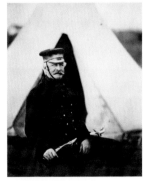

Sir Richard England
1855
18.7 × 15.1 cm
Albumen print. Plate 5
RCINS 2500237, 2506571
Cat. no. 22

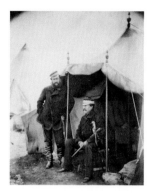

Sir John Campbell & Capt Hume his ADC
April 1855
20.5 × 16.3 cm
Albumen print
RCINs 2500238, 2506575, 2500030
Cat. no. 38

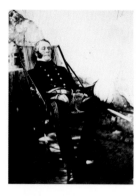

General Estcourt
1855
20.5 × 15.2 cm
Albumen print. Plate 43
RCIN 2500239

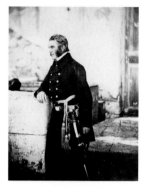

General Estcourt
1855
18.7 × 14.5 cm
Albumen print
RCINs 2500240, 2500021
Cat. no. 183

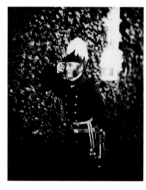

General Estcourt
1855
19.0 × 15.4 cm
Albumen print
RCINs 2500241, 2506580

General Pennefather small in tent
1855
17.8 × 15.6 cm
Albumen print
RCIN 2500242
Cat. no. 254

General Barnard
April 1855
20.5 × 15.2 cm
Albumen print
RCINs 2500243, 2506576, 2500066
Cat. no. 90

General Jones
1855
19.4 × 15.3 cm
Albumen print
RCINs 2500244, 2506577, 2500070
Cat. no. 212

General Codrington
1855
18.1 × 13.1 cm
Albumen print
RCINs 2500245, 2506567, 2500025
Cat. no. 136

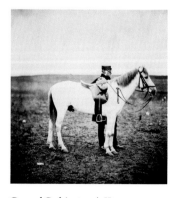

General Codrington & Horse
1855
16.7 × 15.5 cm
Albumen print
RCIN 2500246
Cat. no. 73

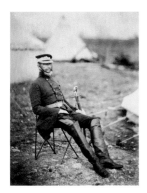

General Buller
1855
20.2 × 15.4 cm
Albumen print
RCINS 2500247, 2506581, 2500026
Cat. no. 87

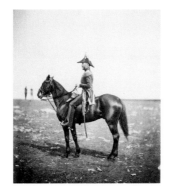

General Buller
1855
17.5 × 15.2 cm
Albumen print
RCIN 2500248
Cat. no. 126

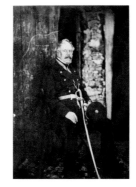

General Lockyer
1855
18.4 × 12.8 cm
Albumen print
RCINS 2500249, 2506582
Cat. no. 35

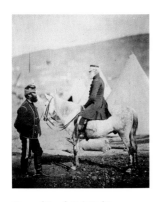

General Scarlett & Col Lowe –
wearing a french jacket – not being on duty
April 1855
19.5 × 16.0 cm
Albumen print. Plate 9
RCINS 2500250, 2506578, 2500115
Cat. no. 193

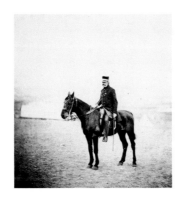

Brigadr Garrett
April 1855
15.2 × 14.1 cm
Albumen print
RCINS 2500251, 2506583, 2500096
Cat. no. 276

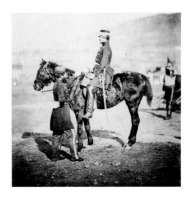

Brigadr Lord G Paget
April 1855
15.9 × 16.0 cm
Albumen print
RCINS 2500252, 2500079
Cat. no. 25

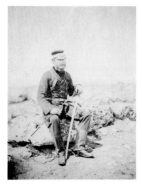

Ld Burghersh
April 1855
19.8 × 15.1 cm
Albumen print
RCINS 2500253, 2506585
Cat. no. 228

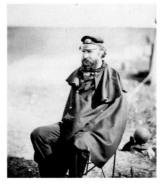

Col Gordon RE
1855
17.6 × 15.5 cm
Albumen print
RCINS 2500254, 2506584, 2500106
Cat. no. 179

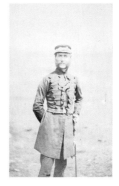

Col Tylden RE
1855
17.6 × 10.9 cm
Albumen print
RCIN 2500255
Cat. no. 195

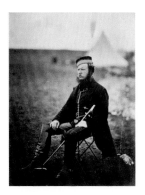

Col Adye RA
April 1855
20.7 × 15.4 cm
Albumen print. Plate 21
RCIN 2500256
Cat. no. 108

Lt Col Prince Edward Saxe Weimar
April 1855
19.1 × 15.6 cm
Albumen print
RCINS 2500257, 2506586, 2500063
Cat. no. 208

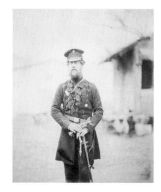

Col Reynardson
1855
20.0 × 15.8 cm
Albumen print
RCIN 2500258
Cat. no. 97

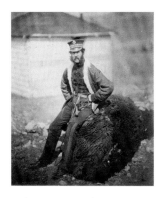

Col Moorsom S F gds
1855
19.9 × 15.9 cm
Albumen print
RCIN 2500259
Cat. no. 76

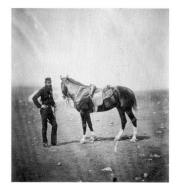

Major Woodford Rifles
1855
18.4 × 16.2 cm
Albumen print
RCIN 2500260
Cat. no. 133

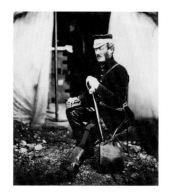

Col Wilbraham
1855
18.6 × 15.8 cm
Albumen print
RCINS 2500261, 2500099
Cat. no. 196

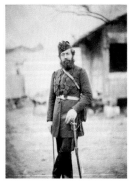

Col Hamilton
1855
20.5 × 15.0 cm
Albumen print
RCIN 2500262
Cat. no. 23

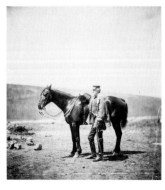

Col Dickson RE
1855
16.5 × 15.2 cm
Albumen print
RCIN 2500263
Cat. no. 199

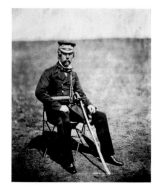

Col Airey D q mgl
1855
19.5 × 16.1 cm
Albumen print
RCINS 2500264, 2500111
Cat. no. 49

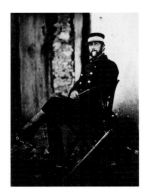

Col Blain
1855
18.6 × 14.2 cm
Albumen print
RCIN 2500265
Cat. no. 12

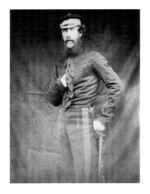

Col Harding Comdt
1855
18.0 × 13.7 cm
Albumen print
RCIN 2500266
Cat. no. 79

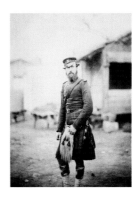

Col Grant 42nd
1855
18.4 × 13.3 cm
Albumen print. Plate 50
RCIN 2500267
Cat. no. 118

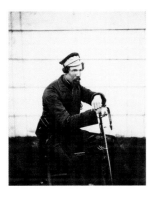

Honbl Major Cathcart
1855
18.7 × 15.1 cm
Albumen print
RCIN 2500268
Cat. no. 86

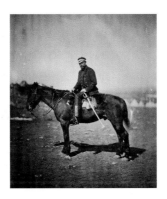

Major Halliwell
1855
17.3 × 14.8 cm
Albumen print
RCIN 2500269

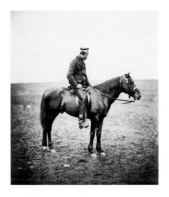

Honbl Major Cathcart
1855
17.4 × 15.5 cm
Albumen print
RCIN 2500270
Cat. no. 34

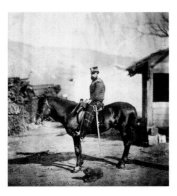

Ld Kirkwall
1855
16.7 × 15.9 cm
Albumen print
RCIN 2500271
Cat. no. 78

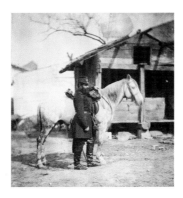

Major Keane RE
1855
15.9 × 15.1 cm
Salted paper print
RCIN 2500272

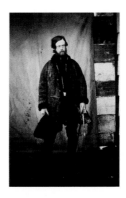

Ld Balgonie
1855
17.7 × 11.7 cm
Albumen print. Plate 42
RCIN 2500273
Cat. no. 109

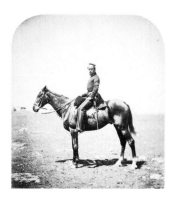

Honble Capt Clifford
1855
17.4 × 15.8 cm
Albumen print
RCIN 2500274
Cat. no. 227

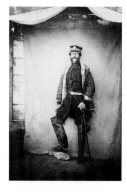

Col Seymour SFGds
1855
19.2 × 12.7 cm
Albumen print
RCINs 2500275, 2506587, 2500080
Cat. no. 115

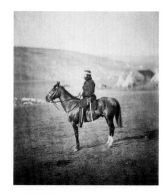

Col Shewell
1855
18.1 × 15.5 cm
Albumen print
RCINs 2500276, 2500098
Cat. no. 33

Capt Baring
1855
19.1 × 12.4 cm
Albumen print
RCIN 2500277
Cat. no. 194

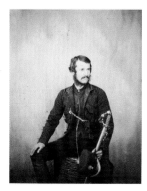

Capt Burnaby SGds
1855
17.0 × 13.5 cm
Albumen print
RCIN 2500278
Cat. no. 111

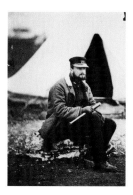

Capt Luard 77 Regt
1855
15.6 × 10.9 cm
Albumen print
RCIN 2500280
Cat. no. 74

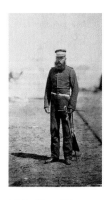

Major Pipon RA
1855
13.8 × 8.2 cm
Salted paper print
RCIN 2500281
Cat. no. 233

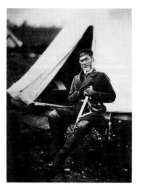

Capt Andrews 28 Regt
1855
19.0 × 14.0 cm
Albumen print
RCIN 2500282
Cat. no. 85

Captain Charles Holder
1855
17.7 × 13.7 cm
Albumen print
RCIN 2500283
Cat. no. 58

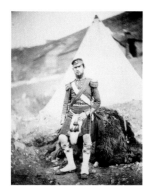

Capt Holder [Captain Cuninghame]
1855
19.9 × 15.5 cm
Albumen print
RCIN 2500284

Capt Goodlake Gds
1855
18.8 × 15.9 cm
Albumen print
RCINS 2500285, 2500560

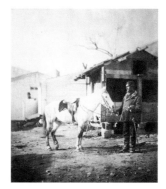

Capt Goodlake Gds
1855
18.2 × 15.8 cm
Salted paper print
RCINS 2500286, 2500568

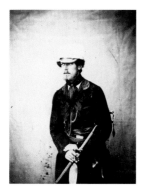

Capt Verschoyle Gds
May 1855
18.1 × 13.6 cm
Albumen print
RCIN 2500287
Cat. no. 64

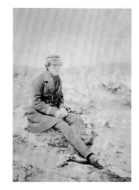

Comdr Maxse
April 1855
18.6 × 13.1 cm
Albumen print
RCIN 2500288
Cat. no. 167

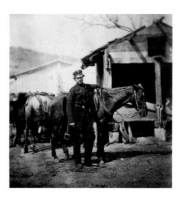

Capt Bathurst
1855
16.5 × 16.0 cm
Albumen print
RCIN 2500289
Cat. no. 1

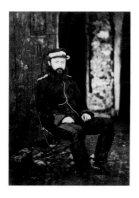

Capt Bolton RA
1855
20.0 × 14.3 cm
Albumen print
RCIN 2500290
Cat. no. 98

Capt Halford 5th D Gds
1855
16.2 × 12.9 cm
Salted paper print
RCIN 2500291
Cat. no. 113

Captain Liley RA
1855
14.8 × 15.9 cm
Salted paper print
RCIN 2500292

Capt Yates 11th Hussars
1855
18.3 × 15.4 cm
Albumen print
RCIN 2500293
Cat. no. 166

Capt King RHA
1855
16.6 × 15.8 cm
Albumen print
RCIN 2500294
Cat. no. 125

Lieut Grylls RHA
1855
15.6 × 15.2 cm
Salted paper print
RCIN 2500295

Lt Barnard 5th D Gds
1855
16.6 × 14.7 cm
Albumen print
RCIN 2500296
Cat. no. 107

Capt Hume & his Brother
1855
16.3 × 16.3 cm
Albumen print
RCIN 2500297
Cat. no. 170

Colonel Hallewell & Major Pearson
1855
18.9 × 15.9 cm
Albumen print
RCIN 2500298

Capt Morgan on the winner of the Crimean races
1855
17.2 × 14.3 cm
Albumen print
RCIN 2500299
Cat. no. 198

General Barnard's horse, grandson of Marengo
1855
16.6 × 15.6 cm
Albumen print
RCIN 2500300
Cat. no. 24

Simpson Esqr The Artist
1855
14.2 × 12.4 cm
Salted paper print. Plate 19
RCIN 2500301

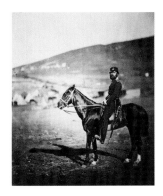

Captain Wilkinson, 27th [9th]
1855
17.9 × 15.2 cm
Albumen print
RCIN 2500302
Cat. no. 211

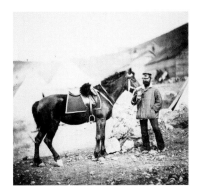

Capt Drysdale 42nd
1855
15.3 × 15.8 cm
Albumen print
RCIN 2500303
Cat. no. 45

Mr Angell Postmaster
1855
18.8 × 16.0 cm
Albumen print. Plate 23
RCIN 2500304
Cat. no. 39

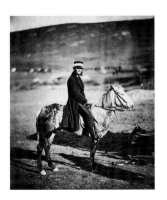

Mr Angell Postmaster mounted
1855
18.4 × 15.8 cm
Albumen print
RCIN 2500305
Cat. no. 17

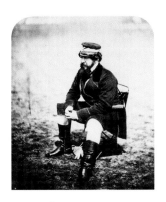

Mr Russell
June 1855
18.1 × 15.3 cm
Albumen print. Plate 18
RCIN 2500306
Cat. no. 67

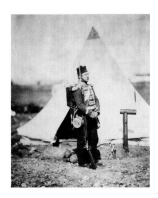

Private full marching order
1855
17.1 × 14.2 cm
Albumen print
RCINS 2500307, 2500227
Cat. no. 51

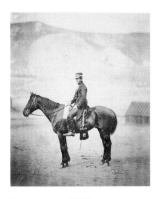

Lt Strangways RHA
1855
19.6 × 16.2 cm
Albumen print
RCIN 2500308
Cat. no. 146

Capt Walker 30th
1855
16.3 × 13.9 cm
Albumen print
RCIN 2500309
Cat. no. 29

Major A Butler 28th
1855
18.0 × 14.7 cm
Albumen print
RCIN 2500310
Cat. no. 5

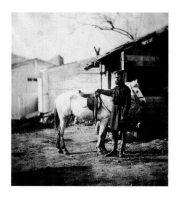

Major Chapman of the Batteries
1855
14.5 × 13.6 cm
Salted paper print
RCIN 2500311
Cat. no. 139

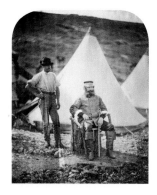

Captain George 4th Lt Dgns
1855
19.6 × 15.8 cm
Salted paper print
RCIN 2500312
Cat. no. 168

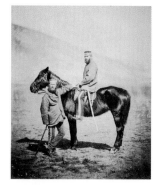

Lt Yates 11th & Capt Phillips 8th
April 1855
18.9 × 15.8 cm
Albumen print
RCIN 2500313
Cat. no. 52

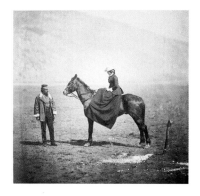

Mr & Mrs Duberley 8th
April 1855
15.2 × 16.0 cm
Albumen print. Plate 40
RCIN 2500314
Cat. no. 77

Capt Turner's friend name unknown
Capt J.J.M Wardrop
1855
17.5 × 15.3 cm
Albumen print. Plate 41
RCINs 2500315, 2500561
Cat. no. 231

Capt Thompson Commist
1855
14.7 × 16.0 cm
Albumen print
RCIN 2500316
Cat. no. 14

Color Sargt of the 21st
1855
17.8 × 14.1 cm
Albumen print
RCIN 2500317

2 officers of the 42nd
[Captain Graham and Captain Macleod]
1855
19.1 × 15.3 cm
Albumen print
RCIN 2500318
Cat. no. 43

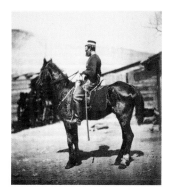

LN Hill 4th Dgns
1855
17.8 × 16.0 cm
Albumen print
RCIN 2500319
Cat. no. 149

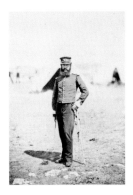

Major Radcliff 20th
1855
16.6 × 11.5 cm
Albumen print
RCIN 2500320
Cat. no. 240

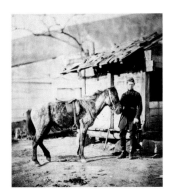

Major Hemeage SFGds
[Major Heneage Coldstream Guards]
1855
17.4 × 15.5 cm
Albumen print
RCIN 2500321
Cat. no. 142

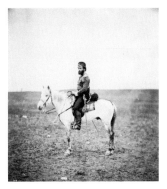

Capt Godley 28th
1855
16.7 × 15.0 cm
Albumen print
RCIN 2500322
Cat. no. 7

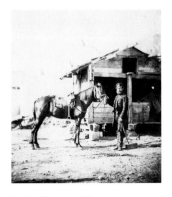

Major Chapman RE
1855
16.8 × 14.9 cm
Albumen print
RCIN 2500323
Cat. no. 82

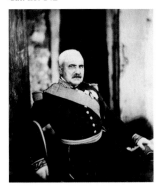

Genl Pelissier
June 1855
17.9 × 15.2 cm
Albumen print
RCINs 2500324, 2500032
Cat. no. 264

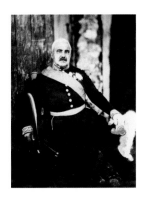

Genl Pelissier
June 1855
18.8 × 14.2 cm
Albumen print
RCINs 2500325, 2506589, 2500033
Cat. no. 271

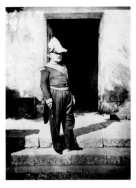

Genl Pelissier
June 1855
18.7 × 14.2 cm
Albumen print
RCIN 2500326
Cat. no. 202

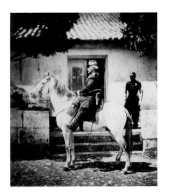

Genl Pelissier
June 1855
17.9 × 15.5 cm
Albumen print. Plate 30
RCIN 2500327
Cat. no. 222

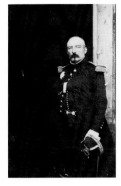

General Bosquet
1855
17.2 × 11.2 cm
Albumen print
RCINs 2500328, 2506590, 2500012
Cat. no. 258

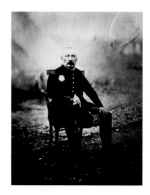

General Bosquet
1855
18.2 × 14.2 cm
Albumen print
RCIN 2500329
Cat. no. 99

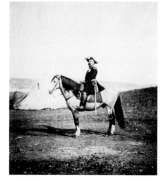

General Bosquet on Bayard
1855
16.7 × 14.9 cm
Albumen print
RCINs 2500330, 2500014
Cat. no. 278

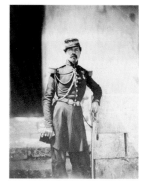

Col Vico attd to Lord Raglan
1855
19.1 × 14.5 cm
Albumen print
RCINs 2500331, 2506593, 2500046
Cat. no. 197

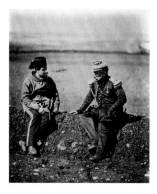

General Cissé and Adc
1855
17.9 × 14.9 cm
Salted paper print. Plate 51
RCIN 2500332
Cat. no. 207

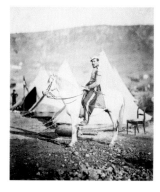

Chausseurs d'Afrique Offr
1855
17.2 × 14.7 cm
Albumen print
RCIN 2500333
Cat. no. 65

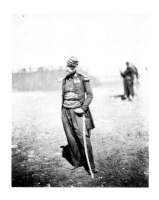

Commandant Ballan
1855
19.1 × 15.4 cm
Salted paper print
RCIN 2500334

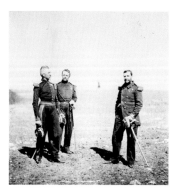

3 French Officers
1855
16.1 × 15.4 cm
Albumen print
RCIN 2500335

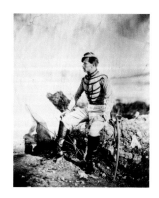

Captain Thomas on Genl Bosquet's staff
1855
20.2 × 16.5 cm
Albumen print
RCINs 2500336, 2500084
Cat. no. 213

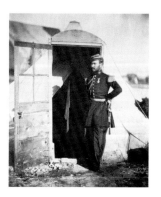

do Fay – do –
[Captain Fay on Genl Bosquet's staff]
1855
19.2 × 15.9 cm
Albumen print
RCIN 2500337
Cat. no. 91

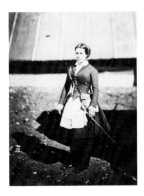

Vivandière
5 May 1855
17.4 × 13.1 cm
Albumen print. Plate 45
RCIN 2500338
Cat. no. 37

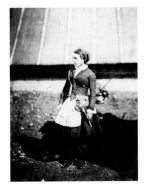

Vivandière
5 May 1855
17.3 × 12.9 cm
Albumen print
RCIN 2500339
Cat. no. 103

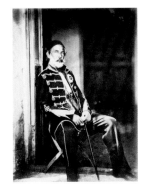

Omar Pacha
1855
19.7 × 14.8 cm
Albumen print
RCINs 2500340, 2506594, 2500017
Cat. no. 272

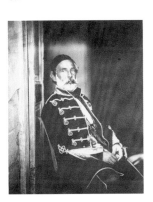

Omar Pacha
1855
17.6 × 14.2 cm
Salted paper print. Plate 13
RCIN 2500341

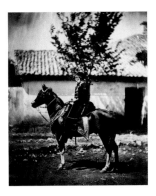

Omar Pacha
1855
18.5 × 15.2 cm
Albumen print. Plate 29
RCINs 2500342, 2500018
Cat. no. 214

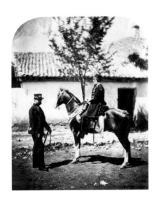

Omar Pacha and Colonel Simmons
1855
19.3 × 15.9 cm
Salted paper print
RCIN 2500343
Cat. no. 138

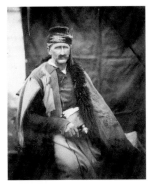

Croat
March 1855
18.2 × 15.0 cm
Albumen print
RCIN 2500344
Cat. no. 234

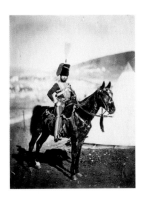

Officer 11th Hussars
1855
19.2 × 14.5 cm
Albumen print
RCIN 2500345
Cat. no. 10

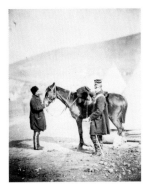

Lieut King 4th Light Dragoons
1855
19.9 × 15.9 cm
Albumen print
RCIN 2500346
Cat. no. 89

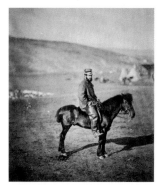

Captain Inglis 5th Dragoons
April 1855
17.9 × 15.3 cm
Albumen print
RCIN 2500347
Cat. no. 239

Major Keane
1855
17.3 × 15.9 cm
Albumen print
RCIN 2500348

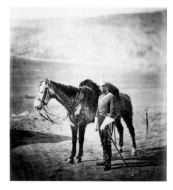

Captain Halford ready for duty
April 1855
17.3 × 15.9 cm
Albumen print
RCIN 2500349
Cat. no. 192

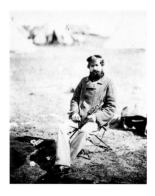

Dr Marlow 20th [28th]
1855
19.1 × 15.8 cm
Salted paper print
RCIN 2500350
Cat. no. 69

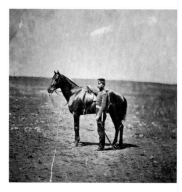

Captain Prettyman 33rd
1855
12.1 × 12.1 cm
Salted paper print
RCIN 2500351

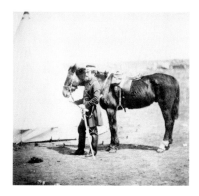

Captain Layard
1855
14.4 × 14.9 cm
Albumen print
RCINS 2500352, 2500104
Cat. no. 164

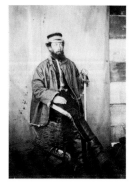

Col Clarke – Scots Greys –
1855
19.9 × 14.0 cm
Albumen print
RCIN 2500353
Cat. no. 54

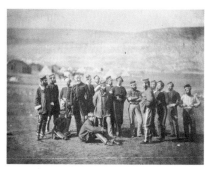

Col Doherty, Officers and men – 13th
1855
14.6 × 19.0 cm
Salted paper print. Plate 36
RCIN 2500354
Cat. no. 187

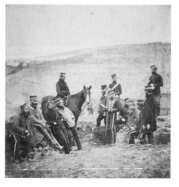

Officers 8th Hussars
April 1855
16.7 × 16.3 cm
Albumen print. Plate 12
RCIN 2500355
Cat. no. 255

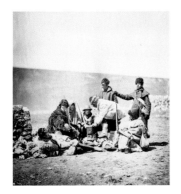

47th Winter Dress for Trenches
1855
16.5 × 15.3 cm
Albumen print
RCIN 2500356
Cat. no. 134

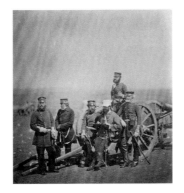

Officers of the 14th with a Gun
1855
16.5 × 15.4 cm
Salted paper print
RCIN 2500357

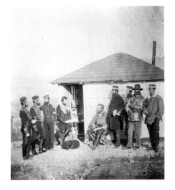

Major Brandling's Hut
1855
17.3 × 15.9 cm
Salted paper print.
RCIN 2500358

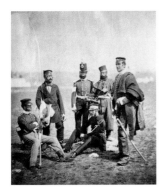

Bde Van Straubenzee & officers
1855
18.2 × 15.8 cm
Albumen print
RCIN 2500359
Cat. no. 238

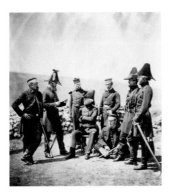

Sir George Brown & staff
5 May 1855
17.9 × 15.9 cm
Albumen print
RCINS 2500360, 2500040
Cat. no. 116

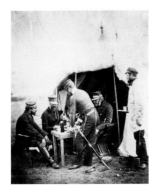

Brd Garrett & staff – camp fire
1855
19.2 × 15.8 cm
Albumen print
RCINS 2500361, 2500095
Cat. no. 189

Gen Dacres – Captain Hamley – Col Adye –
1855
18.3 × 15.7 cm
Albumen print
RCINS 2500362, 2500105
Cat. no. 129

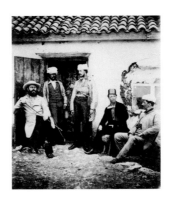

Railway Officials
1855
18.9 × 16.4 cm
Albumen print
RCIN 2500363
Cat. no. 112

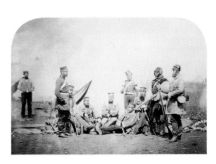

Officers and men 89th
1855
14.2 × 21.3 cm
Albumen print
RCIN 2500364
Cat. no. 36

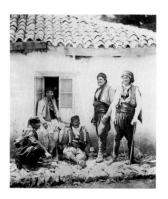

Group of Montenegrins
1855
18.3 × 15.8 cm
Albumen print
RCIN 2500365
Cat. no. 182

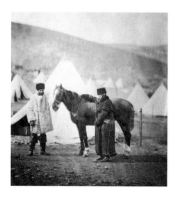

Colonel Lowe 4th Lt Dr
1855
17.6 × 16.1 cm
Salted paper print
RCIN 2500366
Cat. no. 201

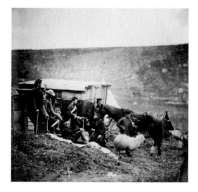

Group 4th Draggon Guards
1855
15.9 × 16.5 cm
Albumen print
RCIN 2500367
Cat. no. 257

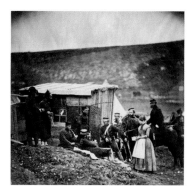

do– do– [Group 4th Draggon Guards]
1855
16.1 × 16.4 cm
Albumen print. Plate 35
RCIN 2500368
Cat. no. 279

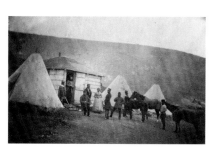

Hut of Captain Webb – 4th Dragoon Guards –
1855
12.9 × 20.5 cm
Salted paper print
RCIN 2500369
Cat. no. 79*

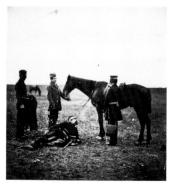

Col Airey – Major Hallewell – & servants
1855
16.4 × 15.6 cm
Albumen print
RCIN 2500370
Cat. no. 242

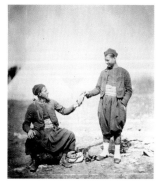

2 Zouaves
5 May 1855
18.4 × 15.9 cm
Albumen print
RCIN 2500371
Cat. no. 71

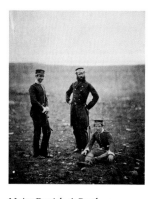

Major Daniels & Brothers –
38th [Major Daniels and officers]
1855
16.9 × 13.8 cm
Albumen print
RCIN 2500372
Cat. no. 237

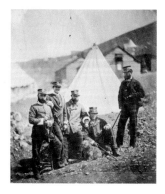

Officers of the 71st
1855
19.2 × 16.4 cm
Salted paper print
RCIN 2500373
Cat. no. 137

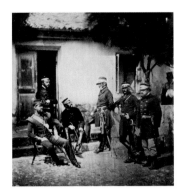

General Estcourt & Staff
1855
17.5 × 16.7 cm
Albumen print
RCINS 2500374, 2500041
Cat. no. 251

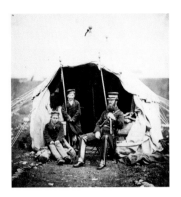

Colonel Brownrigg and the two Russian boys –
Alma and Inkermann –
1855
16.8 × 15.5 cm
Albumen print. Plate 53
RCIN 2500375
Cat. no. 44

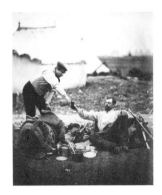

Major Halliwell
1855
19.4 × 16.3 cm
Salted paper print. Plate 32
RCIN 2500376
Cat. no. 185

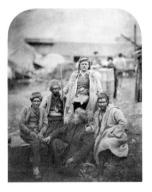

Group of croats
March 1855
19.3 × 15.5 cm
Salted paper print
RCINS 2500377, 2500225
Cat. no. 223

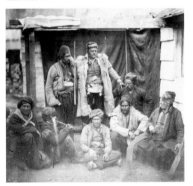

Group of croats
March 1855
15.7 × 16.8 cm
Salted paper print. Plate 54
RCIN 2500378, 2500422
Cat. no. 275

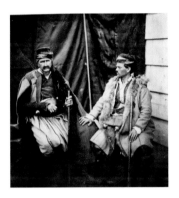

Croats
March 1855
16.9 × 16.1 cm
Albumen print
RCIN 2500379
Cat. no. 144

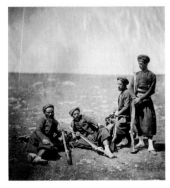

4 Zouaves
5 May 1855
17.2 × 15.9 cm
Albumen print
RCIN 2500380
Cat. no. 232

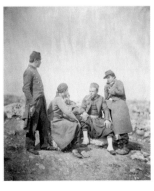

Zouaves and soldiers of the line –
5 May 1855
18.5 × 16.1 cm
Albumen print
RCINS 2500381, 2500178
Cat. no. 131

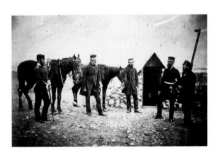

General Garrett's Hut
1855
13.6 × 20.8 cm
Albumen print
RCIN 2500382
Cat. no. 83

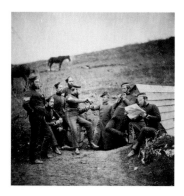

The Entente Cordiale
1855
16.7 × 16.1 cm
Albumen print
RCIN 2500383
Cat. no. 220

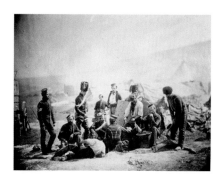

8th Hussars Cooking Hut
1855
15.3 × 19.6 cm
Albumen print. Plate 39
RCINs 2500384, 2500223
Cat. no. 263

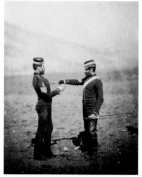

Sergeants 8th Hussars
April 1855
17.4 × 13.8 cm
Albumen print. Plate 52
RCINs 2500385, 2500176

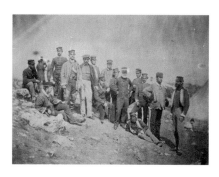

Officers 17th Regiment
1855
15.2 × 20.6 cm
Albumen print
RCIN 2500386
Cat. no. 88

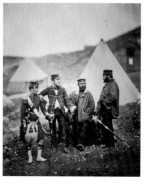

4 Officers of the 42nd
1855
19.3 × 16.0 cm
Albumen print. Plate 49
RCIN 2500387
Cat. no. 236

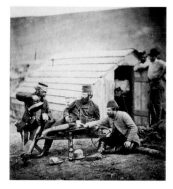

Hardships in the Crimea
1855
17.6 × 16.2 cm
Albumen print. Plate 31
RCIN 2500388
Cat. no. 216

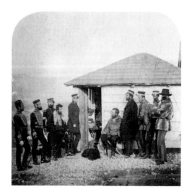

Major Brandling's hut
1855
15.8 × 15.8 cm
Salted paper print
RCIN 2500389

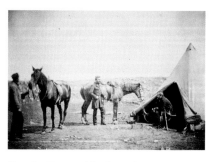

*Captains Hume and Snodgrass /
waiting for the General*
1855
13.9 × 20.1 cm
Salted paper print
RCIN 2500390

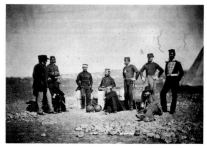

Sir John Campbell and Group of officers
1855
13.6 × 19.7 cm
Albumen print
RCINs 2500391, 2500083
Cat. no. 266

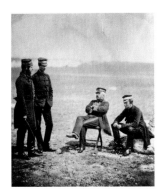

General Barnard & Staff
1855
18.3 × 15.6 cm
Albumen print
RCINs 2500392, 2500067

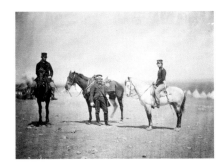

Col Cunynghame
1855
14.1 × 19.3 cm
Salted paper print
RCIN 2500393
Cat. no. 110

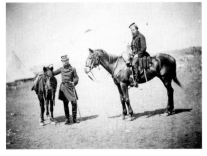

Col Adye and Captain Whitmore
1855
13.8 × 18.7 cm
Albumen print
RCIN 2500394
Cat. no. 249

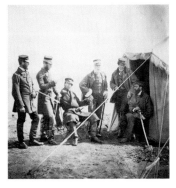

Brg McPherson & officers of the 4th Division
1855
17.4 × 16.5 cm
Albumen print
RCIN 2500395
Cat. no. 59

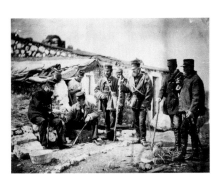

Col Shadforth & Hut
1855
15.8 × 20.5 cm
Albumen print
RCINs 2500396, 2500044
Cat. no. 6

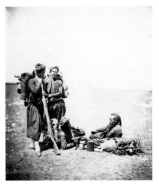

Zouaves in Marching Order
5 May 1855
17.4 × 15.8 cm
Albumen print
RCINs 2500397, 2500177

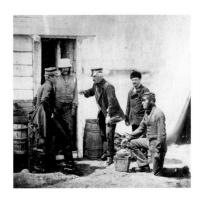

General Barnard & servants
1855
15.4 × 16.1 cm
Albumen print
RCIN 2500398

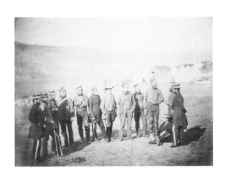

Major Burton & officers 5th Dragoons
1855
15.5 × 21.1 cm
Albumen print
RCIN 2500399
Cat. no. 102

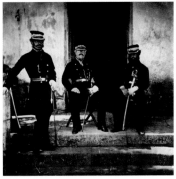

General Lockyer & 2 Staff Officers
1855
15.8 × 16.2 cm
Albumen print
RCINs 2500400, 2500042
Cat. no. 60

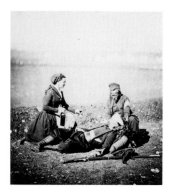

Wounded Zouave & Vivandiere
5 May 1855
17.4 × 15.8 cm
Albumen print. Plate 46
RCIN 2500401

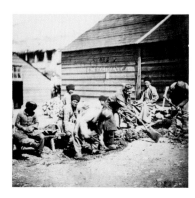

Tartar labourers
1855
16.2 × 16.9 cm
Albumen print. Plate 48
RCIN 2500402
Cat. no. 120

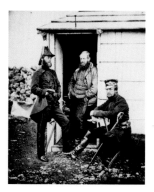

Col Ponsonby etc
1855
19.4 × 15.8 cm
Albumen print
RCIN 2500403
Cat. no. 143

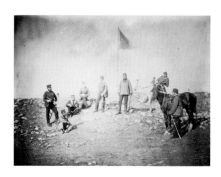

Captn Hall's Group 14th – 12th
1855
14.8 × 19.9 cm
Albumen print
RCIN 2500404

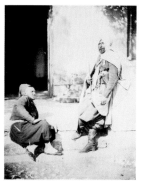

Zouave & Officer of Saphis
1855
20.8 × 16.3 cm
Albumen print
RCIN 2500405
Cat. no. 40

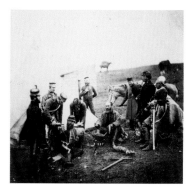

*Mr Thompson of Commissariat with
Ismail Pasha's attendants*
1855
16.3 × 16.6 cm
Albumen print
RCIN 2500406
Cat. no. 241

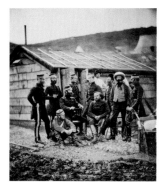

Group of Officers – 4th Light Dragoons
1855
18.1 × 15.9 cm
Albumen print
RCIN 2500407
Cat. no. 16

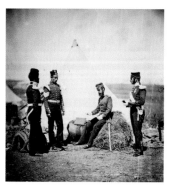

Captn Walker 30th reading General Orders
1855
16.9 × 15.9 cm
Albumen print
RCIN 2500408
Cat. no. 117

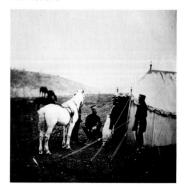

Captn Forster & Officers 4th Dragoon Guards
1855
15.9 × 15.6 cm
Albumen print
RCIN 2500409
Cat. no. 169

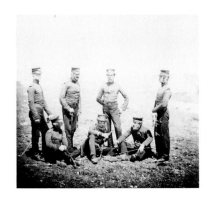

Officers of the 68th
1855
15.1 × 16.3 cm
Albumen print
RCIN 2500410
Cat. no. 21

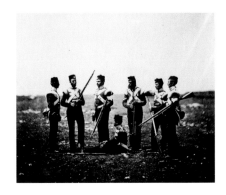

Men of 68th in Parade dress
1855
13.9 × 16.4 cm
Albumen print
RCIN 2500411
Cat. no. 48

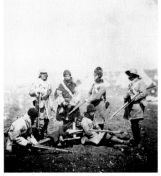

The 68th Regiment, winter dress
1855
16.9 × 15.5 cm
Salted paper print
RCINs 2500412, 2500569
Cat. no. 68

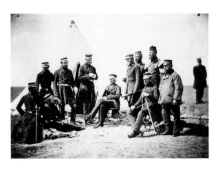

General Pennefather and Officers
1855
14.9 × 20.8 cm
Albumen print
RCINs 2500413, 2500043
Cat. no. 84

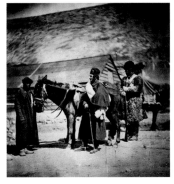

Captain Burnaby Grds & Nubian servants
1855
16.7 × 16.2 cm
Albumen print
RCIN 2500414
Cat. no. 184

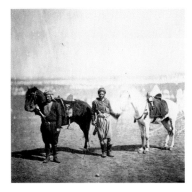

Nubian Servants and Horses
27 April 1855
14.8 × 15.3 cm
Salted paper print
RCIN 2500415

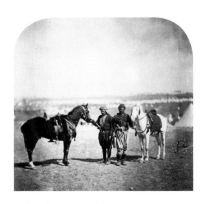

Nubian Servants and Horses
27 April 1855
14.7 × 15.6 cm
Salted paper print
RCIN 2500416

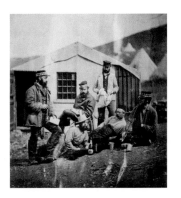

Officers of the 71st with Captain McDonnell
1855
16.5 × 15.3 cm
Albumen print
RCIN 2500417
Cat. no. 188

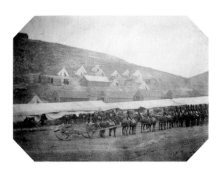

Field Piece
1855
14.0 × 19.6 cm
Salted paper print
RCIN 2500418
Cat. no. 100

Dromedary
1855
18.2 × 15.9 cm
Albumen print. Plate 34
RCINS 2500419, 2500559, 2500226

Mr Cooksley and Group
1855
12.6 × 15.9 cm
Albumen print
RCIN 2500420

Captain Croker & servant
1855
18.3 × 15.8 cm
Albumen print
RCIN 2500421
Cat. no. 150

The pipe of peace
1855
13.9 × 13.2 cm
Salted paper print
RCIN 2500423

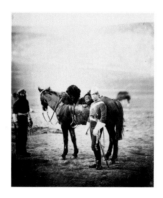

Captain Godman & servant 5th Dragoons
1855
18.1 × 15.3 cm
Albumen print
RCIN 2500424
Cat. no. 121

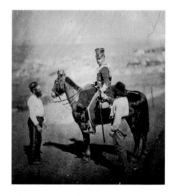

The Pocket Pistol
1855
17.2 × 15.5 cm
Albumen print
RCIN 2500425
Cat. no. 171

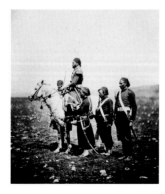

*Ismail Pacha, on horseback,
with Turkish officers*
27 April 1855
17.0 × 15.0 cm
Albumen print
RCIN 2500426
Cat. no. 114

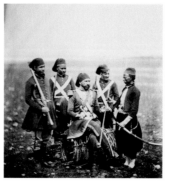

Ismael Pacha receiving his pipe
27 April 1855
17.2 × 16.1 cm
Albumen print
RCIN 2500427
Cat. no. 32

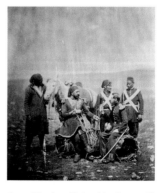

Ismael Pacha offering his pipe to officer
27 April 1855
17.5 × 15.3 cm
Albumen print
RCIN 2500428

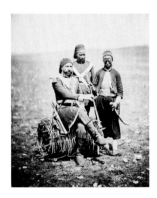

Ismael Pacha his pipe put out
27 April 1855
18.0 × 14.7 cm
Albumen print. Plate 55
RCIN 2500429

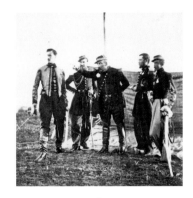

Genl Bosquet & staff
1855
15.8 × 15.5 cm
Albumen print
RCIN 2500430
Cat. no. 119

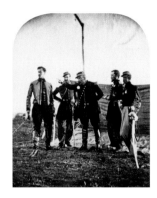

Genl Bosquet pointing with his right hand
1855
19.8 × 16.2 cm
Albumen print
RCIN 2500431

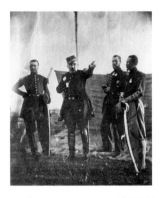

Genl Bosquet pointing with his left hand
1855
19.0 × 16.0 cm
Albumen print
RCIN 2500432
Cat. no. 81*

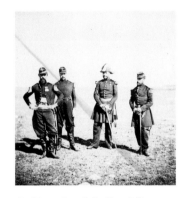

Genl Buret French Artillery Officers
1855
16.7 × 15.8 cm
Albumen print
RCIN 2500433

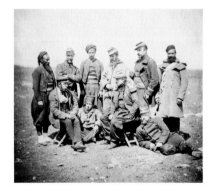

Genl Cissé & Officers
5 May 1855
14.8 × 16.6 cm
Albumen print
RCIN 2500434
Cat. no. 128

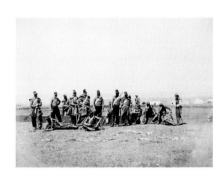

Small group of Chasseurs d'Afrique
5 May 1855
17.8 × 24.1 cm
Albumen print
RCIN 2500435

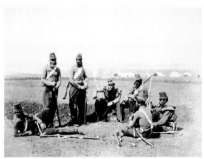

Chasseurs d'Afrique
5 May 1855
17.7 × 23.9 cm
Salted paper print
RCIN 2500436

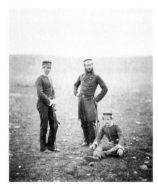

Major Daniels & Brothers
1855
16.3 × 14.1 cm
Salted paper print
RCIN 2500437

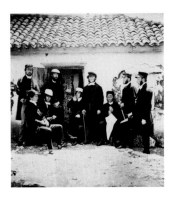

The Group of the Clergy
1855
17.2 × 15.7 cm
Albumen print
RCIN 2500438
Cat. no. 75

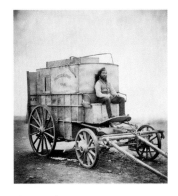

Photographic Van
1855
17.4 × 15.9 cm
Albumen print. Plate 56
RCIN 2500439
Cat. no. 122

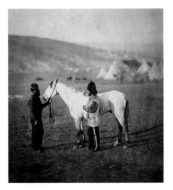

Col Clark S Greys & Horse wounded at Balaklava
1855
15.8 × 14.5 cm
Salted paper print
RCIN 2500440
Cat. no. 2

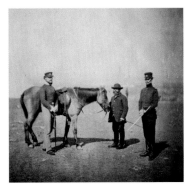

Capt Varne & friend 38th
1855
15.1 × 15.6 cm
Albumen print
RCINS 2500441, 2500566

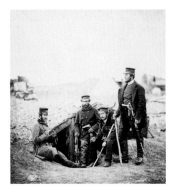

Group of Officers 57th
1855
15.4 × 14.1 cm
Albumen print
RCIN 2500442
Cat. no. 18

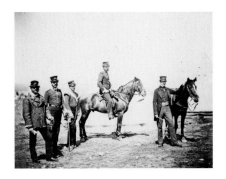

Capt Butler & officers 47th
1855
14.4 × 18.9 cm
Albumen print
RCIN 2500443
Cat. no. 252

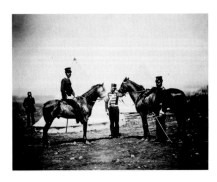

2 officers 47th
1855
14.4 × 18.9 cm
Albumen print
RCIN 2500444
Cat. no. 101

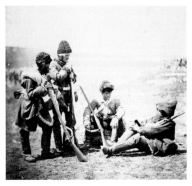

Men of the 77th Regiment Winter Costume
1855
14.7 × 15.8 cm
Salted paper print
RCINS 2500445, 2500224
Cat. no. 46

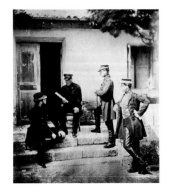

Genl Jones & Staff
1855
19.0 × 16.4 cm
Albumen print
RCIN 2500446
Cat. no. 41

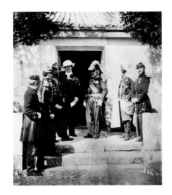

Lord Raglan's head Qrs with Genl Pelissier
1855
18.8 × 16.5 cm
Albumen print. Plate 17
RCIN 2500447
Cat. no. 15

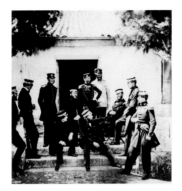

Head Quarters Staff
1855
17.6 × 16.4 cm
Albumen print
RCIN 2500448
Cat. no. 165

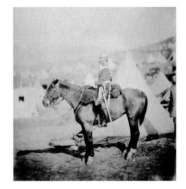

Major Burton 5 Ds Gds
1855
17.1 × 16.5 cm
Albumen print
RCIN 2500449
Cat. no. 9

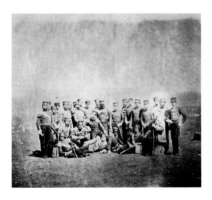

Officers of the 88 before the 7 of June
April 1855
14.1 × 15.8 cm
Albumen print
RCIN 2500450

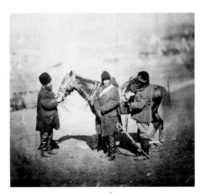

Officers of the 4th Lt Dg
1855
14.8 × 15.9 cm
Albumen print
RCIN 2500451, 2500452
Cat. no. 95

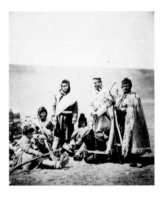

Capt Pechell & men of 77 in Winter Dress
1855
18.5 × 16.0 cm
Albumen print
RCIN 2500453
Cat. no. 219

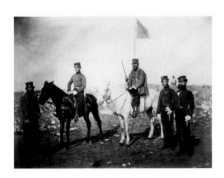

Captain Tinley & officers of 39th
1855
15.0 × 20.1 cm
Albumen print
RCIN 2500454
Cat. no. 250

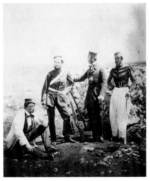

Captn's Lowry and Colworthy etc 1st Royals
1855
18.0 × 15.1 cm
Albumen print
RCIN 2500455
Cat. no. 148

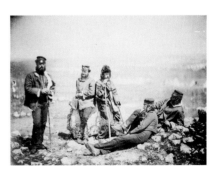

Group of officers at Cathcarts Hill
1855
15.0 × 20.2 cm
Albumen print
RCIN 2500456
Cat. no. 26

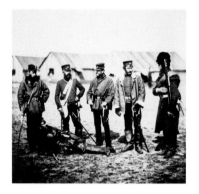

Liuet Colonel Munro and officers
of the 39th Regiment
1855
15.7 × 16.2 cm
Albumen print
RCIN 2500457

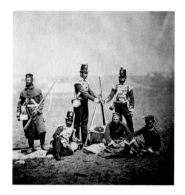

Piling Arms 3 Buffs
1855
16.2 × 15.5 cm
Albumen print
RCIN 2500458
Cat. no. 172

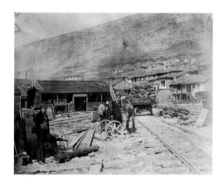

Railway yard at Balaklava
15 March 1855
20.6 × 26.0 cm
Salted paper print. Plate 63
RCINS 2500459, 2500570

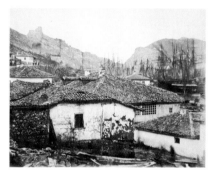

Balaklava looking seawards Russian Cottage
in foreground
March 1855
20.8 × 26.6 cm
Albumen print
RCIN 2500460
Cat. no. 177

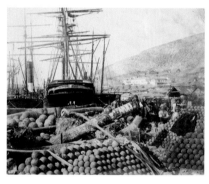

Balaklava Ordnance Wharf
March 1855
20.5 × 25.2 cm
Albumen print. Plate 57
RCIN 2500461
Cat. no. 53

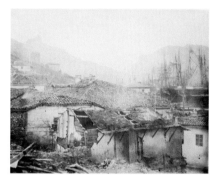

Balaklava looking seawards with
ruined shed in foreground
March 1855
20.9 × 26.3 cm
Albumen print
RCIN 2500462
Cat. no. 230

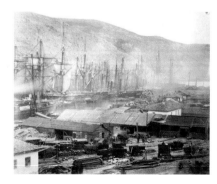

Railway sheds workshops at Balaklava
15 March 1855
20.9 × 26.1 cm
Albumen print. Plate 58
RCIN 2500463

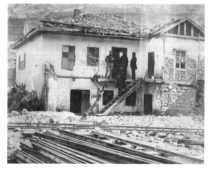

Old Post Office
15 March 1855
19.9 × 25.4 cm
Salted paper print. Plate 64
RCIN 2500464
Cat. no. 8

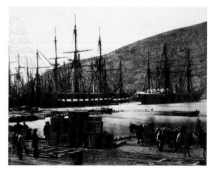

The Diamond and Wasp Balaklava Harbour
March 1855
20.8 × 26.9 cm
Albumen print. Plate 66
RCIN 2500465

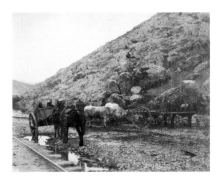

Carts leaving Balaklava
March 1855
20.2 × 25.9 cm
Salted paper print
RCIN 2500466

The Cemetery on Cathcarts hill showing the Flag Staff
1855
18.7 × 25.8 cm
Albumen print
RCIN 2500467
Cat. no. 47

The Cemetery on Cathcarts hill showing the tombs of Strangways, Goldie and Cathcart
1855
18.7 × 25.0 cm
Albumen print
RCIN 2500468
Cat. no. 206

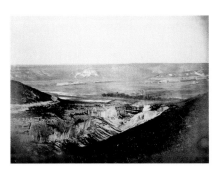

The Quarries & Aqueduct. Valley of Inkermann
May 1855
18.5 × 25.4 cm
Albumen print
RCIN 2500469
Cat. no. 260

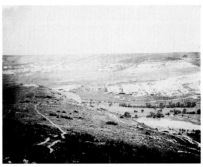

Ruins of Inkermann
May 1855
20.2 × 25.8 cm
Albumen print
RCIN 2500470
Cat. no. 261

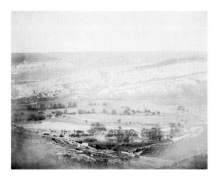

Valley of Inkermann with Tchneraya
May 1855
19.2 × 24.8 cm
Albumen print
RCIN 2500471
Cat. no. 262

Inkermann showing the Guards Battery at the Battle
1855
17.4 × 25.1 cm
Albumen print
RCIN 2500472
Cat. no. 11

Panoramic Views of the Plains of Balaklava
1855
15.8 × 25.6 cm
Albumen print
RCIN 2500473

Panoramic Views of the Plains of Balaklava
1855
18.4 × 24.0 cm
Albumen print
RCINS 2500474, 2500572
Cat. no. 244

Panoramic Views of the Plains of Balaklava
1855
18.0 × 25.7 cm
Albumen print
RCINS 2500475, 2500573
Cat. no. 245

Panoramic Views of the Plains of Balaklava
1855
16.4 × 24.8 cm
Albumen print
RCINS 2500476, 2500574
Cat. no. 246

Panoramic Picture of the Plains of Balaklava
1855
16.8 × 25.4 cm
Albumen print
RCIN 2500477

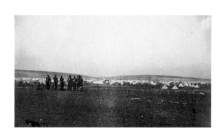

View of Piquet House from Cathcart's hill
1855
14.5 × 26.0 cm
Salted paper print
RCIN 2500478
Cat. no. 50

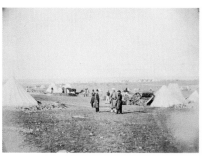

Lt Division Camp from Bosquets Quarters
1855
18.1 × 25.1 cm
Albumen print
RCIN 2500479
Cat. no. 55

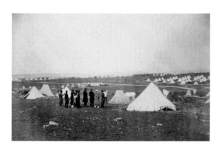

View from Bosquets Qrs looking towards McKenzie's farm
1855
15.4 × 24.6 cm
Albumen print
RCIN 2500480
Cat. no. 94

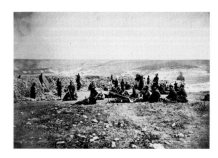

French redoubt at Inkermann
1855
17.1 × 25.3 cm
Albumen print
RCIN 2500481
Cat. no. 186

Sebastopol from the Redoubt des Anglais
1855
14.4 × 23.8 cm
Salted paper print. Plate 71
RCIN 2500482

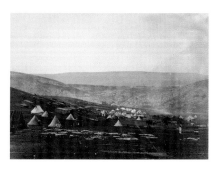

Cavalry Camp looking towards the plateau of Sebastopol
1855
18.7 × 25.9 cm
Salted paper print
RCIN 2500483
Cat. no. 274

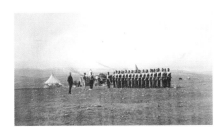

*Sir John Campbell with the remains
of the Light Company of the 38th*
1855
13.5 × 24.0 cm
Salted paper print
RCIN 2500484

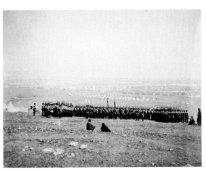

*Col Shadforth & the 57th Inkermann
in the distance*
1855
18.6 × 23.9 cm
Albumen print
RCIN 2500485
Cat. no. 127

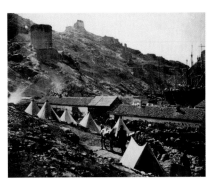

*The old genoese Castle from
above the Cattle Pier*
March 1855
28.3 × 35.2 cm
Albumen print
RCIN 2500486
Cat. no. 3

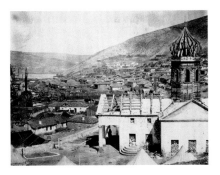

Balaklava from above the Russian Church
March 1855
26.9 × 35.2 cm
Salted paper print. Plate 62
RCINS 2500487, 2500576
Cat. no. 27

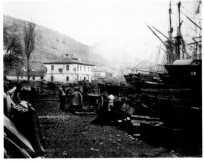

Balaklava, Ordnance Wharf
March 1855
26.8 × 35.0 cm
Albumen print. Plate 60
RCINS 2500488, 2500497
Cat. no. 4

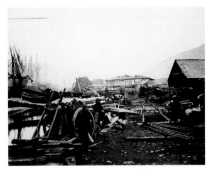

Landing Place. Railway Store
15 March 1855
28.0 × 36.1 cm
Albumen print
RCIN 2500489
Cat. no. 31

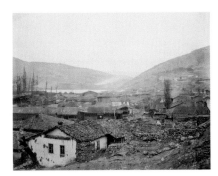

General View of Balaklava Hospital on the right
March 1855
27.7 × 35.5 cm
Albumen print
RCIN 2500490
Cat. no. 81

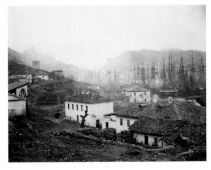

*General view of Balaklava looking seawards
Commdnt House in the foreground*
March 1855
27.0 × 35.3 cm
Albumen print
RCIN 2500491
Cat. no. 28

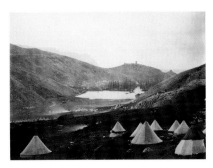

Balaklava from the camp of S F Guards
26 March 1855
25.7 × 35.3 cm
Albumen print
RCINS 2500492, 2500578

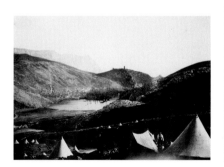

Balaklava from Guards Hill
26 March 1855
24.2 × 33.9 cm
Albumen print
RCIN 2500493
Cat. no. 277

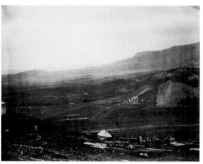

View of Balaklava from Guards hill Canrobert's Hill & Inkermann in the distance
1855
27.3 × 35.5 cm
Albumen print
RCIN 2500494
Cat. no. 30

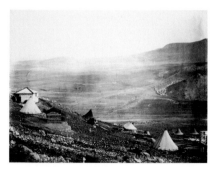

Lines of Balaklava Canrobert's Hill in the distance
1855
26.9 × 35.6 cm
Salted paper print
RCIN 2500495

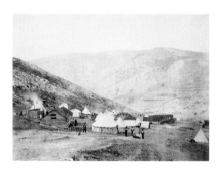

Camp of 71st at Balaklava with Commisnt Camp
1855
25.5 × 35.3 cm
Albumen print
RCIN 2500496
Cat. no. 104

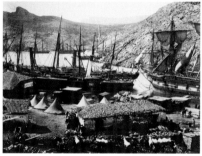

Cossack Bay Balaklava
March 1855
26.8 × 35.6 cm
Albumen print. Plate 59
RCIN 2500498
Cat. no. 210

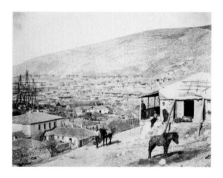

Town of Balaklava with pony in front
March 1855
27.1 × 35.4 cm
Albumen print
RCIN 2500499

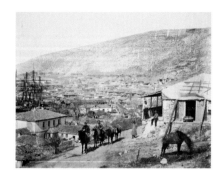

Town of Balaklava with pack horses in foreground
March 1855
27.3 × 35.4 cm
Salted paper print
RCIN 2500500
Cat. no. 93

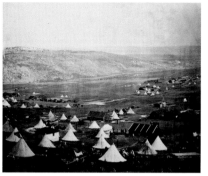

Cavalry Camp 11th Hussars in foreground
1855
27.7 × 33.3 cm
Albumen print
RCINs 2500501, 2500528
Cat. no. 226

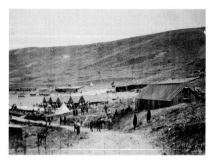

Camp 4 Lt Dgs Soldiers Quarters
1855
24.9 × 33.9 cm
Albumen print
RCIN 2500502
Cat. no. 57

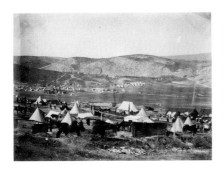

Camp 5th D Gds
1855
26.2 × 35.8 cm
Albumen print
RCIN 2500503
Cat. no. 62

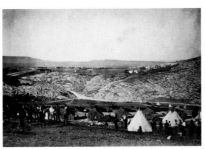

Camp of Major Brandling Troop of Artillery
1855
24.7 × 35.6 cm
Albumen print
RCIN 2500504
Cat. no. 225

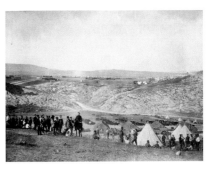

Major Brandling's Troop of Horse Artillery
1855
25.5 × 34.1 cm
Salted paper print
RCIN 2500505
Cat. no. 209

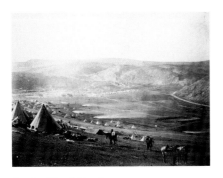

Cavalry Church Parade
1855
26.8 × 35.1 cm
Salted paper print
RCIN 2500506

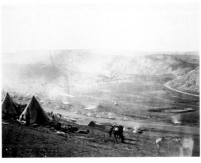

Church Parade Cavalry Camp
1855
26.2 × 34.5 cm
Salted paper print
RCIN 2500507

Quiet day in Mortar battery
23 April 1855
26.4 × 34.8 cm
Albumen print
RCIN 2500508
Cat. no. 56

Mortar Battery loading
23 April 1855
24.3 × 35.7 cm
Albumen print
RCIN 2500509
Cat. no. 191

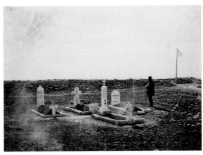

Tombs of the Generals on Cathcart Hill
1855
24.9 × 34.7 cm
Albumen print. Plate 67
RCIN 2500510
Cat. no. 105

*The Mamelon & Malakof from front
of Mortar Battery*
April 1855
26.0 × 33.6 cm
Albumen print
RCIN 2500511
Cat. no. 267

Sebastopol from front of the Mortar Battery
April 1855
18.2 × 34.7 cm
Salted paper print. Plate 33
RCIN 2500512
Cat. no. 273

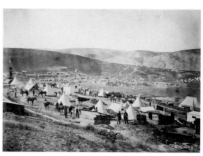

Camp of the 5 D Gds, looking towards Karania
1855
25.5 × 35.9 cm
Albumen print
RCIN 2500513
Cat. no. 63

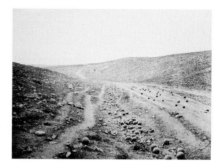

Valley of the Shadow of Death
23 April 1855
25.7 × 35.0 cm
Albumen print. Plate 68
RCIN 2500514
Cat. no. 218

*Sebastopol Gordon's Battery & advanced
trenches with left French attack in the distance
from the look out in front of the mortar battery*
1855
24.9 × 34.1 cm
Albumen print
RCIN 2500515

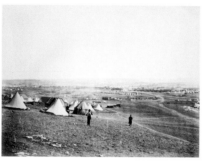

Panoramic Series
April 1855
26.8 × 35.9 cm
Albumen print
RCIN 2500516
Cat. no. 152

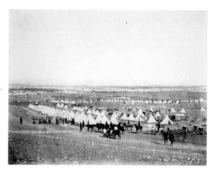

Panoramic Series
April 1855
26.8 × 35.3 cm
Albumen print
RCIN 2500517
Cat. no. 153

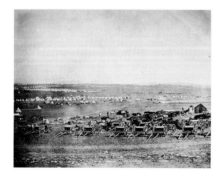

Panoramic Series
April 1855
26.9 × 34.7 cm
Salted paper print
RCIN 2500518
Cat. no. 154

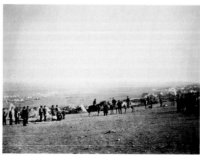

Panoramic Series
April 1855
26.2 × 35.3 cm
Albumen print
RCIN 2500519
Cat. no. 155

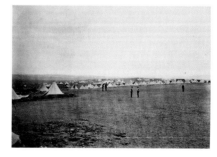

Panoramic Series
April 1855
25.2 × 36.0 cm
Albumen print
RCIN 2500520
Cat. no. 156

Panoramic Series
April 1855
24.5 × 36.5 cm
Albumen print
RCIN 2500521
Cat. no. 157

Panoramic Series
April 1855
22.2 × 35.3 cm
Albumen print
RCIN 2500522
Cat. no. 158

Panoramic Series
April 1855
24.6 × 34.9 cm
Albumen print
RCIN 2500523
Cat. no. 159

Panoramic Series
April 1855
24.1 × 35.0 cm
Albumen print
RCIN 2500524
Cat. no. 160

Panoramic Series
April 1855
24.4 × 35.1 cm
Albumen print
RCIN 2500525
Cat. no. 161

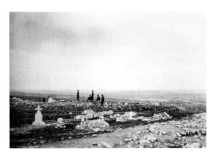

Panoramic Series
April 1855
22.1 × 33.1 cm
Albumen print
RCIN 2500526
Cat. no. 162

Lord Raglan. Omar Pacha & Pelissier. Group.
June 1855
19.1 × 15.8 cm
Albumen print. Plate 14
RCINs 2500527, 2506595, 2500078
Cat. no. 270

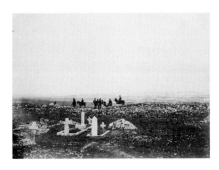

Graves Cathcart's Hill
1855
25.2 × 35.0 cm
Albumen print
RCIN 2500529

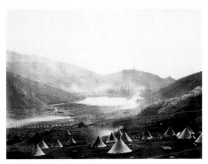

<u>*Guards Hill Church Parade Balaklava*
in the distance</u>
1855
26.1 × 35.3 cm
Salted paper print. Plate 65
RCIN 2500530

Sebastopol from Cathcarts Hill
1855
21.8 × 34.8 cm
Albumen print
RCIN 2500531
Cat. no. 141

View of Sebastopol tent on the left
1855
22.0 × 34.3 cm
Albumen print
RCIN 2500532

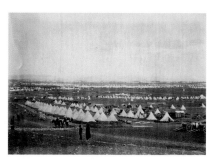

View from Cathcarts Hill towards Simpherapol 23rd tents & horses foreground [Simferopol]
1855
24.3 × 34.6 cm
Albumen print
RCIN 2500533

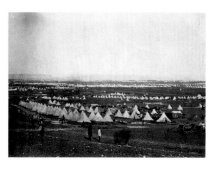

View from Cathcarts Hill man in white coat in front
1855
24.1 × 33.7 cm
Albumen print. Plate 37
RCIN 2500534

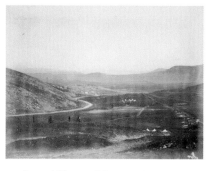

Road to Balaklava Kadakoi in middle distance
1855
26.7 × 35.5 cm
Albumen print
RCIN 2500535

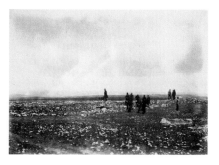

Cemetery Cathcarts hill General Officers looking towards Sebastopol
1855
24.7 × 34.7 cm
Salted paper print
RCIN 2500536
Cat. no. 147

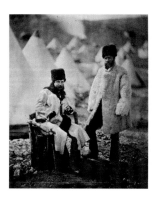

Capt Brown & Servant 4 Lt Drg
1855
19.3 × 16.0 cm
Albumen print. Plate 25
RCIN 2500537
Cat. no. 70

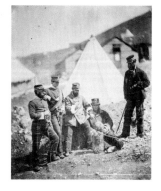

71st Dog begging
1855
19.5 × 16.2 cm
Albumen print
RCIN 2500538
Cat. no. 61

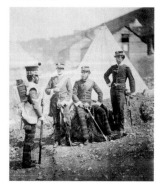

71st Colour Sergeant
1855
18.4 × 15.7 cm
Albumen print
RCIN 2500539
Cat. no. 19

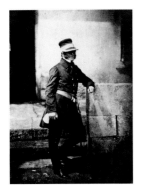

Genl Estcourt standing with Cap
1855
19.9 × 14.5 cm
Albumen print
RCIN 2500540
Cat. no. 135

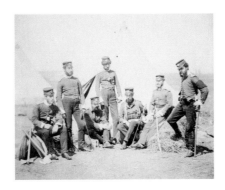

Group of 50th Regt
1855
13.7 × 16.8 cm
Albumen print
RCIN 2500541

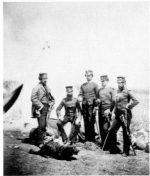

Major Inglis 57th Group with Dog
1855
18.0 × 15.7 cm
Albumen print
RCIN 2500542

Officer of 47th [Lieutenant Gayner]
1855
18.8 × 14.9 cm
Albumen print
RCIN 2500543

Lt Dames RHA
1855
15.4 × 12.9 cm
Albumen print
RCIN 2500544
Cat. no. 221

Capt Staunton & Horse
1855
17.6 × 15.2 cm
Albumen print
RCIN 2500545
Cat. no. 176

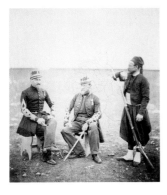

Zouave officers
5 May 1855
18.0 × 15.9 cm
Albumen print
RCIN 2500546

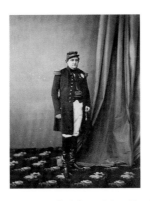

His Imperial Highness Prince Napoleon
1855
29.9 × 23.0 cm
Salted paper print
RCINs 2500547, 2506588, 2500007

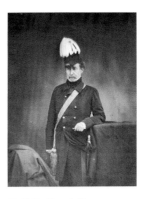

Sir Colin Campbell
1855
21.2 × 16.3 cm
Salted paper print. Plate 7
RCIN 2500548

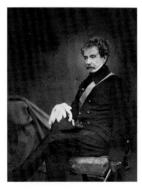

Sir Colin Campbell
1855
21.2 × 16.3 cm
Salted paper print
RCINs 2500549, 2506569

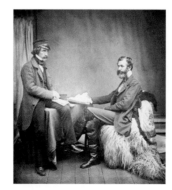

The Sanitary Commission
1855
17.8 × 16.0 cm
Salted paper print. Plate 26
RCIN 2500550

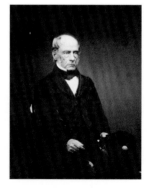

Commissary Genl Filder
1855
19.2 × 15.0 cm
Salted paper print
RCIN 2500551

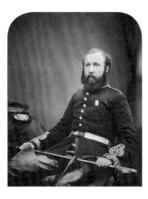

Captain Adye
1855
21.6 × 17.3 cm
Salted paper print
RCIN 2500552

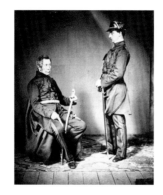

Lieut Gen Sir John Burgoyne and Aide De Camp Lieut Stopford
1855
21.9 × 17.6 cm
Salted paper print. Plate 8
RCIN 2500553

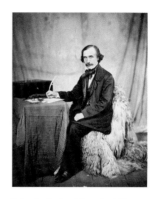

John Sutherland Esquire MD
1855
24.5 × 19.6 cm
Salted paper print
RCIN 2500554

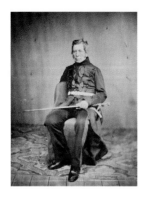

Lieut Genl Sir John Burgoyne GCB
1855
24.3 × 18.1 cm
Salted paper print
RCIN 2500555

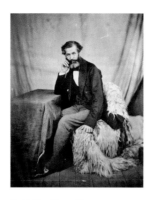

Robt Rawlinson Esq
1855
25.5 × 20.0 cm
Albumen print
RCIN 2500556

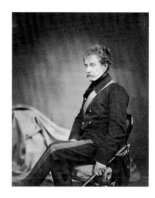

Sir Colin Campbell
1855
21.4 × 17.2 cm
Salted paper print
RCIN 2500557

Colonel Wood & Major Stuart Wortley
1855
13.0 × 15.2 cm
Salted paper print
RCIN 2500558

A Zouave
1855
18.2 × 14.1 cm
Salted paper print
RCIN 2500562

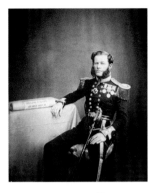

Lieut Montague O'Reilly
1855
17.7 × 14.7 cm
Salted paper print
RCIN 2500563

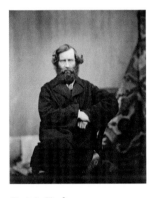

Captain Hughes
1855
19.3 × 15.6 cm
Salted paper print
RCIN 2500564

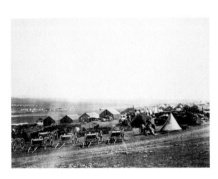

Looking towards Balaklava artillery waggons in the foreground
1855
25.1 × 34.3 cm
Salted paper print. Plate 38
RCIN 2500565
Cat. no. 190

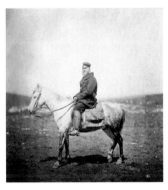

Captain Chawner
1855
16.0 × 15.0 cm
Salted paper print
RCIN 2500567

Panoramic Pictures of the Plains of Balaklava
1855
16.5 × 25.3 cm
Albumen print
RCIN 2500571

Panoramic Views of the Plains of Balaklava
1855
15.5 × 25.1 cm
Albumen print
RCIN 2500575

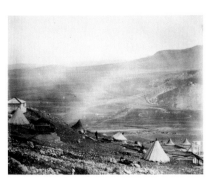

Lines of Balaklava from Guards Hill Canrobert's Hill & Inkerman in the distance sirocco blowing
1855
26.8 × 34.4 cm
Albumen print
RCIN 2500577
Cat. no. 80

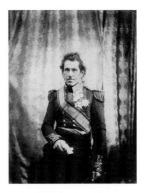

Lieut. Genl. Sir De Lacy Evans G.C.B
1855
19.6 × 15.1 cm
Salted paper print. Plate 3
RCINS 2506570, 2500008
Cat. no. 200

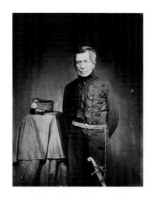

Lieut. Genl. Sir J. Burgoyne G.C.B
1855
18.6 × 14.4 cm
Salted paper print
RCIN 2506572

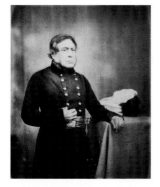

Lieut. Genl. Sir H.J.W Bentinck K.C.B
18 January 1855
17.8 × 14.7 cm
Salted paper print. Plate 44
RCIN 2506573

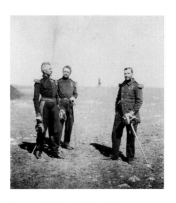

Generals Labousiniére & Beuret
1855
16.2 × 14.9 cm
Salted paper print
RCIN 2506591
Cat. no. 130

General Cissé & Staff Officer
1855
17.6 × 14.3 cm
Salted paper print
RCIN 2506592

Croats
March 1855 (printed 1883)
19.3 × 15.6 cm
Carbon print
RCIN 2500179
Cat. no. 265

**Lieut. Genl. His Royal Highness
the Duke of Cambridge, K. G**
1855–6
23.1 × 18.2 cm
Salted paper print. Plate 20
RCIN 604992

Opposite and following pages:
Catalogue published to accompany the first public
exhibition of Fenton's Crimean War photographs
held at the Gallery of the Water Colour Society,
Pall Mall East, in September 1855. RCIN 2947508

EXHIBITION

OF THE

Photographic Pictures taken in The Crimea,

By ROGER FENTON, Esq.

DURING THE SPRING AND SUMMER OF THE PRESENT YEAR,

AT THE

GALLERY OF THE WATER COLOUR SOCIETY,

N⁰. 5, PALL MALL EAST.

OPEN FROM TEN TILL SIX O'CLOCK.

ADMITTANCE, ONE SHILLING.——CATALOGUES, SIXPENCE.

◆

PRINTED FOR

Messrs. THOMAS AGNEW and SONS,

PUBLISHERS AND PRINTSELLERS TO HER MAJESTY, EXCHANGE STREET, MANCHESTER,

BY THOMAS BRETTELL, RUPERT STREET, HAYMARKET.

1855.

" Mr. R. FENTON, on Wednesday evening, had an audience of upwards of an
" hour with the Emperor at St. Cloud, to exhibit to His Majesty a Series of
" Photographic Views, taken by him in the Crimea during the present year.
" Mr. W. AGNEW, (of the firm of Messrs. THOMAS AGNEW & SONS, Publishers,
" of Manchester, the gentleman who gave a commission to Mr. Fenton to
" proceed to the East, and who intends publishing the Views taken,) was
" also present. His Majesty expressed to these gentlemen his satisfaction.
" Yesterday Mr. Fenton and Mr. Agnew were commanded to be in attendance
" on the Emperor at half-past 10, when His Majesty again expressed his
" approval, and commanded these gentlemen to prepare immediately a number
" of copies of the Views. The work will be published under the patronage
" of the Emperor, of the Queen of England, and of Prince Albert, to whom
" the Views were submitted at Osborne some days ago."—From *The Times'*
Paris Correspondent of September 13, 1855.

CATALOGUE.

THE Series of VIEWS, GROUPS, and PORTRAITS, which will be published under the Patronage of HER MAJESTY THE QUEEN, HIS MAJESTY THE EMPEROR OF THE FRENCH, and HIS ROYAL HIGHNESS PRINCE ALBERT, was taken by Mr. FENTON during the Spring and Summer of the present Year, and is intended to illustrate faithfully the Scenery of the Camps; to display prominent incidents of Military Life, as well as to perpetuate the Portraits of those distinguished Officers, English and French, who have taken part in the ever memorable SIEGE OF SEBASTOPOL.

The Conditions of Publication may be seen at the Table.

☞ *The Secretary will give every information that Visitors may require.*

1. Captain Bathurst, Grenadier Guards.

2. Colonel Clarke, Scots' Greys, with the Horse wounded at Balaklava.

3. The Old Genoese Castle at Balaklava, from above the Castle Pier.

4. Landing Place, Ordnance Wharf, Balaklava; Genoese Castle in the distance.

5. Major Butler, 28th Regiment.

6. Lieutenant-Colonel Shadforth at his Hut, and Officers of the 57th Regiment.

7. Captain Godley, 28th Regiment.

8. The Old Post Office, Balaklava.

9. Major Burton, 5th Dragoon Guards.

10. Cornet Wilkin, 11th Hussars.

11. The Guards' Redoubt, Inkermann.

12. Colonel Blain.

13. Railway Sheds and Workshops, Balaklava.

14. Mr. Thompson, Commissariat.

15. Lord Raglan's Head Quarters, with Lord Raglan, Marshal Pélissier, Lord Burghersh, Spahi and Aide-de-Camp of Marshal Pélissier.

16. Officers of the 4th Light Dragoons.

17. Mr. Angel, Postmaster.

18. Officers of the 57th Regiment.

19. Group of the 71st Regiment, with Colour-Sergeant.

20. Ismail Pasha receiving his Chibouque.

21. Officers of the 68th Regiment.

22. Lieutenant-General Sir Richard England, K.C.B.

23. Colonel F. W. Hamilton, Grenadier Guards.

24. Lieutenant-General Barnard's Horse, Grandson of Marengo, Napoleon's Horse at Waterloo.

25. Brigadier-General Lord George Paget, C.B.

26. Group of Officers at Cathcart's Hill.

27. Balaklava from the Russian Church, Upper Harbour, and Church of Kadikoi in the distance.

28. Balaklava, looking seawards; the Commandant's House in the foreground.

29. Captain Walker, 30th Regiment.

30. View of the Lines of Balaklava from Guards' Hill; Canrobert's Hill in the distance.

31. Landing Place, Railway Stores, Balaklava, looking up the Harbour.

32. Ismail Pacha ordering his Chibouque.

33. Colonel Shewell, Light Cavalry.

34. The Honourable Major Cathcart.

35. Brigadier-General Lockyer.

36. Officers and Men of the 89th Regiment. Captain Skinner, Lieutenant Knatchbull, Lieutenant Conyers, Lieutenant Longfield, Captain Hawley.

37. Vivandière.

38. General Sir John Campbell and Captain Hume, his Aide-de-Camp; the General sitting.

39. Mr. Angel, Postmaster.

40. Zouave and Officer of the Spahis.

41. Lieutenant-General Sir Harry Jones and his Staff.

42. Ismail Pacha and Mr. Thompson of the Commissariat.

43. Two Officers of the 42nd Regiment.

44. Colonel Brownrigg and the two Russian Boys, Alma and Inkermann.

45. Captain Drysdale, 42nd Regiment.

46. Men of the 77th Regiment in Winter Costume.

47. The Cemetery on Cathcart's Hill, shewing the Flagstaff.

48. Men of the 68th Regiment in ordinary dress.

49. Major-General Sir Richard Airey, K.C.B.

50. View of Picquet House on Cathcart's Hill, from General Bosquet's Quarters.

51. English Private, in full marching order.

52. Captain Phillips and Lieutenant Yates, 8th Hussars.

53. The Ordnance Wharf, Balaklava.

54. Colonel Clarke, Scots' Greys.

55. View from General Bosquet's Quarters, looking towards Inkermann.

56. Quiet Day in the " Mortar Battery."

57. Camp of the 4th Light Dragoons, Soldiers' Quarters.

58. Captain Holder, Fusilier Guards.

59. Brigadier McPherson and Officers of the 4th Division; Captain Higham, Captain Earle, Captain Croker, Captain Swale, Captain McPherson.

60. Brigadier-General Lockyer, and two of his Staff.

61. Officers of the 71st Highlanders.

62. Camp of the 5th Dragoon Guards.

63. Camp of the 5th Dragoon Guards, looking towards Kadikoi.

64. Captain Verschoyle, Grenadier Guards.

65. Chasseur d'Afrique, Officer.

66. Lieutenant Garnier, 47th Regiment.

67. William Russell, Esq., the Times' Correspondent.

68. The 68th Regiment, Winter Dress.

69. Dr. Marlow, 28th Regiment.

70. Captain Brown, 4th Light Dragoons, and Servant, Winter Dress.

71. Two Zouaves.

72. Captain Turner, Coldstream Guards.

73. Lieutenant-General Sir William J. Codrington, K.C.B.

74. Captain Luard, Deputy-Quartermaster-General.

75. The Group of the Clergy

76. Colonel Moorsom, Fusilier Guards.

77. Henry Duberly, Esq., Paymaster 8th Hussars, and Mrs. Duberly.

78. Viscount Kirkwall, Captain 71st Highlanders.

79. Colonel Harding, Commandant at Balaklava.

79*. Captain Webb's Hut, 4th Light Dragoons.

80. View of the Lines of Balaklava from Guards' Hill, Canrobert's Hill in the distance.

81. General View of Balaklava, the Hospital on the right.

81*. General Bosquet giving Orders to his Staff.

82. Major Chapman, 28th Regiment.

83. Brigadier-General Garrett and Officers of his Staff.

84. Lieutenant-General Pennefather and Staff.

85. Captain Andrews, 28th Regiment.

86. The Honourable Major Cathcart.

87. Major-General Sir George Buller, K.C.B.

88. Group of Officers of the 17th Regiment.

89. Lieutenant King, 4th Light Dragoons.

90. Lieutenant-General Barnard, C B.

91. Captain Fay, on General Bosquet's Staff.

92. View of Balaklava, from Camp of Fusilier Guards.

93. The Town of Balaklava.

94. View from General Bosquet's Quarters, looking towards Mackenzie's Farm.

95. Captain Portal, 4th Light Dragoons, equipped for Balaklava.

96. General Estcourt.

97. Colonel Reynardson.

98. Captain Bolton, Royal Artillery.

99. General Bosquet.

100. Field Piece.

101. Two Officers of the 47th Regiment.

102. Major Burton and Officers of 5th Dragoon Guards.

103. Vivandière.

104. Encampment of the 71st Regiment at Balaklava, Commissariat Camp, &c.

105. The Tombs of the Generals, on Cathcart's Hill.

106. Lieutenant-General Pennefather and Orderly.

107. Captain Bernand, 5th Dragoon Guards.

108. Colonel Adye, Royal Artillery.

108*. Officers of the 90th Regiment.

109. Captain Lord Balgonie, Grenadier Guards.

110. Captain Conyngham, 42nd Regiment.

110*. Colonel Conyngham, Quartermaster-General of the Turkish Contingent, Mr. Ellis, and Orderly.

111. Captain Burnaby, Grenadier Guards.

112. Railway Officials, Messrs. Swan, Cadell, Middleton, Howse, and Kellock.

113. Captain Halford, 5th Dragoons.

114. Ismail Pacha on Horseback, with Turkish Officers.

115. Colonel Seymour, Fusilier Guards.

116. Lieutenant-General Sir George Brown, G.C.B., and Officers of his Staff:— Major Halliwell; Colonel Brownrigg; Orderly; Colonel Airey; Captain Pearson; Captain Markham; Colonel Ponsonby.

117. Captain Walker, 30th Regiment, reading General Orders.

118. Colonel Grant, 42nd Highlanders.

119. General Bosquet giving Orders to his Staff.

120. Tartar Labourers.

121. Lieutenant Godman, 5th Dragoons.

122. The Artist's Van.

123. Kadikoi from the Camp of Horse Artillery.

124. Distant View of Sebastopol, with the Mamelon and the Malakoff Tower, the Lines of Gordon's Battery in the Middle Distance.

125. Captain King, Horse Artillery.

126. Major-General Sir George Buller, K.C.B.

127. Colonel Shadforth and men of the 57th Regiment; Inkermann in the distance.

128. General Cissé, with Officers and Soldiers of General Bosquet's Division.

129. Major-General Sir R. Dacres, Captain Hamley, and Colonel Adye.

130. General Labousinière and General Buret.

131. Zouaves and Soldiers of the Line.

132. Lieutenant-General Sir George Brown, G.C.B., K.H.

133. Colonel Woodford, Rifle Brigade.

134. Group of the 47th Regiment, Winter Dress, ready for the Trenches.

135. General Estcourt.

136. Lieutenant-General Sir W. J. Codrington, K.C.B.

136*. Officers of the 88th Regiment.

137. Officers of the 71st Regiment.

138. Omar Pacha and Colonel Simmons.

139. Lieutenant-Colonel Chapman, C.B., Royal Engineers.

140. Captain Payne, Royal Marines.

141. Sebastopol from the front of Cathcart's Hill.

142. Captain Heneage, Coldstream Guards.

143. Colonel Ponsonby, Captain Pearson, and Captain Markham, on the Staff of Sir George Brown.

144. Discussion between two Croats.

145. Two Sergeants, 4th Light Dragoons.

146. Lieutenant Strangways, Royal Horse Artillery.

147. Officers on the look-out at Cathcart's Hill.

148. Captain Lowry, Captain Colworthy, &c. ; Head Quarters.

149. Quartermaster Hill, 4th Light Dragoons ; the Horse taken immediately after the Winter Season.

150. Captain Croker, 17th Regiment.

151. Lieutenant-General Barnard, C.B., and Officers of his Staff.

THE ELEVEN SUBJECTS, *from* No. 152 *to* 162 *inclusive, form a continuous Panoramic Picture of* THE PLATEAU BEFORE SEBASTOPOL, *commencing at Inkermann.* The Spectator is supposed to move *round to the right.*

152. Cathcart's Hill, looking towards the Light Division and Inkermann.

153. Looking towards Mackenzie's Heights, Tents of the 33rd Regiment in the foreground.

154. Kamara Heights in the distance, Artillery Waggons in the foreground.

155. Looking towards Balaklava, Turkish Camp in the distance, to the right.

156. Looking towards St. George's Monastery, Tents of the 4th Division in the foreground.

157. General Garrett's Quarters and Tents of the 4th Division.

158. Camp of the 3rd Division, French Tents in the distance.

159. French Left Attack, Kamiesch in the distance. Tents of Sir John Campbell in the foreground.

160. Sebastopol, with the Redan, Malakoff, and Mamelon; Colonel Shadforth seated in the foreground.

161. The Cemetery, Cathcart's Hill; the Picquet House, Victoria Redoubt, and the Redoubt des Anglais in the distance.

162. The Cemetery, Redoubt des Anglais, and Inkermann in the distance.

163. Balaklava, the Railway Street.

164. Captain Layard, Aide-de-Camp to Lieutenant-General Pennefather, K.C.B.

165. Head Quarters' Staff:—1, Colonel Vico; 2, Captain Curzon; 3, Lord Burghersh; 4, Orderly; 5, Count Revel; 6, Mr. Calvert, Interpreter; 7, Colonel Paulet Somerset; 8, Colonel A. Hardinge; 9, Dr. Prendergast; 10, Commander Maxse; 11, Colonel Kingcote.

166. Lieutenant Yates, 11th Hussars.

167. Commander Maxse.

168. Captain George, 4th Light Dragoons, and Servant.

169. Captain Forster, and Officers of the 4th Dragoon Guards.

170. Captain Hume, on the Staff of Sir John Campbell, and his Brother.

171. The Pocket Pistol.

172. Piling Arms.

173. General Estcourt.

174. Captain Halford, ready for Duty.

175. Mr. Cook, Commissariat.

176. Captain Staunton.

177. View of Balaklava, looking seaward; Russian Cottages in the foreground.

178. The Provost Marshal of the Division of General Bosquet.

179. Colonel Gordon, Royal Engineers.

179*. Officers of the 90th Regiment.

180. Major Halliwell, Assistant-Quarter-Master-General.

181. Officers of the 57th Regiment.

182. Group of Montenegrins.

183. General Estcourt.

184. Captain Burnaby of the Guards, and Nubian Servant.

185. Major Halliwell, Day's work over.

186. Redoubt at Inkermann.

187. Colonel Doherty and the Officers of the 13th Light Dragoons.

188. Officers of the 71st Regiment, Captain McDonnell, &c.

189. Brigadier Garrett and Officers of the 46th Regiment.

190. Artillery Waggons, view looking towards Balaklava.

191. Mortar Batteries in front of Picquet-house, Light Division.

192. Captain Halford, 5th Dragoon Guards.

193. Lieutenant-General The Honourable Sir James Yorke Scarlett, K.C.B.

194. Captain Francis Baring, Fusilier Guards.

195. Colonel Tylden, Royal Engineers.

196. Colonel Wilbraham.

197. Colonel Vico, attached to the British Head Quarters.

198. Captain Morgan, of General Barnard's Staff, on the Winner of the Crimean Races.

199. Colonel Dickson, Royal Engineers.

200. Lieutenant-General Sir De Lacy Evans, G.C.B., M.P.

201. Colonel Lowe, 4th Light Dragoons, and Servant, in Winter Dress.

202. Maréchal Pélissier.

203. Group of the 4th Dragoons.

204. Lieutenant-General Barnard, C.B., and Officers of his Staff, Capt. Morgan, and Major Daniels.

205. Head of the Harbour, Balaklava.

206. The Cemetery on Cathcart's Hill.

207. General Cissé, and Aide-de-Camp.

208. Lieutenant-Colonel Prince Edward of Saxe Weimar.

209. Major Brandling's Troop of Horse Artillery.

210. Cossack Bay, Balaklava.

211. Captain Wilkinson, 9th Regiment.

212. Lieutenant-General Sir Harry Jones.

213. Captain Thomas, Aide-de-Camp to General Bosquet.

214. Omar Pacha.

215. General Bosquet and Captain Dampierre.

216. Hardships in the Crimea.

217. Balaklava Harbour, the Castle Pier.

218. The Valley of the Shadow of Death.

219. 77th Regiment in Winter Costume, ready for the trenches.

220. " L'Entente Cordiale."

221. Lieutenant Deane, R.H.A.

222. Maréchal Pélissier.

223. Group of Croats.

224. Lieutenant-General Pennefather, C.B.

225. Major Brandling's Troop.

226. Cavalry Camp, looking towards Kadikoi.

227. Captain Clifford, Aide-de-Camp to General Buller.

228. Lieutenant-Colonel Lord Burghersh, C.B.

229. Railway Sheds at Balaklava.

230. View of Balaklava looking seaward, with ruined Shed in the foreground.

231. Portrait.

232. Four Zouaves in Turbans.

233. Major Pipon, 21st Regiment.

234. Croat.

235. Sergeant of British Light Infantry.

236. Four Officers of the 42nd Regiment.

237. Major Daniels and Officers.

238. Brigadier-General Van Straubenzee and Officers of the Buffs.

239. Captain Inglis, 5th Dragoon Guards.

240. Major Radcliffe, 20th Regiment.

241. Mr. Thompson, of the Commissariat, and Attendants of Ismail Pacha.

242. Major-General Sir Richard Airey, K.C.B., and Major Halliwell.

The FIVE SUBJECTS, *from* No. 243 *to* No. 247 *inclusive, form a continuous Panoramic Picture of* THE PLAINS OF BALAKLAVA.

243. Rear of the Allied Camps; heights of Inkermann in the distance.

244. Position of the Russian Artillery, when charged by the French Cavalry, at the Battle of Balaklava; Lines of the Russian Camp in the distance, taken in May last by the French.

245. Plain of Balaklava, crossed by the Woronzoff Road, the site of the Light Cavalry Charge; the hills in the second distance are those occupied by the French and Sardinians at the Battle of the Tchernaya.

246. Plain of Balaklava, shewing the series of hills on which were placed the Redoubts held by the Turks.

247. Balaklava, from the rear of the Allied Camps. Troops encamped on the right.

248. Major Brandling's Hut.

249. Colonel Adye and Captain Whitmore.

250. Major Turner, and Officers of the 39th Regiment.

251. General Estcourt and Staff.

252. Reverend Mr. Butler and Officers of the 47th Regiment.

FIRST SCREEN.

253. Balaklava The Railway Yard.

254. Lieutenant-General Pennefather, C.B.

255. Group of Officers, 8th Hussars.

256. Chasseurs d'Afrique.

257. Group of 4th Dragoon Guards.

258. General Bosquet.

259. Cattle and Carts leaving Balaklava.

SECOND SCREEN.

260. The Quarries and the Aqueduct at the Head of the Harbour, Valley of Inkermann.

261. The Ruins of Inkermann.

262. The Valley of the Tchernaya.

263. Cooking House, 8th Hussars.

264. Maréchal Pélissier.

265. Group of Three Croats.

266. Sir John Campbell and Group of Officers.

THIRD SCREEN.

267. The Mamelon and the Malakoff from the front of the Mortar Batteries.

268. General Simpson.

269. Field Marshal Lord Raglan.

270. Council of War held at Lord Raglan's Head Quarters the Morning of the successful Attack on the Mamelon, Portraits of Lord Raglan, Maréchal Pélissier, and Omar Pacha.

271. Maréchal Pélissier.

272. Omar Pacha.

273. Sebastopol from the Mortar Battery.

FOURTH SCREEN.

274. The Cavalry Camp, Balaklava, looking towards the Plateau of Sebastopol.

275. Group of Croats.

276. Brigadier Garrett.

277. View of Balaklava from the top of Guards' Hill.

278. General Bosquet on Bayard.

279. Camp of the 4th Dragoons, Convivial Party, French and English.

280. Group of Chasseurs d'Afrique.

As a very limited number of impressions can be printed, it is respectfully requested that those wishing to secure them will make early application to the Publishers.

NOTICE.

The Photographic Pictures of the Seat of War in the Crimea, dedicated by Special Permission to Her Most Gracious Majesty, will be issued to Subscribers in the following manner:—

SCENERY,—VIEWS OF THE CAMPS, &c.

Ten Parts, each to contain Five Subjects, at · . . £.2 2 0 per Part.

The First Part will be published in October and contain,—View of Balaklava from Guards' Hil¹; the Genoese Castle at Balaklava, from the Castle Pier; the Ordnance Wharf; the Railway Yard; and the old Post Office.

INCIDENTS OF CAMP LIFE,—GROUPS OF FIGURES, &c.

Ten Parts, each to contain Six Subjects, at . . £.2 2 0 per Part.

The First Part will be published in October and contain,—Group of Tartar Labourers at the Stores of the 14th Regiment; Group of English Infantry piling Arms; Group of Zouaves; Group of Chasseurs d'Afrique; a Vivandière; and GENERAL BOSQUET and the Officers of his Staff.

HISTORICAL PORTRAITS.

Five Parts, each to contain Six Subjects, at . . £.2 2 0 per Part.

The First Part will be published in October and contain,—the Portraits of the late FIELD-MARSHAL LORD RAGLAN, MARSHAL PÉLISSIER, GENERAL SIMPSON, LIEUTENANT GENERAL SIR GEORGE BROWN, and COLONEL GORDON, Royal Engineers.

	£.	s.	d.
The Panorama of the Plateau before Sebastopol, in Eleven Views, delivered in a Portfolio	6	6	0
Panorama of the Plains of Balaklava, in Five Views, delivered in a Portfolio	2	12	6
The Valley of Inkermann, in Three Views	1	11	6
The Valley of the Shadow of Death	1	1	0
The Tombs of the Generals on Cathcart's Hill	1	1	0
The Council of War on the Morning of the Attack of the Mamelon,—LORD RAGLAN, GENERAL PÉLISSIER, and OMAR PACHA	1	1	0
FIELD-MARSHAL LORD RAGLAN,—the single Portrait	0	10	6
MARSHAL PÉLISSIER, ditto	0	10	6
GENERAL SIMPSON, ditto	0	10	6
GENERAL OMAR PACHA, ditto	0	10	6
GENERAL BOSQUET, ditto	0	10	6

&c. &c.

N.B.—*Single Impressions of most of the Subjects can be obtained.*

The Photographic Pictures of The Seat of War in The Crimea,

By ROGER FENTON, Esq.

GENTLEMEN,

 Please to insert my Name as a Subscriber to the PHOTOGRAPHIC PICTURES OF THE SEAT OF WAR, *and for those against which my Signature is affixed.*

PRICE TO SUBSCRIBERS ONLY.	NUMBER OF COPIES.	NAME, ADDRESS, AND DATE OF ORDER.
Scenery,—Views of the Camps, &c. Ten Parts, each to contain Five Subjects, at } £.2 2s.		
Incidents of Camp Life,—Groups of Figures, &c. Ten Parts, each to contain Six Subjects, at } £.2 2s.		
Historical Portraits. Five Parts, each to contain Six Subjects, at } £.2 2s.		
Miscellaneous Subjects. See Catalogue.		

To Messrs. **THOMAS AGNEW & SONS**, PUBLISHERS, MANCHESTER;
 or at THE EXHIBITION OF THE PHOTOGRAPHIC PICTURES, 5, PALL MALL EAST, LONDON.

This Form filled up and forwarded to the Publishers will receive strict attention.

NOTES

The Russian War of 1853–5

1 The 'Thin Red Line' is a phrase used to describe the actions of the 93rd Highland Regiment when they took up a position against attacking Russian cavalry by forming a defence only two lines deep during the Battle of Balaklava, 25 October 1854. It is a distilled version of a phrase used by the reporter William H. Russell in one of his Crimean dispatches: 'thin red streak tipped with a line of steel' (*The Times*, 14 November 1854).

2 Sardinia entered the war on 26 January 1855. The Sardinians were to play an important role in the Battle of Chernaia on 16 August 1855, successfully fighting alongside the French against the Russians.

3 Figes 2010, pp. 73–4.

4 RCINS 2906004–2906011. Five views from the series were exhibited in the Photographic Society exhibition in London, from 11 January to late March 1855.

5 Figes 2010, p. 159.

6 London 2003, p. 75.

7 The figure given by most historians for the total number of Chargers on 25 October 1854 is 673. Different numbers are given in other sources: Roy Dutton's list, for example, which provides biographical details, gives a figure of 591 for those who rode (Dutton 2007).

8 *The Times*, 14 November 1854

9 Figes 2010, p. 268.

10 London 2003, p. 158.

11 Figes 2010, p. 273.

12 Adye 1895, p. 72.

13 RA VIC/MAIN/QVJ/1856: 21 September.

14 London 2003, p. 201. The circulation figures are taken from the *ILN*.

15 The *ILN*, as well as employing artists in London, sent several to the Crimea to provide images: Edward Angelo Goodall, Joseph Archer Crowe, Constantin Guys, Oswald Walters Brierly, William Luson Thomas and Robert Thomas Landells. See London 2003, p. 197.

16 *The Athenaeum*, 17 February 1855.

17 For example, *ILN*, 13 May 1854, pp. 626–7; 15 July 1854, p. 45.

18 Sir Charles Phipps was Private Secretary to Prince Albert before being appointed Keeper of the Privy Purse in 1849, thus having control of the royal finances. He remained a key aide to Queen Victoria until his death in 1866.

19 RA VIC/MAIN/F/1/102. The letter was published first in the *Morning Chronicle*, 5 January 1855, p. 4.

20 RA VIC/MAIN/QVJ/1855: 6 January.

21 The letter and the wider role of the Queen in the narrative of the Crimean War is discussed at length in Bates 2015a.

22 The initial sketch was published in the *ILN*, 10 March 1855, p. 237. The watercolour was still in the artist's possession in 1862; it is not known exactly when it entered the Royal Collection, although its presence at Sandringham suggests it may have been acquired by the Prince of Wales (later King Edward VII). A chromolithograph of the painting by W. Bunney was published by Vincent Brooks in December 1903. In addition to the Coldstream and Grenadier Guards, the Scots Fusilier Guards were seen by the Queen on 23 February 1855, and other meetings were held in 1855; for example, the Queen saw a large number of Guardsmen at Buckingham Palace on 2 April.

23 The Queen visited wounded soldiers at Fort Pitt and Chatham on 3 March, 19 June and 28 November 1855 and 16 April 1856. She also visited soldiers at Portsmouth military hospital on 31 July and 4 August 1855, and met wounded men at Woolwich as well on 9 March 1855 and 1 December 1855. RA VIC/MAIN/QVJ/1855: 3 March.

24 RA VIC/MAIN/QVJ/1855: 31 July and RA VIC/MAIN/QVJ/1856: 4 October.

25 Bates 2015a.

26 Adye 1895, p. 99.

27 Seacole 1857, p. 178.

28 Figes 2010, p. xix.

Roger Fenton: First War Photographer

1 A connection between Fenton's photographs and Barker's painting has been previously recognised by Helmut Gernsheim (Gernsheim 1954, p. 30) and Ulrich Keller (Keller 2001, pp. 124–5, 228–30).

2 Fenton may have first travelled to Paris in 1842 to begin his studies in the studio of Paul Delaroche. He may have remained as a student in Paris until 1846, although he returned home at least once, to marry Grace Maynard on 29 August 1843. All biographical information throughout, unless otherwise stated, is taken from New York 2004–6.

3 Although the Picturesque is a British aesthetic employed predominantly by artists in Britain, the Picturesque viewpoint travelled the world with British artists and was used in countries as far afield as Brazil, India and the Pacific Islands. As the Picturesque was the overriding visual paradigm for depicting architecture and landscape for British artists, Fenton – particularly as he was a trained painter – would probably have had to fight his artistic instincts whilst in Russia. There is a substantial body of literature discussing the Picturesque and foreign travel, for example B. Smith, *European Vision and the South Pacific, 1768–1850*, Oxford, 1960; M. Archer and R. Lightbown, *India Observed: India as Viewed by British Artists 1760–1860*, London, 1982; G. Quilley and J. Bonehill, eds., *William Hodges 1744–1797: The Art of Exploration*, New Haven and London, 2004.

4 New York 2004–6, p. 15.

5 Ibid., p. 263, note 74. The original source is given as *Morning Post*, 14 January 1854, p. 5. The photographs of Russia by Fenton are not in the Royal Collection today and so far no archival evidence has been found to confirm that they were purchased.

6 It was not until 1860 that the first photographs of the royal family (taken by John Mayall) were widely available for sale.

7 London 2010, p. 239. Posing for tableaux which were photographed was a favourite pastime of the royal family, and numerous examples have survived taken as late as the 1890s. See London 2016, pp. 70–1.

8 The album *Crimean Officers' Portraits, 1854 to 1856* (RCIN 2500000) contains 121 photographs, including work by Roger Fenton, John Mayall and James Robertson, as well as unidentified photographers. Although most of the portraits were taken either during or

after the conflict, some would have been taken before the war, as those represented subsequently died whilst away. For example, there is a photograph of Lieutenant-Colonel Robert Boyle (RCIN 2500051) who died from cholera in 1854 whilst with the British Army at Varna, en route to the Crimea. It is likely that the majority of the works taken before the war by unidentified photographers are by a photographer working for the firm Messrs Dickinson of Bond Street. This company is reported in the Court Circular of 3 April 1854 as 'submitting to the Queen and Prince the photographic miniatures of the Guards and Staff accompanying the expedition to Turkey'. See Fisher 2009, p. 130. This album is discussed particularly with respect to its apparent hierarchical structure in Keller 2001, pp. 194–8.

9 See W. Bambridge, *Prince Arthur, Princess Helen and Princess Louise*, 1856, albumen print, 11.5 × 15.0 cm, RCIN 2900066 and J. Simpson, *The Allies*, 1857, enamel on porcelain, 14.8 × 14.0 cm, RCIN 408954.

10 London 2013, pp. 21–3.

11 Until the mid-1850s, the prints would have been engravings, mezzotints or lithographs; from the 1850s onwards, it was also possible to produce successful photographic copies of works of art, although they would not be in colour. Roger Fenton was employed at the British Museum in the 1850s to take photographs of various works for this market.

12 Dennis Farr, 'Colnaghi family (*per. c.*1785–1911)', *ODNB* accessed January 2017.

13 *The Art Journal*, 1 April 1856, p. 123.

14 Even earlier, the Royal Navy had allowed photography on board HMS *Hecla*, which had been sent to the Baltic in February and March 1854. 'Mr. Elliot said that he had practised photography and had been with the fleet to the Baltic as a photographer.' *Journal of the Photographic Society*, 21 December 1854.

15 *The Morning Chronicle*, 25 March 1854.

16 *Freemans Journal*, 31 March 1854.

17 The Chief Clerk at Woolwich, Sergent Thomas Connolly, kept a journal between 1848 and 1864. A transcription in the Royal Engineers Museum reads, 'I learn from Mack that Pendered and Hammond are likely to be successful photographers. Prince Albert visited them on the 6th instant, & was so well satisfied with their manipulation that he desired a specimen of their work to be sent to him'. Entry for Saturday 8 April 1854, Royal

Engineers Museum, Chatham, 92.1.

18 Both are in album RCIN 2500122, objects RCIN 2500123 and RCIN 2500137.

19 Fisher 2009, p. 130.

20 Nicklin's death was noted at a meeting of the Photographic Society on 1 February 1855, as was the loss of the photographer Major Halkett in the Charge of the Light Brigade. Halkett was reported to have displayed a modified camera at one of the society's earlier meetings. *Journal of the Photographic Society*, 21 February 1855, p. 117.

21 Cited in Gernsheim 1954, p. 12. No source is given. Gernsheim was the first historian to write about Brandon and Dawson as Government photographers in the war, but he does not provide any primary sources.

22 There is no evidence that Szathmári went on to photograph in the Crimean peninsula, as has been stated in secondary sources.

23 'Cet amateur distingué, M. de Szathmári, [...] est arrivé ces jours derniers à Paris, apportant une collection de plus de deux cents épreuves prises en Valachie.' [This distinguished 'art-lover', M. de Szathmári, arrived recently from Paris bringing a collection of more than two hundred prints taken in Wallachia] from *La Lumière*, 2 June 1855, p. 1.

24 Ionescu 2014. Ionescu speculates that the 'missing' photographs from the royal album were lost in a fire at Windsor Castle in 1912, but no official record of such a fire exists.

25 In 1854 a message sent from the Crimea to London could take five days or more. The electric telegraph was introduced in 1855, first with a line between Varna and London and then a line between Varna and Balaklava, completed by the end of April. A line between Varna and Istanbul was finished in October 1855.

26 Fenton 1856, pp. 284–91.

27 Letter (3) of 8 March 1855 to Grace Fenton, RFLC, accessed 22 February 2017.

28 Letter (4) of 9–12 March 1855 to William Agnew, RFLC, accessed 22 February 2017.

29 Letter (12) of 6 May 1855 to Grace Fenton, RFLC, accessed 22 February 2017.

30 Unknown 1855, pp. 272–3.

31 Letter (6) of 28 March 1855 to Grace Fenton, RFLC, accessed 22 February 2017.

32 There are substantial surviving sets in the Library of Congress (263 photographs) and the Gernsheim collection of Fenton's Crimean photographs, held at the Harry Ransom Center, University of Texas at Austin

(363 photographs). For example, both the Royal Collection and the Library of Congress have the 11-part panorama of Sevastopol, but the images used differ. Reading the panorama from left to right, the third and the ninth plates are both different.

33 Letter (6) of 28 March 1855 to Grace Fenton, RFLC, accessed 22 February 2017.

34 'By the kindness of the Duke Newcastle and of Sir Morton Peto, my passage was provided.' Fenton 1856, p. 286.

35 Letter (7) of 4–5 April 1855 to Grace Fenton, RFLC, accessed 22 February 2017.

36 The hill was used as a burial ground for some of the British dead. It was named after Sir George Cathcart (1794–1854), who died at the Battle of Inkerman (5 November 1854), one of the first senior officers to be killed. At the time of his death Cathcart was Adjutant-General.

37 Fenton also made a five-part panorama of the Plains of Balaklava (RCINs 2500473–7), and a three-part panorama of the Valley of Inkerman (RCINs 2500469–71). A printed key for the Balaklava panorama also exists.

38 *The Athenaeum*, 21 June 1856, p. 784.

39 Letter (11) of 20 April 1855 to Grace Fenton, RFLC, accessed 22 February 2017.

40 Letter (20) of 4 June 1855 to Annie Grace Fenton, RFLC, accessed 22 February 2017. The final assaults on Sevastopol did not take place until 8 September 1855, after Fenton had returned to Britain.

41 Many of the portraits not taken in the Crimea were added to the sequence later and so were not included in the first display of Fenton's work in September 1855. The works were subsequently added into the later exhibition catalogues where many are identified with an asterisk against the number and title. However, the use of the asterisk is not applied uniquely to those works taken outside the Crimea. The series of photographs in the Royal Collection remains in the order in which it was stored when first acquired in the 1850s. All of the non-Crimean portraits appear at the end of the sequence and are not part of the hand-written catalogue, suggesting they were acquired later than the main set. This supports the argument that they were produced at a later date. The order also suggests that other portraits, including those of Colin Campbell, Filder and Hughes, amongst others, may also have been taken in London.

42 The Spahis were a cavalry regiment that fought in the French army, drawn from North African

countries, including Algeria and Morocco.

43 Duberly published an account of her time in the Crimea (Duberly 1855). Despite the royal family's interest in the war, no copy seems to have been acquired for the Royal Library.

44 Kars is a city in eastern Anatolia, which was attacked and besieged by the Russians in June 1855. Resistance was led by General Sir Fenwick Williams (1800–1883), but after extreme deprivation Williams had to surrender to the Russians on 28 November 1855. His courageous resistance made him a hero when he returned to Britain in March 1856 after his imprisonment in Russia. The Siege of Kars was the last major event of the war.

45 'Fenton's War Pictures', advertisement in the *Bristol Mercury*, 15 March 1856, p. 5. 'Taken by Roger Fenton, Esq., in the Crimea, at the risk of his life, and which cost the Proprietors £10,000.'

46 Agnew 1967, p. 67.

47 'Photographic Pictures of the Seat of War by Roger Fenton', *The Athenaeum*, 18 August 1855, p. 938; *The Morning Chronicle*, 17 August 1855, p. 1.

48 Letter (6) of 28 March 1855 to Grace Fenton.

49 'I send you a portrait of some Croats [–] let Dr Becker see it & take care no publisher sees it.' Letter (6) of 28 March 1855 to Grace Fenton.

50 RA VIC/MAIN/QVJ/1855: 8 August 1855. The photograph referred to is the 'Council of War' group, pl. 14.

51 *ILN*, 15 September 1855, p. 326.

52 Letter (15) of 18 and 20 May 1855 to William Agnew, RFLC, accessed 22 February 2017.

53 Letter (14) of 18 May 1855 to Grace Fenton, RFLC, accessed 22 February 2017.

54 Letter (22) of 9 June 1855 to Joseph Fenton, RFLC, accessed 22 February 2017.

55 *Daily News*, 20 September 1855.

56 See Gartlan 2005 for a close study of Robertson and Beato's working relationship with respect to their Crimean photographs.

57 Venues traced through newspaper reports and surviving exhibition catalogues include London (x4), Glasgow, Oxford, Manchester, Cheltenham, Edinburgh, Liverpool, Bristol, Lancaster, Dublin, Newcastle, Birmingham, Nottingham, Belfast, Sheffield, Bath, Worcester, Bradford, Leeds, Gloucester, Yeovil, Exeter and Cardiff. I am grateful to Roger Taylor for sharing his research on the various venues. Additional information comes from 'Photographic Exhibitions in Britain,

1839–1865', www.peib.dmu.ac.uk.

58 *The Athenaeum*, 29 September 1855, pp. 1117–18; *The Art Journal*, 1 October 1855, p. 285.

59 *The Athenaeum*, 29 September 1855, p. 1118.

60 *Belfast Newsletter*, 31 March 1856, p. 2. 'The pictures have received the marked approval of her Majesty, and have been visited by more than two millions of persons in the various towns where they were exhibited.'

61 RA VIC/MAIN/EVIID/1856: 21 February and 28 June. The Prince of Wales also visited the display of Robertson's photographs at Kilburn's Gallery on 28 February, and an exhibition of Simpson's and Armitage's work on 10 April.

62 Griffiths 1996, pp. 30–31.

63 Roger Taylor, 'Tripe's Printing Techniques', in Washington 2015, p. 194.

64 *The Athenaeum*, 3 January 1857, p. 2.

65 Various notices appeared in newspapers in advance of the auction, for example, *The Times*, 4 December 1856, p. 5.

66 'New Exhibition of Crimean Photographs', *The Morning Post*, 1 January 1856, p. 1.

67 See Paris 1994–5 for information on French photographers of the war.

68 London 2010, pp. 22–7.

69 RCINs 2906230–2, part of Prince Albert's 'Calotypes' album.

Postscript: After the War

1 RA VIC/ADDA3/132, Prince of Wales to Queen Victoria, 13 April 1869.

2 Ibid.

BIBLIOGRAPHY

Abbreviations

ILN *Illustrated London News*
ODNB *Oxford Dictionary of National Biography*
 (online edition)
QVJ Queen Victoria's Journal
RA Royal Archives
RFLC Roger Fenton's Letters from the Crimea

Archival sources

RA VIC/ADDA3/132
RA VIC/MAIN/F/1/102
RA VIC/MAIN/QVJ/1854
RA VIC/MAIN/QVJ/1855
RA VIC/MAIN/QVJ/1856
RA VIC/MAIN/EVIID/1854
RA VIC/MAIN/EVIID/1856

Articles

Bates 2015a
R. Bates, '"All Touched my Hand": Queenly Sentiment and Royal Prerogative', 19: *Interdisciplinary Studies in the Long Nineteenth Century* 20, 2015 <http://dx.doi.org/10.16995/ntn.708>

Bates 2015b
R. Bates, 'Negotiating a "Tangled Web of Pride and Shame": A Crimean Case-Study', *Museum and Society* 13:4, November 2015, pp. 503–21

Bektas 2017
Y. Bektas, 'The Crimean War as a Technological Enterprise', *Notes and Records*, 1 February 2017 <http://rsnr.royalsocietypublishing.org/content/early/2017/01/31/rsnr.2016.0007>

***Belfast Newsletter*, 31 March 1856**
'The Crimean Photographs', *Belfast Newsletter*, 31 March 1856, p. 2

Cooke 1999
B. Cooke, 'G Shaw Lefevre – Crimean Photographer', *The War Correspondent. The Journal of the Crimean War Research Society*, 17:3, October 1999, pp. 9–13

***Daily News*, 20 September 1855**
'Mr. Fenton's Photographic Pictures of the Crimea', *Daily News*, 20 September 1855, p. 2

Fenton 1856
R. Fenton, 'Narrative of a Photographic Trip to the Seat of War in the Crimea', *Journal of the Photographic Society*, 21 January 1856, pp. 284–91

Fisher 2009
G. Fisher, 'John Pendered, Royal Sappers and Miners', *The Journal of the Society for Army Historical Research* 87, 2009, pp. 128–34

***Freemans Journal*, 31 March 1854**
'The Preparations for War', *Freemans Journal and Daily Commercial Advertiser*, 31 March 1854

Gartlan 2005
L. Gartlan, 'James Robertson and Felice Beato in the Crimea: Recent Findings', *History of Photography* 29:1, Spring 2005, pp. 1–9

Harrington 2001
P. Harrington, 'Simpson's Crimean Sketchbooks', *The War Correspondent. The Journal of the Crimean War Research Society*, 19:1, April 2001, pp. 10–12

Henisch and Heinz 1974
B. Henisch and K. Heinz, 'Robertson of Constantinople', *Image* 17:3, 1974, pp. 1–11

Henisch and Heinz 1990
B. Henisch and K. Heinz, 'James Robertson of Constantinople', *History of Photography* 14:1, January 1990, pp. 23–32

Herschkowitz 1993
R. Herschkowitz, 'Cundall's and Howlett's Crimean Heroes', *History of Photography* 17:1, Spring 1993, pp. 120–21

Houston 2001
N. M. Houston, 'Reading the Victorian Souvenir: Sonnets and Photographs of the Crimean War', *Yale Journal of Criticism*, 14.2, 2001, pp. 353–83

Ionescu 2014
A. Ionescu, 'Szathmari, a great documentary artist', *RIHA Journal 79*, January–March 2014

***Journal of the Photographic Society*, 21 December 1854**
Journal of the Photographic Society 2:25, 21 December 1854, p. 93.

***Journal of the Photographic Society*, 21 February 1855**
Journal of the Photographic Society 2:27, 21 February 1855

***La Lumière*, 2 June 1855**
'La Photographie et la Guerre', *La Lumière*, vol. 22, 2 June 1855

Osman 1992
C. Osman, 'The Later Years of James Robertson', *History of Photography* 16:1, Spring 1992, pp. 72–3

Unknown 1855
'Fenton's Photographs from the Crimea', *Notes and Queries* 12:310, 6 October 1855, pp. 272–3

St John-McAlister 2010
M. St John-McAlister, 'Edward Angelo Goodall (1819–1908): An Artist's Travels in British Guiana and the Crimea', *The Electronic British Library Journal*, 2010, Article 5 <http://www.bl.uk/eblj/2010articles/pdf/ebljarticle52010.pdf>

***The Art Journal*, 1 October 1855**
'Photographs from Sebastopol', *The Art Journal*, 1 October 1855, p. 285

***The Art Journal*, 1 April 1856**
'The Crimean Exhibition', *The Art Journal*, 1 April 1856, p. 123

***The Athenaeum*, 17 February 1855**
'Fine-Art Gossip', *The Athenaeum*, no. 1425, 17 August 1855, p. 207

***The Athenaeum*, 18 August 1855**
'Photographic Pictures of the Seat of War by Roger Fenton', *The Athenaeum*, no. 1451, 18 August 1855, p. 938

***The Athenaeum*, 29 September 1855**
'Photographs from the Crimea', *The Athenaeum*, no. 1457, 29 September 1855, pp. 1117–18

***The Athenaeum*, 21 June 1856**
'Fine-Art Gossip', *The Athenaeum*, no. 1495, 21 June 1856, p. 784

***The Athenaeum*, 3 January 1857**
'Fenton's Photographs', *The Athenaeum*, no. 1523, 3 January 1857, p. 2

***The Morning Chronicle*, 25 March 1854**
'Photography and War', *The Morning Chronicle*, 25 March 1854

***The Morning Chronicle*, 17 August 1855**
'Letter from the Crimea', *The Morning Chronicle*, 17 August 1855, p. 8

***The Morning Post*, 1 January 1856**
'New Exhibition of Crimean Photographs', *The Morning Post*, 1 January 1856, p. 1

***The Times*, 14 November 1854**
'The Operation of The Siege', 1854, p. 7

***The Times*, 4 December 1856**
'Destruction of The Stones Bearing Simpson's Seat of War In The East (Colnaghi's Authentic Series)', 1856, p. 5

Books

Ayde 1895
J. Adye, *Recollections of a Military Life*, London, 1895

Agnew 1967
G. Agnew, *Agnew's 1817–1967*, London, 1967

Baldwin 1996
G. Baldwin, *Roger Fenton: Pasha and Bayadère*, Los Angeles, 1996

Bates 2015c
R. Bates, 'Curating the Crimea: The Cultural Afterlife of a Conflict', PhD thesis, University of Leicester, 2015

Brighton 2004
T. Brighton, *Hell Riders: The Truth about the Charge of the Light Brigade*, London, 2004

Duberly 1855
F. I. Duberly, *Journal Kept During the Russian War: From the Departure of the Army from England in April 1854, to the Fall of Sebastopol*, London, 1855

Dutton 2007
R. Dutton, *Forgotten Heroes: The Charge of the Light Brigade*, Oxton, 2007

Evans 1828
G. Evans, *On the Designs of Russia*, London, 1828

Figes 2010
O. Figes, *Crimea: The Last Crusade*, London, 2010

Gaury 1972
G. Gaury, *Travelling Gent: The Life of Alexander Kinglake 1809–1891*, London and Boston, 1972

Gernsheim 1954
H. Gernsheim, *Roger Fenton, Photographer of the Crimean War: His Photographs and His Letters from the Crimea*, London, 1954

Green-Lewis 1996
J. Green-Lewis, *Framing the Victorians: Photography and the Culture of Realism*, Ithaca and London, 1996

Griffiths 1996
A. Griffiths, *Prints and Printmaking: An Introduction to the History and Techniques*, London, 1996

Hannavy 1975
J. Hannavy, *Roger Fenton of Crimble Hall*, London, 1975

Hannavy 2012
J. Hannavy, *The Victorians and Edwardians at War*, Oxford, 2012

Harrington 1993
P. Harrington, *British Artists and War: The Face of Battle in Paintings and Prints, 1700–1914*, London, 1993

Jones 2012
D. R. Jones, *In the Footsteps of William Simpson, Crimean War Artist*, Worcestershire, 2012

Jones 2014a
D. R. Jones, *In the Footsteps of Roger Fenton, Crimean War Photographer*, New South Wales, 2014

Jones 2014b
D. R. Jones, *In the Footsteps of James Robertson and Felice Beato, Crimean War Photographers*, New South Wales, 2014

Keller 2001
U. Keller, *The Ultimate Spectacle: A Visual History of the Crimean War*, Amsterdam, 2001

Kent 2016
N. Kent, *Crimea: A History*, London, 2016

Kinglake 1863–87
A.W. Kinglake, *The Invasion of the Crimea: Its Origin and an Account of its Progress down to the Death of Lord Raglan*, 8 vols, London, 1863–87

Lalumia 1984
M. Lalumia, *Realism and Politics in Victorian Art of the Crimean War*, Ann Arbor, 1984

Lewinski 1978
J. Lewinski, *The Camera at War*, London, 1978

Maas 1975
J. Maas, *Gambart, Prince of the Victorian Art World*, London, 1975

Magocsi 2014
P. R. Magocsi, *This Blessed Land: Crimea and the Crimean Tartars*, Toronto, 2014

Markovits 2009
S. Markovits, *The Crimean War in the British Imagination*, Cambridge, 2009

McLean 1976
R. McLean, *Joseph Cundall: A Victorian Publisher. Notes on his Life and Check-List of his Books*, Pinner, 1976

Millar 2001
D. Millar, *Victorian Watercolours and Drawings in the Collection of Her Majesty The Queen*, London, 2001

Öztuncay 1992
B. Öztuncay, *James Robertson: Pioneer Photography in the Ottoman Empire*, Istanbul, 1992

Öztuncay 2013
B. Öztuncay, *Robertson: Photographer and Engraver in the Ottoman Capital*, Istanbul, 2013

Plunkett 2003
J. Plunkett, *First Media Monarch*, Oxford, 2003

Rappaport 2007
H. Rappaport, *No Place for Ladies: The Untold Story of Women in the Crimean War*, London, 2007

Royle 1999
T. Royle, *Crimea: The Great Crimean War 1854–1856*, London, 1999

Russell 1858
W. H. Russell, *The British Expedition to the Crimea*, London, 1858

Russell 1895
W. H. Russell, *The Great War with Russia: The Invasion of the Crimea*, London, 1895

Schaaf and Taylor 2001
L. J. Schaaf and R. Taylor, *British Paper Negatives 1839–1864, Sun Pictures Catalogue Ten*, New York, 2001

Schaaf and Taylor 2005
L. J. Schaaf and R. Taylor, *Roger Fenton: A Family Collection, Sun Pictures Catalogue Fourteen*, New York, 2005

Seacole 1857
M. Seacole, *The Wonderful Adventures of Mrs. Seacole in Many Lands*, London, 1857

Sparling 1856
M. Sparling, *Theory and Practice of the Photographic Art including its Chemistry and Optics*, London, 1856

Sweetman 2014
J. Sweetman, *The Crimean War 1854–1856*, Oxford, 2014

Tennyson 1855
A. Tennyson, *Maud and other Poems*, London, 1855

Wong 2010
R. Wong, 'Edmund Gilling Hallewell's Crimean Panoramas', The War Correspondent, *The Journal of the Crimean War Research Society*, 27:4, January 2010, pp. 23–31

Woodham-Smith 1953
C. Woodham-Smith, *The Reason Why*, London, 1953

Exhibition Catalogues

Aberdeen 2010
Roger Fenton, Julia Margaret Cameron: Early British Photographs from the Royal Collection, Aberdeen Art Gallery and Blackwell, Bowness-on-Windermere

Cleveland 1978
Constantin Guys: Crimean War Drawings 1854–1856, Cleveland Museum of Art, Cleveland, Ohio

Edinburgh 1974
The Camera Goes to War: Photographs from the Crimean War 1854–56, Scottish Arts Council Gallery, Edinburgh, Gracefield Arts Centre, Dumfries, Perth Art Gallery, Perth, Aberdeen Art Gallery and Museum, Aberdeen and Kircaldy Art Gallery, Kirkcaldy

Istanbul 2006
150th Anniversary of the Crimean War, Vehbi Koç Foundation, Istanbul

London 1987
Crown and Camera: The Royal Family and Photography 1842–1910, The Queen's Gallery, London

London 1988
Roger Fenton: Photographer of the 1850s, Hayward Gallery, London

London 2003
A Most Desperate Undertaking: The British Army in the Crimea, 1854–56, National Army Museum, London

London 2010
Victoria and Albert: Art and Love, The Queen's Gallery, London

London 2013
Cairo to Constantinople: Francis Bedford's Photographs of the Middle East, The Queen's Gallery, London and The Queen's Gallery, The Palace of Holyroodhouse

London 2016
Painting with Light: Art and Photography from the Pre-Raphaelites to the Modern Age, Tate Britain, London

New York 2004–6
All the Mighty World: The Photographs of Roger Fenton, 1852–1860, Metropolitan Museum of Art, New York, National Gallery of Art, Washington, J. Paul Getty Museum, Los Angeles and Tate Britain, London

New York 2007–8
Impressed by Light: British Photographs from Paper Negatives, 1840–1860, Metropolitan Museum of Art, New York, National Gallery of Art, Washington and Musée d'Orsay, Paris

Paris 1994–5
Crimée, 1854–1856: premiers reportages de guerre, Musée de l'Armée, Paris

Washington 2015
Captain Linnaeus Tripe: Photographer of India and Burma, 1852–1860, National Gallery of Art, Washington and Metropolitan Museum of Art, New York

Websites

Crimean War Research Society
http://www.crimeanwar.org

Library of Congress Photographs
http://www.loc.gov/pictures/collection/ftncnw

RFLC
http://rogerfenton.dmu.ac.uk

ODNB
http://www.oxforddnb.com

ACKNOWLEDGEMENTS

About the authors

Sophie Gordon is Head of Photographs, Royal Collection Trust. Her previous publications include *Cairo to Constantinople: Francis Bedford's Photographs of the Middle East* (Royal Collection Trust, 2013) and articles on the relationship between the Prince of Wales's overseas travels and photography. She also contributed to *A Royal Passion: Queen Victoria and Photography* (Getty Publications, 2014).

Louise Pearson is Collections Online Assistant (Photographs), Royal Collection Trust.

Acknowledgements

The permission of HM The Queen to reproduce items in the Royal Collection and to consult documents in the Royal Archives is gratefully acknowledged by the authors.

We would like to express our grateful thanks to our many colleagues who have assisted with the research for this publication. In particular Rhian Wong, Stephen Patterson and Laura Hobbs have lent their knowledge and expertise of Crimean works within the Royal Collection and Royal Archives.

Beyond the Royal Household, we have been fortunate to have benefited from the advice of many experts in both the history of photography and the history of the war. This includes Omar Koç who graciously provided access to his collection, assisted by curator Bahattin Öztuncay, and Michael Wilson who provided access to his Crimean war photographs, assisted by curator Hope Kingsley. Thank you also to Richard Fattorini of Sotheby's, who helped trace a painting; and the attendees of a study day held in October 2015: Rachel Bates (Bedfordshire Archives); John Falconer (British Library); Glenn Fisher (Crimean War Research Society); Holly Furneaux (Cardiff University); Luke Gartlan (University of St Andrews); John Hannavy; Mike Hinton (Crimean War Research Society); Alastair Massie (National Army Museum); Natasha McEnroe (Florence Nightingale Museum) and Trudi Tate (University of Cambridge). We also thank Rose Teanby who has shared her research on Robert Howlett; and others who have assisted, Jenny Allsworth; Alison Clarke; Roy Flukinger (Harry Ransom Center, University of Texas); Paul Frecker; Ian and Angela Moor (The Centre for Photographic Conservation); Charles Noble; Diane Taylor (The Devonshire Collection, Chatsworth House); Michael Pritchard (Royal Photographic Society); Danielle Sellers (Royal Engineers Museum); Pierre Spake; Juliet Hacking and the attendees of a very timely study day in July 2016, 'Photography and Art in Britain, 1835–1910' (Tate Britain/Paul Mellon Centre for Studies in British Art).

Finally special thanks go to Roger Taylor, the pre-eminent expert on the life and work of Roger Fenton who has shared his knowledge and expertise so freely throughout the entire process. We are indebted to his extraordinary generosity and supportive encouragement.

INDEX

Locators in roman refer to page numbers and are given first; locators in *italics* refer to figures and are given next; and, finally, locators in **bold** refer to plates.

Published 2017 by Royal Collection Trust
York House, St James's Palace
London SW1A 1BQ

ISBN 978 1 909741 38 6
101101

British Library Cataloguing in Publication data:
A catalogue record of this book is available from the British Library

Designer Mick Keates
Project Manager Elizabeth Silverton
Production Manager Debbie Wayment
Edited by Sarah Kane and Bev Zimmern
Colour reproduction Tag publishing
Printed on Arctic ivory volume 150gsm
Printed and bound in Turkey by Ofset Yapimevi

Front cover: *Col Adye RA*, April 1855, 20.7 × 15.4 cm, albumen print. RCIN 2500256

pp. 2–3: *Panoramic Series,* April 1855, 26.8 × 35.3 cm, albumen print. RCIN 2500517

p. 4: *Captn Forster & Officers 4th Dragoon Guards*, 1855, 15.9 × 15.6 cm, albumen print. RCIN 2500409

Back cover: *Photographic Van*, 1855, 17.4 × 15.9 cm, albumen print. RCIN 2500439